FRANS **WILDENHAIN**

1950–75: CREATIVE AND COMMERCIAL AMERICAN CERAMICS AT MID-CENTURY

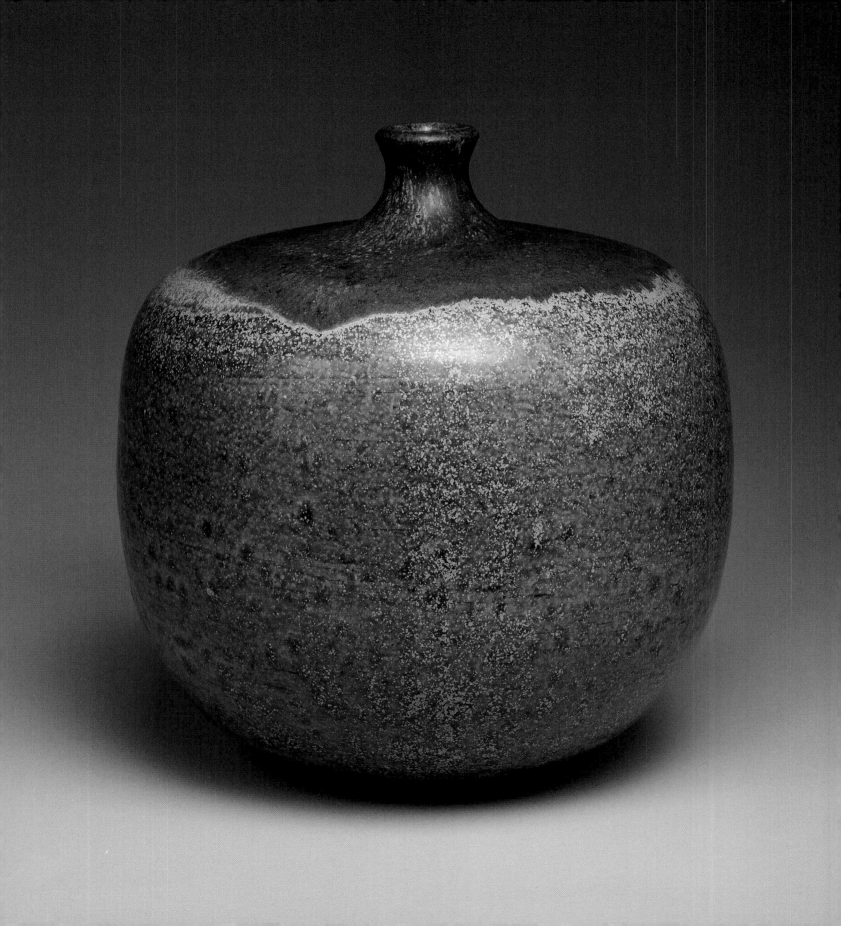

FRANS WILDENHAIN

1950–75: CREATIVE AND COMMERCIAL AMERICAN CERAMICS AT MID-CENTURY

BRUCE A. AUSTIN

PHOTOGRAPHY BY A. Sue Weisler

WITH ESSAYS BY Jonathan Clancy and Becky Simmons

A catalog accompanying the exhibition presented simultaneously at Bevier Gallery and Dyer Arts Center, Rochester Institute of Technology, August 20–October 2, 2012

STONEWARE
10.75 x 10.25 inches, reduction fired

Original photography copyright © 2012 by A. Sue Weisler. "'No medium for the craftsman unsure of himself': Studio Pottery After World War II" © 2012 by Jonathan Clancy. "Craft Education and the First Thirty Years of the School for American Crafts" © 2012 by Becky Simmons.

DESIGN HT Design Studio, LLC, New York, NY
PHOTOGRAPHY A. Sue Weisler, Rochester, NY
COPY EDITOR Kathleen S. Smith, Rochester, NY
PRINTED BY Printing Applications Laboratory, Rochester, NY
SET IN Verlag, designed by Hoefler & Frere-Jones and Arno Pro, designed by Robert Slimbach
COVER Detail "Allegory of a Landscape," Ingle Auditorium, Student Alumni Union, RIT

Unless otherwise credited, all ceramic objects were created by Frans Wildenhain and are part of the Archive Collections, Rochester Institute of Technology, a gift of Robert Bradley Johnson. Cataloging (medium, dimensions, glaze) of the Johnson collection was by John Shea. Object dimensions: height precedes width.

RIT LIBRARIES CATALOGING-IN-PUBLICATION DATA
Austin, Bruce A., 1952-
 Frans Wildenhain, 1950-75 : creative and commercial American ceramics at mid-century /
 by Bruce A. Austin ; photography by A. Sue Weisler.
 p. cm.
 Includes bibliographical references.
 ISBN 978-0-61564527-8 (hardcover)
 1. Wildenhain, Frans, 1905-1980--Exhibitions. 2. Art pottery--20th century--Exhibitions.
 3. Art pottery, American--New York (State)--Rochester--Exhibitions. 4. Modernism (Art)--
 New York (State)--Rochester-- Exhibitions. I. Weisler, A. Sue. II. Title.
NK4210.W469 A4 2012
738.092—dc20

CONTENTS

ACKNOWLEDGMENTS

I am indebted to many people who in a variety of ways helped bring this project to fruition.

Three people worked tirelessly on the exhibition catalog you are holding: A. Sue Weisler, Heidi Trost, and Kathleen S. Smith. Together, they are a dream team of professionals with special sensitivity to each dimension of the project. Sue created the exceptional images you see on virtually every page. Too, except for me, no one worked longer and was more invested in the project than Sue. Heidi created the book's appealing design as well as a host of related documents, including advertising and promotional materials. Kathy diligently copy edited every word and coached the authors.

Chapter authors Jonathan Clancy of Sotheby's Institute of Art and Becky Simmons of RIT's Archive Special Collections enthusiastically answered my call for their contributions. David Rago at Rago Arts and Auction Center introduced and connected me to Jonathan.

Becky Simmons, RIT Archivist, and Jody Sidlauskas, Associate Archivist, were gracious, hospitable, patient, and enormously helpful partners throughout the project's life. They rearranged their own schedules to meet the project's needs and assigned capable student assistants to fulfill selected project responsibilities.

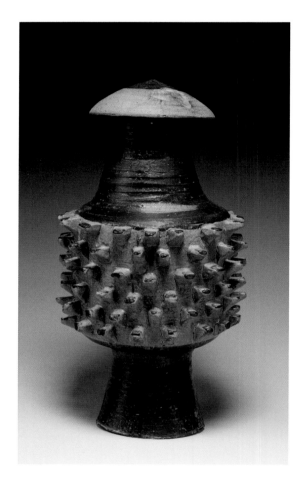

STONEWARE
17.5 x 8.75 inches, reduction fired

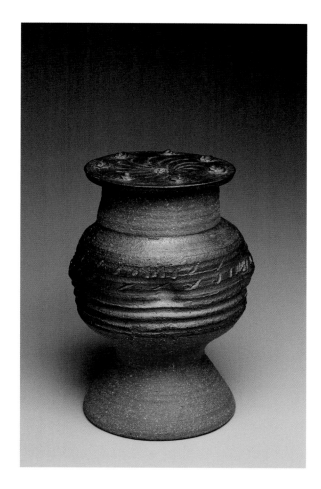

STONEWARE
12.5 x 8 inches, reduction fired

One of my intentions for the exhibition was to connect Susan Bevier's turn-of-the-century generosity that initiated and supported the Institute's interest in art with the third quarter 20th-century generosity of Joseph and Helen Dyer, whose financial support for the Dyer Arts Center recognized the National Technical Institute for the Deaf's significant contributions to deaf education, technology, and the arts. To achieve this, Betsy Murkett and Bob Baker coordinated the exhibition schedules for their two galleries, Bevier Gallery and Dyer Arts Center, and welcomed the exhibition to their spaces for this inaugural cross-campus collaboration.

Robert Johnson's gift to RIT of more than 300 Wildenhain pots revitalized an idea that had gone into the file cabinet and inspired a more ambitious project than the one I initially envisioned. Robert and Winn McCray welcomed me to their home on numerous occasions, shared anecdotes and information, and permitted me to walk out carrying some of the things with which they lived for 55 years.

Stanley D. McKenzie, RIT Provost Emeritus, commented on documents in the project's proposal stage. Stan also read and commented on the chapters I wrote and donated money to support the project. Melinda Beyerlein of the Department of Communication cheerfully provided professional administrative office support for the project. In September 2011, Steve Bodnar, Department

of Communication, became immediately invested in the project and created promotion and publicity materials. Israel Brown, College of Liberal Arts, managed the project's budget. Barbara Giordano and Fred White at RIT's Printing Applications Laboratory provided prompt and professional service.

In addition, I am grateful to a host of people who contributed to the success of this project in one fashion or another. They are: Kelly Anderson, Douglas Baker, Karen Barrows, Mansfield Bascom, Megan Bastian, Amit Batabyal, Raman Bhalla, Sara Bowllan, Kathleen Brooks, Tammy Carter, Roy Cartwright, Virginia Cartwright, Tarrant Clements, Molly Cort, Heather Cottone, Barbara Cowles, Barry Culhane, Mike Danial, Carol Davison, Will Dube, Kate Elliott, Dan English, Kurt Feuerherm, Angela Fina, James Foley, Alyssa Galiney, Kathy Gerbic, Peter Gerbic, Henry Gernhardt, Peter Giapulos, Jerry Gombatto, Stephen Greenberg, Andrea Hamilton, Bob Harris, Bernadette Heiney, Rick Hirsch, Julia Browne Jackson, Mike Johansson, Nancy Jurs, Bill Keyser, Dan Knerr, Elizabeth Torgerson-Lamark, Tina Lent, Sarah Lentini, Rick Lilla, R. Bruce Lindsay, Shawna Lusk, Wendy Marks, Anastasia Markson, Kathleen Martin, Kelly Norris Martin, Nancy Martin, Ashley McCall, Bonnie McCracken, Douglas McFarland, Erin McGraw, Sara Michael, Linda Miller, Scott Miller, Marcia Morphy, Mindy Mozer, Frances Murray, Sue Nurse, Janet Straub Ofano, Nick Paulus, David Pedu, Richard Peek, Ken Poole, Howard Prince, Paul C. Rankin, Wade Robison, Susan Rogers, Bill Sax, Patrick Scanlon, Jonathan Schroeder, Dean Schwarz, Clyde Smith, Marnie Soom, Hanna Stoehr, John Tassone, Lucy Toomey, Michael Touhey, Bill Towler, Mary Anna Towler, Marcia Trauernicht, Alicia Treat, Marie Via, Tracey Weisler, Carrie White, and Shirley Wright.

I am grateful to the professionals in the antiques, art, and retail trades who generously provided promotional support for the exhibition and catalog: Aminy Audi, Edward J. Audi, and Brenda Jaynes of Stickley, Audi & Co. (Manlius, NY); Garth Clark of Cowan's + Clark + DelVecchio (Santa Fe and Cincinnati); Sam and Matt Cottone of Cottone Auctions (Geneseo, NY); Riley Humler of Humler & Nolan (Cincinnati); Bruce Johnson, director of the annual Arts & Crafts Conference (Asheville, NC); David Rago of Rago Arts and Auction Center (Lambertville, NJ); Arnie Small of the American Art Pottery Association; John Toomey (John Toomey Gallery, Chicago); and Don Treadway (Treadway Gallery, Cincinnati).

Work on the project produced benefits I did not anticipate at its outset. I gained a friend and am deeply indebted to Paul C. Rankin for his unflagging support. Paul's support is in memory of his mother, Lili Wildenhain.

Colleagues from all across RIT helped propel the project and I am grateful and appreciative for their support.

Dr. James J. Winebrake (Dean, College of Liberal Arts) was the earliest, most enthusiastic, and generous supporter. Additionally, I thank Ms. Shirley Bower (Director of RIT Libraries), Dr. Mary-Beth Cooper (Senior Vice President for Student Affairs), Mr. Bob Finnerty (Chief Communications Officer, University News), Dr. Christine M. Licata (Senior Associate Provost), Dr. Sophia Maggelakis (Dean, College of Science), Dr. James G. Miller (Senior Vice President, Enrollment Management & Career Services), Dr. James Myers (Director, Center for Multidisciplinary Studies), Dr. Ryne Raffaelle (Vice President for Research and Associate Provost), Dr. Ashok Rao (former Dean, E. Philip Saunders College of Business), Dr. Andrew Sears (Dean, B. Thomas Golisano College of Computing and Information Sciences), Ms. Deborah M. Stendardi (Vice President, Government and Community Relations), and Dr. Lynn Wild (Associate Provost for Faculty Success).

I am indebted to five private donors for their generous financial support and enthusiasm for the project.

I appreciate the corporate financial support for the exhibition and catalog provided by S. J. McCullagh, Inc., Tripifoods, and United Refining.

The exhibition's media sponsors were *City Newspaper*, the Little Theatre, and WXXI.

The exhibition is made possible with funds from the Decentralization Program, a regrant program of the New York State Council on the Arts, administered by the Arts & Cultural Council for Greater Rochester.

A grant from Museumwise underwrote my attendance at the 2011 "Museums in Conversation" conference. The Edward and Verna Gerbic Family Foundation generously provided support for the exhibition and its catalog. The German Consulate General provided support for the exhibition catalog. I appreciate being awarded a College of Liberal Arts Faculty Development grant.

Bruce A. Austin
Rochester, NY
May 30, 2012

Consulate General
of the Federal Republic of Germany
New York

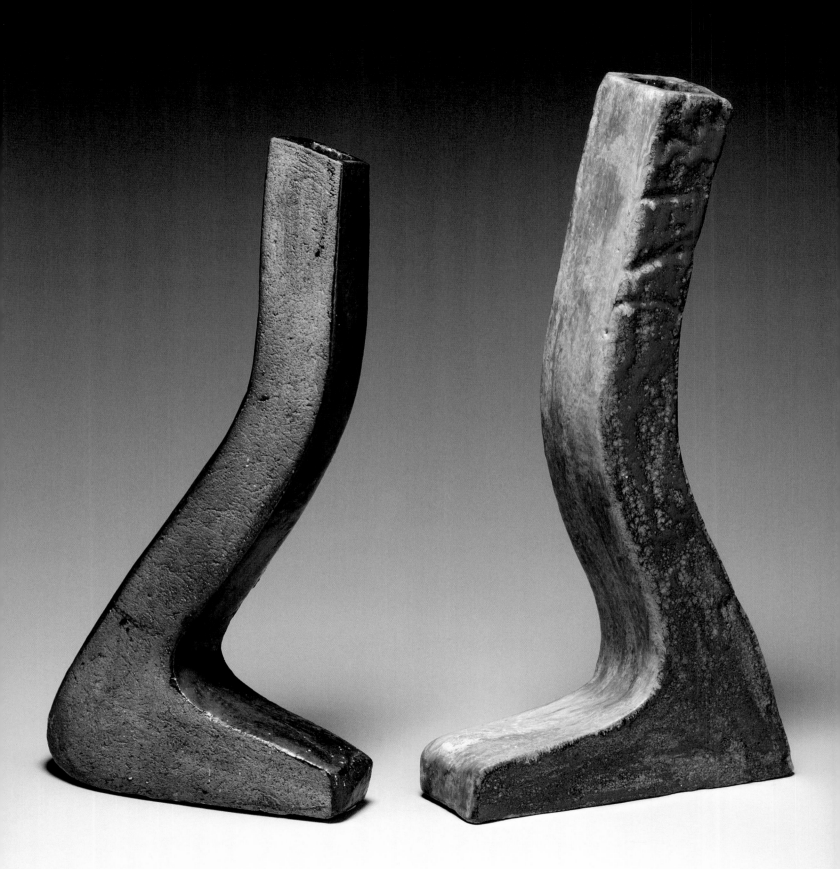

INTRODUCTION
BRUCE A. AUSTIN

My initial idea for this exhibition was modest. Confident I could pull together 50 to 75 examples of Frans Wildenhain's work from a dozen or so private collectors, in July 2009 I proposed an exhibit of ceramic work created by Wildenhain to be held at RIT's Bevier Gallery. The exhibit would offer brief descriptive cards accompanying objects of sufficient breadth and in sufficient number—I hoped—to introduce Wildenhain's work to a larger audience. I was acquainted with his work, owned a few pots, and had a copy of two slender publications that accompanied previous Wildenhain exhibits: RIT's *Frans Wildenhain: A Chronology of a Master Potter* (1975) and the Memorial Art Gallery's *Wildenhain* (Donovan, 1984). And, because of these texts and their photography credits, I was familiar with a collector named Robert Johnson.

The proposal followed thematically and was an evolutionary extension of a 1991 Bevier exhibit I organized: *The Arts & Crafts Movement in Western New York, 1900–1920* (Austin, 1991). That exhibit, and its catalog of objects from the early 20th century, focused on the educational and artistic contributions of the Mechanics Institute (MI) to the Arts and Crafts Movement. Featured then was the largest and broadest assemblage to date of examples by studio ceramist Frederick Walrath, who worked and taught at MI from 1908 to 1918; also represented was ceramist Lulu Scott

LEFT: **STONEWARE**
18.5 x 9.5 x 3.25 inches, reduction fired

RIGHT: **STONEWARE**
20 x 10.5 x 3.25 inches, reduction fired

Backus, who had worked at MI from 1918 to 1952. With the proposed Wildenhain exhibit, I intended to move the focus temporally forward a half-century from Walrath.

Two things pulling in opposite directions altered my initial plans. First, I could not get traction for the proposal. And second, Mr. Johnson fortuitously and generously donated his collection of Wildenhain ceramics to RIT.

Toward the end of that summer, Becky Simmons, RIT's archivist, serendipitously stopped by my office. I told her that I had intended to speak with her about the now abandoned Wildenhain exhibit idea. Shortly thereafter, she informed me of Mr. Johnson's forthcoming donation of hundreds of Wildenhain ceramics. The promised gift was just too good an opportunity to allow my idea to lie fallow— so I expanded it.

The early 20th century Arts and Crafts Movement extolled the virtues of hand craftsmanship. Ironically, the best-known (then and now) American Arts and Crafts creators were busy cranking out products from their factories. In addition to furniture by Gustav Stickley and metalwork by Roycroft, Arts and Crafts included art pottery, frequently manufactured in factory settings, using industrial methods: skill specialization, division of labor, and production line procedures yielded the final output. The incredible contemporary availability of Rookwood Pottery (Cincinnati, Ohio, 1880–1967) cannot otherwise be explained.

FREDERICK WALRATH
Circa 1910
RIT Archive Collections

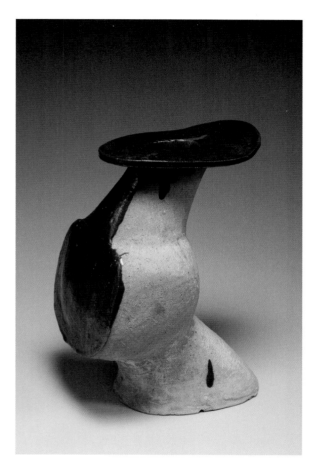

EARTHENWARE
17.25 x 11.25 x 8.5 inches, reduction fired

This is not to suggest that factories were the only sources of art pottery. Studio potters who conceived and brought to completion their ideas by singly executing the shaping, decorating, glazing, and firing of clay were not novelties in the Arts and Crafts period (see Lauria, 2000). The example of Walrath immediately comes to mind. He is joined by such other Arts and Crafts studio potter contemporaries as Theophilus A. Brouwer (Middle Lane/Brouwer Pottery, East and West Hampton, New York, 1894–1902/1903–1946), William Percival Jervis (Jervis Pottery, Oyster Bay, New York, circa 1908–1912), and William J. Walley (Walley Pottery, West Sterling, Massachusetts, 1898–1919), to cite just a few of the hundreds identified by Ken Forster in his two recent titles (2010).

Arts and Crafts period ceramics typically complement the furniture and decorative accessories produced during the same time. Wildenhain's work, in contrast, stands juxtaposed to the sleek, industrial, precision-manufactured smoothness of mid-century modern design furniture. Wildenhain's work shares with some Arts and Crafts period ceramics a certain earthiness of theme, though in many ways absent their "finished" or refined smoothness. The glaze bubbles and pops that today draw the eye to a Wildenhain piece would have been "X-ed" as seconds at Rookwood Pottery. Walrath's stylized natural decorations telegraph a patient and trained hand to observers; Wildenhain's forms

and his scratches in clay suggest a certain ambiguity to viewers about a more hurriedly passionate hand that did the marking as well as the meaning of the marks.

The present exhibition and text focus on the 1950–75 time bracket. Often, one does recognize the entry of a new epoch. With hindsight the new becomes sharp and clear. The interpretative, subjective lens of rearview vision helps make important that which came before as much as it creates stars, anchors themes, and telegraphs a sense of significance, often at the expense of moving to the periphery that which failed, was disputed, or became orphaned—yet in each case, was very much a part of the "process." Wildenhain and the School for American Craftsmen (SAC) together began their RIT careers in 1950, and 1975 marked Wildenhain's final RIT exhibition (*Frans Wildenhain*, 1975) as well as the demise of his innovative craft artists' cooperative, Shop One.

The timing is significant. The Second World War's consequences for education were profound. The GI Bill democratized and enabled college attendance among those who otherwise might not have been able to attend. After 1945, veterans filled college halls, including those at art schools. About a decade later, the college enrollment bubble again expanded with servicemen, this time as a consequence of deployment for the Korean War. At the same time, as Jonathan Clancy reports, the studio pottery movement exploded on the art scene.

Modernism had embraced the machine to the same extent that the Arts and Crafts Movement rejected it. Arts

WILDENHAIN SIGNATURE

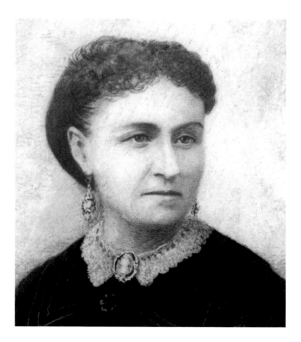

SUSAN BEVIER
Circa 1900
RIT Archive Collections

and Crafts viewed as corrupt the machine's dehumanizing elements. Rather than bemoaning poor design and shoddy construction and blaming the machine, Modernists sought to harness the precision possible by the machine and its ability to execute exactly, repetitively, and without complaint the craftsman's commands. As masters of the machine and innovators of the idea, Modernists rejected the amateurish dilettantism produced by the well meaning or reform-intended. (Just as today, one hopes we recognize that neither Auto-Tune nor Photoshop do singers or photographers make.) And by mid-century, a "handmade modernism" (Scanlan, 2011) emerged that blended craft elements (the medium, shapes, techniques for creation) with industrial capacity. Reversing the course of mechanized modernism, Clancy's chapter reveals how mid-century potters further extended their handmade medium by embracing self-expression in service to social and political statements.

The paired threads—Modernism and Arts and Crafts, Wildenhain as much as Walrath and, more broadly, Mechanics Institute and Rochester Institute of Technology—were guided, supported, and woven together in their artistic endeavors from the beginning of the 20th century to its end thanks to two remarkable women. Each was enormously significant in guiding the hands at the wheels: Susan Bevier and Aileen Osborn Vanderbilt Webb.[1]

Susan Bevier (1822–1903) frequently had summered with friends who lived on Rochester's South Washington Street and she became familiar with art students and faculty at

Mechanics Institute. A New York City art collector interested in art education, she gave $70,000 and her art collection to the Institute and, following her death in February 1903 bequeathed to MI her estate valued at up to $300,000. She designated the funds for a memorial building to include an art gallery, auditorium, classrooms and workshops.[2] Perhaps surprising to contemporary minds, the gift produced as much angst as it did appreciation among the Institute's Board of Trustees due to the chasm between MI's practical, vocational training and, well, virtually everything else, especially things associated with art. Finally, by 1911, directed by Rochester architect Claude Fayette Bragdon's design, the Bevier Memorial Building was erected at the corner of Spring and Washington streets (see Massey, 2009). Although this was not the Institute's first foray into the world of art or the Arts and Crafts Movement—Theodore Hanford Pond established MI's Department of Fine and Applied Arts in 1902; and in April 1903 MI hosted Gustav Stickley's exhibit of Arts and Crafts and presented a second Arts and Crafts exhibit in 1905—it was an unambiguous step forward, leaving a substantial footprint. In 1918, MI hosted an exhibit of the National Society of Craftsmen of New York and the Arts and Crafts Society of Boston.

Aileen Osborn Vanderbilt Webb (1892–1979) is described by Cooper (2004, p. 133) as a "'tall, authoritative, yet strangely shy' figure who was a great patron of modern studio crafts and who combined a regal presence with genuine humility and an idealistic commitment to the crafts."

MECHANICS INSTITUTE EXHIBITION OF GUSTAV STICKLEY ARTS AND CRAFTS
April 15–25, 1903
RIT Archive Collections

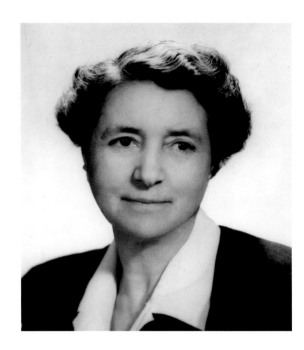

AILEEN OSBORN VANDERBILT WEBB
Circa 1950
RIT Archive Collections

William Keyser, a SAC graduate and faculty member who met her on more than one occasion, describes her as "a very gracious woman, a grand lady who was kind of ordinary [in appearance] and very approachable" (Keyser, 2011; also Jackson, 2011). He adds: "She did not micromanage, she got people started on things and didn't interfere, even if she didn't like" the work that was produced. Married to Vanderbilt Webb, the great-grandson of railroad and shipping baron "Commodore" Vanderbilt, she was nested comfortably in a family interested in art and art collecting and that afforded her the financial means to drive her philanthropy. In the 1930s, early in her philanthropic career, Webb formed Putnam County (New York) Products as a marketing outlet and source of income for the poor who had been dispossessed by the Great Depression. But it was in the midst of the Second World War that her interest in craft manifested itself in several empirical and influential ways. In 1940, she was elected president of the one-year-old Handcraft Cooperative League of America, an affiliation of craft groups. The same year, the League opened America House in New York City as a retail outlet for crafts (see Levin, 1988, p. 166) and a year later, in 1941, *Craft Horizons* (now *American Craft*) began publication. With her guidance and support, the American Craftsmen's Educational Council (ACEC, now the American Craft Council) was organized in 1943. This was followed by the installation of the School for American Craftsmen at Dartmouth College in 1944, sponsored by ACEC. Becky Simmons explores this

subject in her chapter.[3] SAC moved to the New York State University College at Alfred in 1946 and then was relocated a second time in 1950 to RIT, where it has resided for more than six decades, its name now shortened to School for American Crafts.

Susan Bevier and Aileen Webb's contributions advanced the curriculum and teaching of art and crafts at Rochester Institute of Technology. Mrs. Bevier's gifts propelled the modest Department of Fine and Applied Arts beyond Pond's initial aspirations. Mrs. Webb championed Crafts, underwrote the School, and persistently lobbied for its successful relocation to RIT in 1950. The introduction of SAC and its faculty to the RIT portfolio, including Frans Wildenhain, proved to be the incubator for a virtually unique artists' cooperative—Shop One, a place where retail customers could purchase the work produced by SAC faculty and others. Among the earliest customers was a young RPI physics graduate and recently employed Eastman Kodak optical engineer named Robert Johnson. As he reports in the interview, Johnson says he bought a Wildenhain lamp base in 1955 for the perfectly sensible reason that he needed a lamp. Simple and straightforward. He had moved from cramped quarters at the downtown Rochester YMCA,[4] where he also had been burglarized, to a much more spacious Prince Street apartment in a gothic Victorian house (coincidentally and unknowingly, a five-minute walk from Wildenhain's Strathallan Park residence).

The lamp base and initial exposure—"infection"—to the collecting "virus" as he calls it, led to a quarter century of "sickness" from which RIT and we now benefit. Mr. Johnson's collecting diligence affords us today's opportunity to view the product of the hands that formed the work at the School.

In the 1975 RIT Wildenhain publication referenced earlier, Harold J. Brennan, Dean Emeritus of the College of Fine and Applied Art, wrote that that exhibit was a "retrospective exhibition of diverse labors among the arts, and the measures of his [Wildenhain's] achievements." With the present exhibition and text we are given the opportunity to appreciate the creator and his work, as well as the collector who ensured our appreciation.

WILDENHAIN SIGNATURE

ROBERT BRADLEY JOHNSON
Fall 2010

NOTES

1 For a discussion of collectors who were women and their influence see Macleod (2008).

2 Gordon (1982, p. 82) states the $300,000 figure while the *New York Times* reported $50,000 ("Bequest to," 1903). The present report about Bevier relies on Gordon's work.

3 Later, in 1956, the Museum of Contemporary Crafts (later the American Craft Museum and now the Museum of Arts and Design) opens in a brownstone purchased by Mrs. Webb at 29 West 53rd Street in New York City. The Council divests itself of America House in 1959 and the shop moves across the street to another brownstone purchased by Mrs. Webb at 44 West 53rd. On June 12, 1966, Mrs. Webb founds the World Crafts Council (www.wccna.org) and America House closes in 1971 (www.craftcouncil.org). For more information on Webb see Zaiden (n.d.).

4 Coincidentally, in addition to the Bevier Building, Claude Bragdon designed the exterior and lobby for the Gibbs Street YMCA (see Costa, 1967, pp. 8–9 and McKelvey, 1954, p. 19).

REFERENCES

Austin, Bruce A. (1991). *The Arts & Crafts Movement in Western New York, 1900–1920*. Rochester: Rochester Institute of Technology, Bevier Gallery exhibition, December 9, 1991–January 22, 1992.

"Bequest to Rochester Athenaeum" (1903, March 21). *New York Times*.

Cooper, Emmanuel (2004). "Bernard Leach in America." In Robert Hunter (Ed.), *Ceramics in America 2004* (pp. 130–142). Hanover: Chipstone Foundation/University Press of New England.

Costa, Erville (1967). "Claude F. Bragdon, Architect, Stage Designer, and Mystic." *Rochester History*, 29 (4), October.

Donovan, Susan Rubright (1984). *Wildenhain*. Rochester: Memorial Art Gallery exhibition, October 27–November 25.

Forster, Ken (2010). *Alternative American Ceramics, 1870–1955: The Other American Art Pottery*. Atglen, PA: Schiffer Publishing.

Forster, Ken (2010). *Biographies in American Ceramic Art: 1870–1970*. Atglen, PA: Schiffer Publishing.

Frans Wildenhain: A Chronology of a Master Potter (1975). Rochester: Rochester Institute of Technology, Bevier Gallery exhibition, October 18–November 17.

Gordon, Dane R. (1982). *Rochester Institute of Technology: Industrial Development and Educational Innovation in an American City*. NY: Edwin Mellen Press.

Jackson, Julia Browne (2011). Telephone interview with Bruce A. Austin, November 1.

Keyser, William (2011). Telephone interview with
 Bruce A. Austin, November 2.

Lauria, Jo (2000). "Mapping the History of a
 Collection: Defining Moments in Ceramics at
 LACMA." In Jo Lauria (Ed.), *Color and Fire:
 Defining Moments in Studio Ceramics, 1950–2000*
 (pp. 13–85). NY: Rizzoli.

Levin, Elaine (1988). *The History of American Ceramics,
 1607 to the Present: From Pipkins and Bean Pots to
 Contemporary Forms*. NY: Harry N. Abrams.

Macleod, Dianne Sachko (2008). *Enchanted Lives,
 Enchanted Objects: American Women Collectors
 and the Making of Culture, 1800–1940*.
 Berkeley: University of California Press.

Massey, Jonathan (2009). *Crystal and Arabesque:
 Claude Bragdon, Ornament, and Modern
 Architecture*. Pittsburgh: University of
 Pittsburgh Press.

McKelvey, Blake (1954). "The Y.M.C.A.'s First Century
 in Rochester." *Rochester History*, 16 (1), January.

http://www.craftcouncil.org

http://www.wccna.org

Zaiden, Emily (n.d.). "Untold Stories: The American
 Craft Council and Aileen Osborn Webb."
 http://www.craftinamerica.org/artists_metal/
 story_585.php

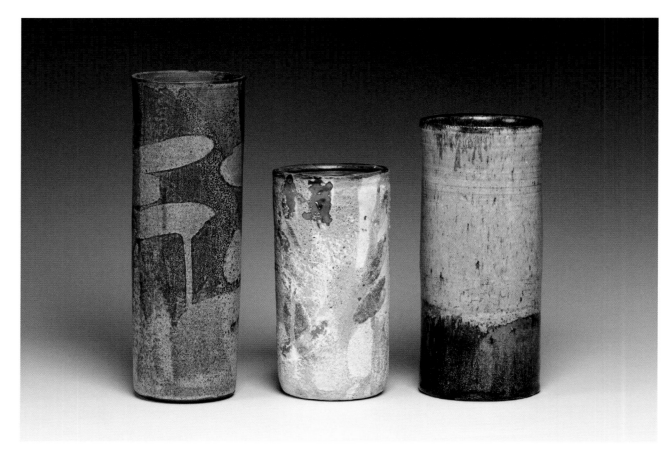

LEFT: **EARTHENWARE**
10 x 3.25 inches, reduction fired

CENTER: **EARTHENWARE**
7 x 3.25 inches, reduction fired

RIGHT: **EARTHENWARE**
8.25 x 3.5 inches, reduction fired

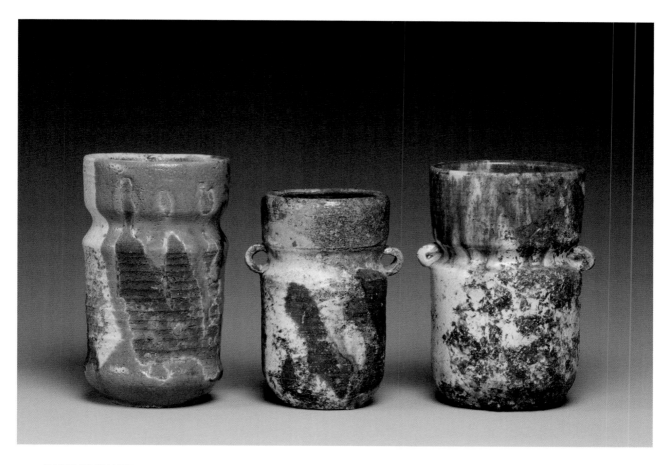

LEFT: **EARTHENWARE**
6.75 x 3.75 inches, post-fired reduction

CENTER: **EARTHENWARE**
6 x 3.25 inches, raku and post-fired reduction

RIGHT: **EARTHENWARE**
6.5 x 4.5 inches, post-fired reduction

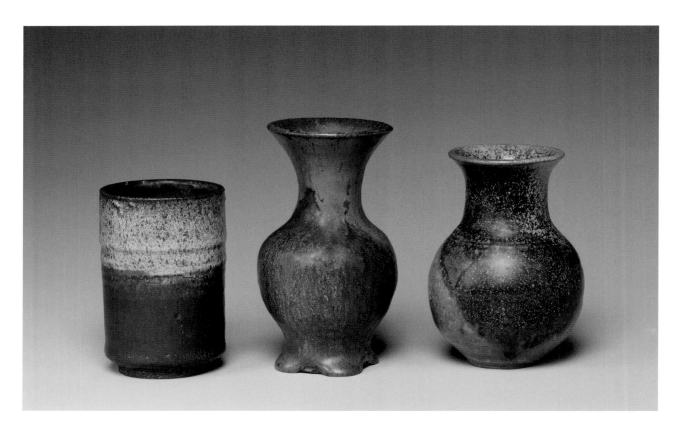

LEFT: **STONEWARE**
3.75 x 2.5 inches, reduction fired

CENTER: **EARTHENWARE**
5 x 2.75 inches, reduction fired

RIGHT: **STONEWARE**
4.5 x 3.25 inches, reduction fired

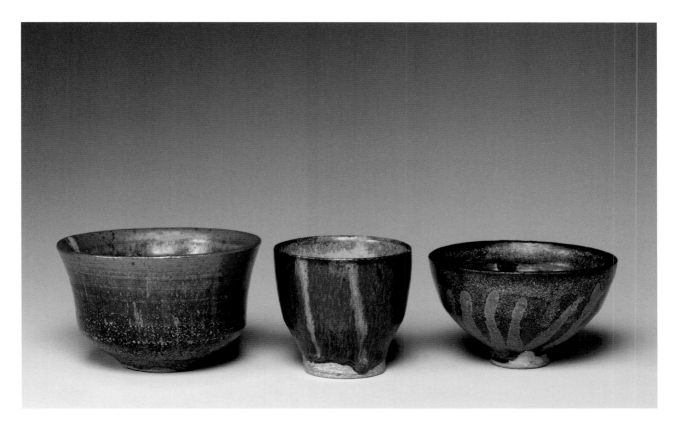

LEFT: **STONEWARE**
3 x 4.75 inches, reduction fired

CENTER: **EARTHENWARE**
2.75 x 3 inches, reduction fired

RIGHT: **STONEWARE**
2.5 x 4.25 inches, reduction fired

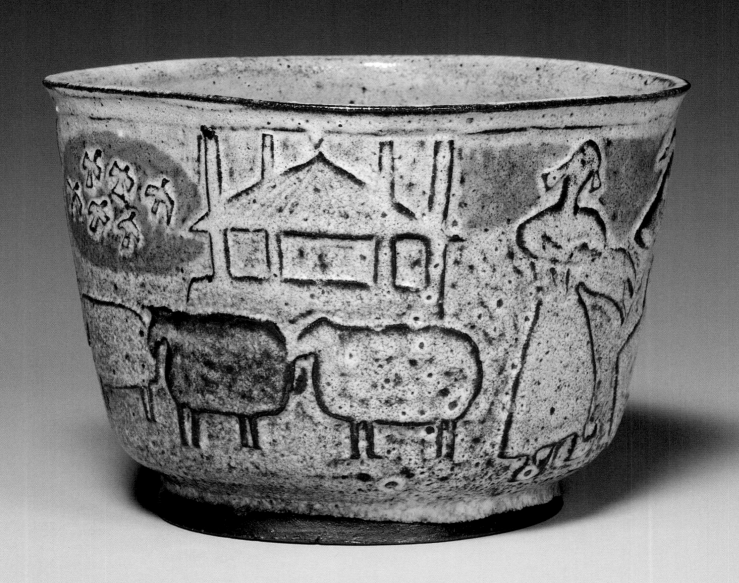

2

BIOGRAPHY
BRUCE A. AUSTIN

"You have stolen my name for your work!" (Schwarz, 2007, pp. 13–14)

Frans Wildenhain's angry explosion at his wife, Marguerite, is both curious and revealing. The accusation was delivered as he left Pond Farm, their California crafts cooperative, in the company of Marguerite's secretary, Marjorie McIlroy, who soon would become his second wife. The confrontation followed the couple's seven years of wartime separation and within just a few years of being reunited. Most astonishingly, his declaration was leveled knowing that she was his teacher and was famous well prior to "stealing" his name.

Chutzpas, arrogance, or ego-centrism—the level of contemporary charity extended to Wildenhain may differ by observer. The direction of sentiment, though, is similar. Biographical information about Frans Rudolf Wildenhain is widely reported if differently focused, and the chronology of his artistic accomplishments is fairly clear, though the level of detail and fidelity varies across sources.

Frequently boisterous and, in current parlance, at least on occasion an "attention whore" well known for theatrics such as bellowing while simultaneously ringing a bell at opening receptions (Krakowski and Cowles, n.d.), Wildenhain was a multifaceted artist, a nurturing and

EARTHENWARE
4.75 x 6.5 inches, reduction fired

dedicated teacher, and very much of the Old School. One writer described his work in words that also might be used to describe the man: "Wildenhain's work belies the myth of Bauhaus uniformity, of an 'international style' which, when dispersed, shaped a world of reductive and rigidly formal solutions" (Chambers, 1979, p. 3). Labeling his life an "adventure" imposes a gushing Victorian romanticism revealing little and disguising much. Likewise, characterizing him as a "conflicted creative" is no more than armchair analysis that explains little and seeks to excuse much. Perhaps it is enough to describe him and his life as "interesting," accompanied by all of the term's robust connotations and ambiguities. A product in nearly equal measures of his training, his passions, and a tumultuous socio-political milieu, Wildenhain's career culminated in a two-decade residency at a place that in many ways seemed designed for him as much as he was destined for it.

SCHOOL

"My father and grandfather were carpenters. My mother said: 'Frans, do not be a carpenter.' Therefore I am a potter" (Krakowski and Cowles, n.d.). An oversimplification, of course, and were it only that straightforward to trace a career's trajectory.

Wildenhain was born to a poor family on June 6, 1905, in Leipzig, Germany. Toward the end of his life, he wrote this description in a notebook: "So as I was brought up as a child wasn't too bad and it wasn't so good either. Not a wealthy

FRANS WILDENHAIN
Black wash/watercolor, 10 x 16 inches
Private collection

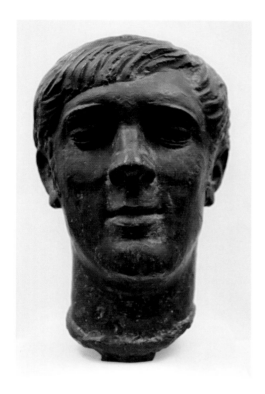

GERHARD MARCKS
Bronze, "Kopf Rudolf Frans Wildenhain," 1932
Photograph courtesy of Luther College Fine Art Collection

father When I was 9 years old father went to war, when he came back I was almost 13. As the only boy ... Mother and I planned a day-to-day warfare for survival. Knocking— begging—on the doors of unwilling, uncooperating [*sic*] farmers. I was often very lucky. Stealing from the fields was very punishable—we try to avoid it. Money—I didn't know really what it meant. Since I learned very early that food, a pair of shoes and a roof over the head was what you actually need, so money has never occupied—or chased to survive— my mind" (Wildenhain, 1976, January 7). Wildenhain's professional life began at age 14 when he apprenticed as a graphic draftsman and lithographer. His early work in the two-dimensional medium was influential and he maintained a lifelong interest in painting and art. Levin described him as, "A prolific artist equally at ease with oils, watercolors and clay" (Levin, 1985). And Harold Brennan, Wildenhain's chairman at RIT's School for American Craftsmen (SAC), wrote, "His approach to dealing with clay on the wheel is constantly nourished and modified by frequent essays in sculpture, and an interest in painting that has engaged him all his life" (Brennan, 1958, p. 39).

Teutonic and ruggedly handsome, a boyish-looking Frans is depicted by his mentor, sculptor Gerhard Marcks, in a 1932 14-inch bronze bust. In 1954, a journalist described the adult Wildenhain as "a six-footer with big shoulders and hands like steel" (Walrath, n.d.). One of his students, a 1960 SAC graduate, describes him as "kind of like an enormous bear" (Jackson, 2011) and another reports Wildenhain had

"hands like suitcases" (Hirsch, 2011). Wildenhain was a "larger than life personality" (Jurs, 2011) and "a pretty powerful guy" (Gerbic, 2011). At about the time of Wildenhain's death, collector Robert Johnson said: "The man exuded such a force of personality and was so direct. He was as powerful and rough-hewn as his pots" (quoted in Cowles, 1980, p. 33).

Beginning in February 1924, thanks to a scholarship (Norton, 1985, p. 49), he became a student at the Bauhaus in Weimar. His training there set the tone both for his pedagogy and his art. At the same time, social and, especially, political and financial dislocations at Weimar manifested themselves, disrupting the Bauhaus's structure. In November 1924, Wildenhain began studying under Marcks and Max Krehan and in 1925 he was the last student to enter Krehan's workshop—his apprenticeship—at the Bauhaus pottery facility in Dornburg.[1] There, Wildenhain met another potter, Marguerite Friedlaender. One of the very first Bauhaus students when she enrolled in 1919, Friedlaender's pottery Master had also been Krehan (Wildenhain, 1973, pp. 25–26). Marcks, the Wildenhains' Bauhaus Master of Form, who offered instruction on form, line and expression, was enormously influential; both Frans and Marguerite wrote and spoke of him and would correspond with him for virtually their entire lives.

Founded in the old *Kunstgewerbe Schule* (School of Arts and Crafts) (Wildenhain, 1973, p. 23) by architect

FRANS WILDENHAIN
Watercolor, landscape, 16.25 x 19 inches, signed F. W./L.W.
Private collection

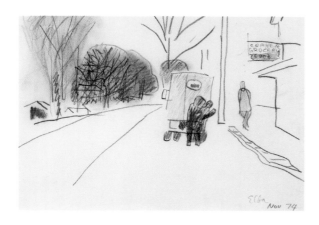

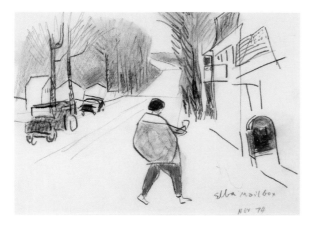

FRANS WILDENHAIN DRAWINGS
Each titled Elba and dated Nov. '74
10.25 x 13.25 inches each
Private collection

Walter Gropius following Germany's defeat in World War I, the Bauhaus emerged in an ambience of experimental liberalization. With a global influence extending temporally well beyond its 1919 to 1933 existence, the Bauhaus inculcated upon its students a prejudice-free integration of fine art, craft, and design, wedding those threads to industrialized mass production.

The Bauhaus ideal was bold, if not wholly original. On a bumper sticker it would read: Head, Heart, and Hand. In fact, in a circuitous way, some 19th-century tenets of William Morris or, more dramatically, the actions of the Luddites, very much set the stage for the Bauhaus. Later, more grounded and capitalistically successful, the early 20th century Americanization of Morris's British Arts and Crafts Movement by Gustav Stickley and Elbert Hubbard was the economic model illustrating how profitability could be wrought (or wrung) from high-mindedness and how industry could be harnessed in service to the artist.

Whether in pure (Morris) or bastardized (Stickley, Hubbard) form, industrialization, mechanization, and factory production were seen by some as debasements of the commonweal. The integration of art and craft coupled with industrialized product was revolutionary. And as the products of the hands, inspired by the heart, were surrendered to the economic efficiencies of industrialization, so too did that which was of the head: U.S. public education

and its curricula increasingly seemed streamlined processes, critics said, centered more on the goal of moving pupils through to completion than on their complete education.

Still, the Bauhaus's novel integration of art and craft coupled with industrialized production was for some magnetic. Teachers and students, drawn by the irresistible pull, achieved an education at the Bauhaus that countered the traditional ways art was taught and learned. Students were immersed in their art education eight hours daily. They were paired with a Master of Form (the artist) and a Workshop Master (the craftsman), or Master of Craft. Together, the two masters provided the student's complete art education. The craftsman and artist were fused, elevating and joining each title it was thought. A good artist also was a good craftsman and vice versa. Bauhaus students gained an applied, practical knowledge of materials coupled with imaginative execution, all resulting in functional design. The curriculum mandated a half-year foundation course for students, followed by a full-time, three-year apprenticeship with the Workshop Master. Advanced as the Bauhaus was in one respect, its curriculum was very much traditional in an important other, hewing closely to the 11th and 12th century medieval guild system that began with apprentice, advanced to journeyman, and culminated in craftsman (see Thill, 2007).

Bauhaus products exalted an unadorned sleekness. "Less is more" was Ludwig Mies van der Rohe's aphorism for Bauhaus minimalism; and that drew from American architect

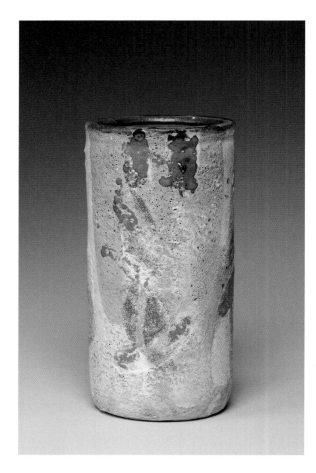

EARTHENWARE
7 x 3.25 inches, reduction fired

BEFORE BAUHAUS IN ENGLAND AND AMERICA
Bruce A. Austin

In the late 1800s, English socialist and designer William Morris advocated for a return to handcrafted goods, accessible to the wide public. His well-known statement applied as much to the aristocrat as the peasant: "Have nothing in your homes that you do not know to be useful and believe to be beautiful." Responding to the evils of industrialization and mechanization that substituted the hourly worker's labor for the craftsman's handwork, Morris sought a return to the pre-industrial close, honest affiliation between craftsman and that which he produced. (In fact, of course, there was no alternative to handcraftsmanship in pre-industrial times.) Appealing in sentiment, but impractical in practice, the handcrafted goods that eschewed the machine were too costly for the very people for whom they were created. Indeed, the products were priced well beyond the financial means of all but the wealthy, thereby distancing still farther the craftsman's work from its consumer. Bringing beauty to the masses necessitated abandoning the strict hand craftsmanship of Morris's dictum and that was required for the sake of honesty and virtue.

Across the ocean, the early 20th century U.S. capitalists took a radically different posture while retaining elements of Morris's idealism. In Syracuse, New York, Gustav Stickley embraced the machine for his furniture factory named Craftsman Workshops, but preached the Morris gospel in his monthly magazine, *The Craftsman*. And 150 miles west of Stickley's plant, in East Aurora,

Elbert Hubbard, a socialist when convenient, initiated Roycroft in 1895. Begun as a print and bindery operation, Roycroft was modeled on Morris's Kelmscott Press, featuring finely bound, limited edition and hand-illumined books produced using printing technology and typography from previous centuries. Like Stickley, within 10 years Hubbard moved Roycroft to producing metalware crafts and furniture, each very much using the factory as its production method.

Too, and at virtually the same time, there was Frederick Winslow Taylor and his time-and-motion studies. The antithesis of the craftsman, Taylor dissected factory labor into more or less discrete actions and provided managers with instructions for making more efficient each action in order to maximize productivity for all. Taylor was the logical (and maybe absurd) extension of that which Morris abhorred, as well he should: a choreography of separate assembly-line hands, a Busby Berkeley rendition of industrial production. At the Bauhaus, though, efficiency was tempered by craftsmanship for purposes of an object's design; the machine would only "take over" at the production stage and once the design had been perfected.

Not everyone is enamored or unconditional in their appreciation for the Bauhaus. Tom Wolfe (1981, p. 9), for instance, punctures the pretentions and posturing, the sniffing superiority of the Bauhaus and, especially, its American disciples in *From Bauhaus to Our House*. After the First World War, he writes, the "boho adventure" of "American architects along with artists, writers, and odd-lot intellectuals" on a "postwar discount tour" all accepted the motto, "They do things better in Europe."

Louis Sullivan's 1896 proclamation, "Form ever follows function."[2] Just enough, and never more. Rather than rejecting mass production, as did Morris, the Bauhaus ideal *intentioned* design for industry, embracing the industrial process—as did Stickley and Hubbard—to achieve the goal of broad economic accessibility for well-conceived products by the masses.[3] Much later, Donhauser (1978, p. 101) observed that, despite Wildenhain's Bauhaus background, he "did not transmit in his teaching nor in his own work" all that often is associated with the school: Wildenhain's "work is usually imbued with a strength and simplicity of form, with close attention given to appropriate decorations that reinforce the basic structure ... exud[ing] a vitality that brings the work to a level of genuine art."

For the foundations course, Wildenhain studied under versatile and multitalented artist Laszlo Moholy-Nagy as well as with modernist and color theorist Paul Klee and abstract painter Josef Albers. Truth be told, teachers teach the way they like to be taught. The result is doubtlessly self-gratifying for teachers, particularly beneficial to students whose learning styles match the teaching style, and not so much for the rest. The Bauhaus held an implied recognition of the first two elements and the foundations course functioned as its metaphor suggests: providing a supportive base structure allowing and encouraging students to explore and sort out for themselves which of several possible avenues they were best suited to pursue, all while under the strict guidance of a Master.

When the Bauhaus moved to Dessau in 1925, pottery was dropped from its curriculum. Shortly thereafter, Krehan died and Marcks left, accepting an appointment as head of *Burg Giebichenstein* (the State School of Fine and Applied Arts) in Halle-Saale, Germany. Thanks to Marcks' recommendation, Friedlaender was hired to head the Ceramics Department there. She had, by then, earned her Master's credential and had begun crafting tableware prototypes for Royal Berlin Porcelain. Frans[4] moved with them to complete his education and work in pottery. In 1926 he passed his Craftsman's Examination before the Guild of Potters at Halle-Saale (Boylen, 1989, p. 12).

In *The Invisible Core: A Potter's Life and Thoughts*, Marguerite detailed the arduous and meticulous work at the pottery (Wildenhain, 1973). Too, she offered chatty anecdotes and frequent lengthy digressions. For instance, she discussed managing one journeyman who threatened to murder the fiancée who had "dumped" him and counseling a binge-drinking worker who spent all his wages, driving his wife to despair. Marguerite carefully noted students' advances in proficiency in throwing, glazing, and firing, as well as new challenges in mass production associated with her own design work for the Royal Berlin Porcelain factory. And in between all these details, facts and asides, she buried one line, almost as a throw-away: "In 1930, Frans Wildenhain and I were married" (Wildenhain, 1973, p. 34). Given the detail she lavished on lesser events, this seemed uncharacteristic, albeit explicable in light of later events.

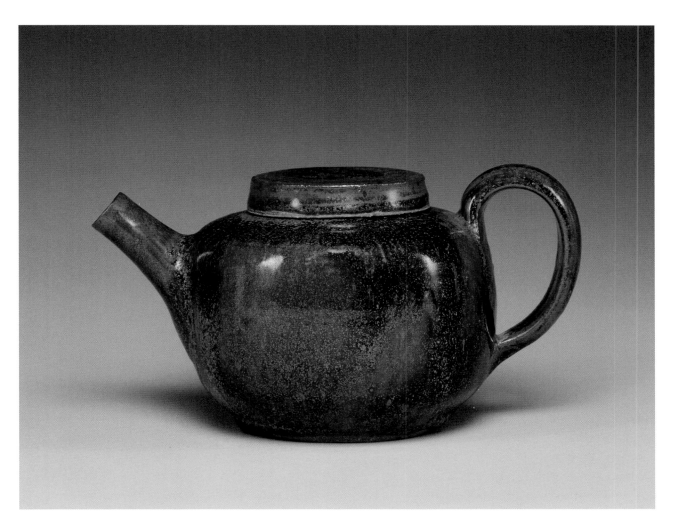

STONEWARE
5 x 8.75 x 5 inches, reduction fired

In 1929, Frans became a Master Potter (Levin, 1984, p. 8; Boylen, 1989, p. 12) and a pottery instructor at Folkwand School Workshop, Essen-Ruhr, and joined the teaching staff of the State School at Halle-Saale. The contentment the Wildenhains then experienced was short-lived.

WAR

Assuming power in 1933, the Nazis purged German schools of non-Aryan teachers, including Marguerite, who was Jewish. Ousted from her job in Halle-Saale, Marguerite moved to Holland, living with her brother, and leased a small ceramics workshop in Putten. Frans arrived shortly after (Levin, 1984, p. 9). They named their new studio *Het Kruikje* (Little Jug). Marguerite began making models for the Petrus Regout Porcelain Factory in Maastricht; in 1937 she was awarded second prize at the International Exhibition of "Arts and Techniques" in Paris (Williams, 1968). She was a Master Potter, an experienced teacher, and was now winning prizes and public acclaim.

In 1939, the Wildenhains were visited in Putten by an American couple enamored of Bauhaus ideals: Gordon and Jane Brandenstein Herr. The meeting was not wholly accidental: Jane, a writer, was distantly related by marriage to Marguerite "in some inscrutable way" (Wildenhain, 1973, p. 53). The Herrs were interested in creating in the United States a community of craftsmen modeled on the Bauhaus. The venture they envisioned would be underwritten by

Jane, who was heiress to the fortune of the M.J. Brandenstein Company, San Francisco importers of coffee and spice. The Herrs offered the Wildenhains a place in their yet-to-be-formed colony of craftsmen—an offer that was later accepted.

The Nazis overran Europe in 1940. Shortly before their invasion of Holland, Marguerite again fled the Fascists. In March, she crossed the English Channel on a Dutch boat. From England she sailed to the United States, landing in New York on March 12 (Schwarz, 2004; see too Williams, 1968). Frans, however, had to remain behind in Holland. Immigration quotas restricted his entry to the United States (Cloutier, 2007, p. 15) and, later, his German citizenship would allow him to enter the U.S. "only if he had a contract for a teaching position at an accredited college" (Schwarz and Schwarz, 2004). Details about Frans's life in Holland during the war are sketchy.

The Wehrmacht marched into Putten in June 1940. By 1941 Frans had moved to Amsterdam, teaching briefly at the Arts and Crafts School and studying sculpture with Jan Bronner at the *Rijksakademie van Beeldende Kunsten* (Royal Academy of Visual Arts). Too, he operated a workshop in Amsterdam and taught at the School of Applied Arts and, briefly, at St. Lioba, the Benedictine Convent in Noord, Holland. By January 1943 he had been conscripted into the German Army (Cloutier, 2007, p. 15; Boylen, 1989, p. 12), and in September 1944 he took part in the pitched, nine-day Battle of Arnhem, a victory for the Germans. In April 1945 he either

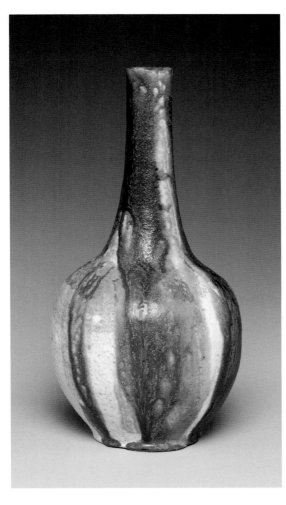

EARTHENWARE
12.25 x 6.25 inches, reduction fired

deserted and was hidden by friends in Amsterdam or, as reported by Boylen's (1989, p. 12) study of Frans's journals, was "captured by a British patrol." Frans's own account of the conclusion to his army service is recorded later in a 1979 notebook as a letter to Mary Maher: "Your father and I made a big hole in a little hut of the backyard of your parents house—buried my uniform and then we took off in civilian clothes on bicycles over the roads and bridges—if one of the Germ. Soldiers would have checked us—we would have been lost. On the bottom of your bag was my gun—which I later handed over to the Dutch underground In the early evening one of your friends took me [temporarily] in hiding—it was a highly tension [*sic*] in the air—also the coming of the liberation Hans [?] brought me the other day to a safer place—where I stayed until the liberation. The people in the house thought I was Flemish I tried to read some books ... but most of the time I was waiting. For what. One day I heard planes overhead—Americans which brought food" (Wildenhain, 1979b). These few details aside, the Wildenhain "war record" is Marguerite's diary of her trip from New York to California, May 10 to September 10, 1940 (in Schwarz, 2004) and her reminiscences of the years of separation from Frans (Wildenhain, 1973).

Arriving in New York, Marguerite stayed with her brother and his family for two months. She unsuccessfully searched for work for Frans and herself in New York; Washington, D.C.; Baltimore; and Cambridge. Her diary entries, intended

for Frans's reading, reported on her bus journey to California. Ironically, as it would turn out, the trip took her past Rochester and other upstate New York cities. Throughout, she repetitively wondered about Frans's whereabouts. Her entry on May 10 described her devotion to him and her angst at their separation and the war: "Oh you—where are you? The Germans have invaded Holland today; I don't know where to look for you." On the 13th she wrote: "I only hope you got behind the line and reached France or England before falling into the hands of these beasts." Her June 15 entry read: "That I think of you, my Franz, all the time I need not emphasize—You and I have our lives [,] but one without the other is only half of all" (Schwarz, 2004).

Moments of understandable insecurity crept in as with this July 4 entry: "Sometimes I lose my courage and my confidence—oh you—but I must not do that. I must have faith in the Lord's help. But at times it is difficult." Five days later she noted: "I was alone, felt lonely, but was close to you, dear Franz, despite 5000 kilometers that separate us. I have a feeling that you long for me in Europe. I do everything not to lose the confidence to see you again." Despairing their separation, she revealed one purpose for the diary in a short June 28 entry: "Wrote you a long letter today. My diary has suddenly become useless. But I will continue to write it for your reading" (Schwarz, 2004).

Marguerite's diary leaves little doubt of her devotion to Frans. Her student and a personal friend, Dean Schwarz, claims, "She loved him all the time, right up to her death"

FRANS WILDENHAIN'S POTTERY AS DISPLAYED ON THE BACK STEPS TO HIS BUSHNELL'S BASIN HOUSE, 1960
Unidentified photographer. RIT Archive Collections, Paul Rankin collection in memory of Lili Wildenhain

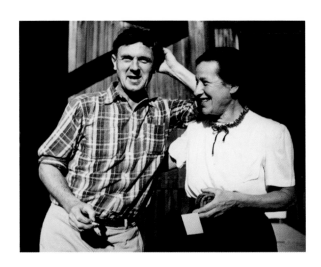

UNTITLED PHOTOGRAPH OF FRANS AND MARGUERITE WILDENHAIN AT POND FARM
Circa 1949, Photograph by Otto Hagel.
Collection Center for Creative Photography, University of Arizona © 1998 The University of Arizona Foundation

(Schwarz, 2011). Doubtless, this made their eventual breakup all the more painful. Dane Cloutier's essay for the Sonoma County Museum's 2007 exhibition catalog of Marguerite's work describes Frans as having abandoned her (Cloutier, 2007, p. 16) and Marguerite is quoted as saying while standing by the cliffs at Jenner, California: "This is where I was going to jump when Frans left me" (Cloutier, 2007, p. 19, footnote 4).

But, to some outside observers, their marriage seemed somewhat "unusual," even from the start. Gordon Herr—who played an important role in the Wildenhains' lives in America—in a letter to his wife, Jane, described differences between the two: "Marguerite is 42, *nine* [emphasis in original] years older than Franz. She wants, or would like children—he does not. He wants nothing to hold them down. They have been married 10 years. She goes away alone for a month or two—he does likewise, as last year when he went for 3 months to Halle Now I doubt that all is well. They have separate rooms, and I feel sure she feels that her place in his life is precarious He is so boy-like—even in his maturity. She cannot feel any security in him and I know she must need it terribly. She begins to show her age, only a little, but enough for her to feel He assumes no responsibility. No business ability or education—cannot manage his affairs. She dictates—he signs his name He is quite 'pure' as an artist, but I cannot believe that irresponsibility goes with simplicity, necessarily" (Schwarz and Schwarz, 2004b).[5]

AMERICA

The 1930s and '40s placed an enormous strain and wreaked tremendous emotional turmoil on all Europeans. The threat and then realization of war, the social and political upheavals, and, for the Wildenhains, the loss of their schools and jobs as well as their physical separation certainly all took a toll on their personal and professional relationship.

Foremost among Marguerite's goals was finding employment for herself and for her husband in order to realize his emigration and their reunion. Establishing herself and, in absentia, him, meant expanding and enhancing their reputation. To that end, she was able to land a show of their pottery at the Art Institute of Chicago from March 1 to April 27, 1941 (Schwarz, 2004). The location is significant insofar as several former Bauhaus faculty had settled in Chicago after leaving Germany. Among them were Laszlo Moholy-Nagy as director of the New Bauhaus and, significantly, the final original Bauhaus director, Mies van der Rohe. The latter had become head of the architecture school at the Armour (now Illinois) Institute of Technology. Too, and by chance, an American soldier, Harold Brennan, saw the exhibit; a decade later, this, too, is significant.

A year previous, on July 20, Marguerite wrote about arranging for Frans's employment: "The College in Oakland ... made me a small offer. 2 mornings a week= $400 a month. The offer comes with a workshop. There is a chance of teaching an evening class. And then this: once I know where you are an annual offer for you. Start of the

FRANS WILDENHAIN, "MEXICO," 1962, NEAR THE PATIO AT HIS BUSHNELL'S BASIN HOME
Unidentified photographer. RIT Archive Collections, Paul Rankin collection in memory of Lili Wildenhain

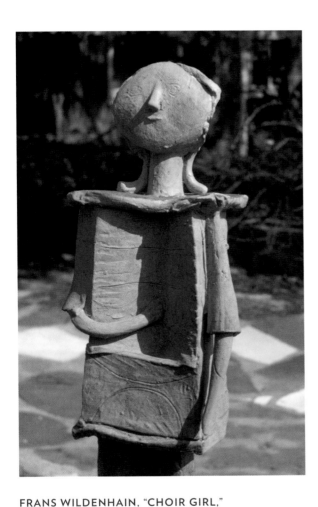

**FRANS WILDENHAIN, "CHOIR GIRL,"
JUNE 1964, ON THE PATIO AT HIS
BUSHNELL'S BASIN HOME**
*Unidentified photographer. RIT Archive Collections,
Paul Rankin collection in memory of Lili Wildenhain*

semester is August 19—I am to substitute for you. It is not certain yet, but probable Things are looking up." On August 4 she reported, "I have the job in Oakland, will start on the 19th and from then on will do everything to get you out here" (Schwarz, 2004).

Perhaps more significant for purposes of Frans's immigration to the United States—more than teaching opportunities, personal ability, or an exhibition record—was that Marguerite became a U.S. citizen. And, in 1946, she was honored with an award for the best ceramic design suitable for mass production at the 11th National Ceramic Exhibition at the Syracuse Museum of Fine Arts. Frans arrived in New York in 1947, she picked him up and together they drove to Guerneville, Sonoma County, California, where the Herrs' cooperative community of craftsmen had taken shape (Wildenhain, 1973, p. 95). Pond Farm, it would later turn out, partially served as an organizational model for the more successful retail enterprise Frans initiated a few years later, without Marguerite, in Rochester, New York: Shop One.

In her diary, Marguerite described San Francisco, Oakland, and the Pond Farm location, writing (June 26): "The city is really attractive, and I'm sure you will like it. And the landscape is beyond all descriptions. Simply beautiful" (Schwarz, 2004). Pond Farm was idyllic; it also was very rural and much removed from the two other cities Marguerite described. Out there, in the country, Frans and Marguerite ran the school's pottery program and, as Marguerite reported, while the co-op ran well and was filled

with students for three years, "personal difficulties" and "differences of opinion as to how the school should be run" produced "personalities [who] clashed" and caused "tempers [to be] on edge" resulting in "violent quarrels" (Wildenhain, 1973, p. 96).

Gerry and Dean Schwarz observed that by the time Frans arrived at Pond Farm, "he may have perceived himself to be an unknown in comparison with his wife. Franz struggled to find his place in the Pond Farm community of artists/teachers at a time when they were engulfed in philosophical and economic issues" (Schwarz and Schwarz, 2004b). In one of his notebooks, Frans wrote: "M. was the established teacher of this colony. I taught only when she was off" (quoted in Boylen, 1989, p. 12). As had been true in Europe, Frans again was overshadowed by his wife. She had a reputation. She was an award winner. She had moved first to the U.S., had become a citizen, and had established herself in California and, specifically, at Pond Farm. Very much invested in the cooperative, Marguerite worked with Gordon Herr to install water lines and establish gardens to ensure the community's sustainability, and she built and restored structures for living and learning. Frans, physically removed by seven years—it might as well have been a lifetime—and an ocean and a war was very much the "new guy." Writing about the Wildenhains, Levin notes: "On a personal level they faced many problems—establishing a crafts school in a postwar industrial climate, adjusting to a difficult country and to seven years apart" (Levin, 1985).

FRANS WILDENHAIN, WALL MOSAIC AT HIS BUSHNELL'S BASIN HOME, 1960
Unidentified photographer. RIT Archive Collections, Paul Rankin collection in memory of Lili Wildenhain

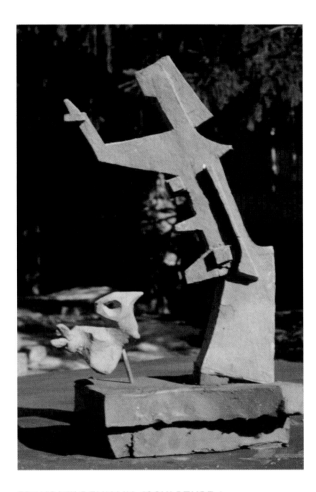

FRANS WILDENHAIN, "SCULPTURE A: WOMEN [*sic*] WITH BIRD," 1960, NEAR THE PATIO AT HIS BUSHNELL'S BASIN HOME
Unidentified photographer. RIT Archive Collections, Paul Rankin collection in memory of Lili Wildenhain

Friction was, perhaps, inevitable. Tim Tivoli Steele, the Herrs' grandson, writes: "In the end, the trait that all the artists had relied on to survive the war and follow their visions—the strength of their personalities—would also contribute to the demise of the Workshops. Constant bickering tore the group apart" (Steele, 1992, p. 3). And the Schwarzes continue: "It is no surprise that the ideas of Jane and Gordon Herr were challenged with the same vigor as were those of Walter Gropius by the Bauhaus masters. One by one the teachers left Pond Farm. Finally Franz also left, accepting a teaching position at the Rochester Institute of Technology in New York" (Schwarz and Schwarz, 2004b).

The Schwarzes' clipped account of the demise of the Wildenhains' marriage is a clinical version of the wrenched "abandonment" described by Marguerite (see Cloutier, 2007, pp. 12, 16). She wrote: "I was hit the hardest when Frans left me. All the waiting had been in vain ... and I remained alone once again" (Wildenhain, 1973, p. 96). In her own text, Marguerite refers as much to Frans as to people more broadly: "I have found that only those you love can hurt you; the so-called enemies one can easily take in stride, smiling" (Wildenhain, 1973, p. 205). And, reports one of her students, Virginia Cartwright (2011), Marguerite remained bitter toward Frans, telling her students: "Don't trust men. Pots will never let you down."

On the surface, for the Wildenhains, America seemed to afford the storybook new home with new opportunities. And Pond Farm was satisfying to its instructors insofar

as the Bauhaus educational model was familiar to them. But Marguerite quickly formed a negative impression, later shared by Frans, of American college students. Her students were a breed very much different and far more undisciplined than were those (and her peers) at the Bauhaus. Too, she formed an equally not-so-warm impression about the American educational system. Art education in America, she thought, produced dilettantes or those interested only in earning a degree so they could teach (Wildenhain, 1973, pp. 63–77). The absence of an apprenticeship, and its substitution by sitting in a class for a few hours a week, only ensured the students' ignorance and its perpetuation once the students moved to the other side of the lectern. She complained of "an art education that is thus neither sufficiently basic, nor competent in its techniques. We have fostered a generation of 'Rock 'n' Roll' craftsmen who float in a sea of violent and misunderstood 'self-expressionism,' disregarding all essential laws of human and artistic integrity" (Wildenhain, 1973, p. 14). Seemingly picking up on Marguerite's earlier complaint, years later Frans noted the slipperiness of American education: "The term Master-Craftsmen is used very loosely. I am perhaps a bit old fashioned in my views. But my concern is serious and not indulging in semantics. Also the apprentice should have after his apprenticeship[,] something written or printed in his possession to prove that he has had training by a master

HOBART COWLES
Circa 1970
RIT Archive Collections

MARJORIE MCILROY AND FRANS WILDENHAIN
Probably at their Strathallan Park apartment, circa 1950
Unidentified photographer. Photograph courtesy of
Andrea Hamilton

Of course when you drop the whole issue of 'apprenticeship' then we have to find other way[s] to pass on skills" (Wildenhain, 1978).

ROCHESTER

Twentieth-century American art schools functioned as did art patrons of centuries past; universities provided the financial support for artists by virtue of their employment as professors.[6] The patron role, arguably, was most sharply true for the nascent, still-struggling-for-recognition craft community at mid-century—a community where craft and art did not exist on the same plane and rarely in the same room (see Mainzer, 1988). With the university assuming the patron's financial responsibility, the artist was as much "kept" as was Joe Gillis by Norma Desmond in *Sunset Boulevard*, albeit without the tragic poolside consequences. The coincidence of movie release date and Wildenhain's move to Rochester is only amusingly curious.

Wildenhain's invitation to join the newly situated-in-Rochester School for American Craftsmen was issued by Harold Brennan. He had directed the School when it was at Alfred and, by 1960, would become RIT's first dean of its College of Fine and Applied Arts. More significantly, Brennan had seen and been impressed by the Chicago exhibition of the Wildenhains' work. He later recalled: "What I had seen was a glimpse of past and present greatness,

and I determined then and there that I had to have these people in the School for American Craftsmen" (quoted in Cowles, 1980b). Levin reports both Frans and Marguerite were offered teaching positions at SAC: "Frans accepted, but Marguerite declined; she saw her future as a potter at Pond Farm" (Levin, 1985; see too Norton, 1985, p. 49). Doubtlessly accurate, the explanation is not comprehensive; the fragile state of the Wildenhain marriage most certainly also was in play. Nonetheless, within three years of his arrival in the United States and his stint at Pond Farm, Frans accepted the offer to become a professor of pottery and sculpture, leaving with Pond Farm's secretary, Marjorie McIlroy (Cloutier, 2007, p. 16) to begin a 30-year tenure in upstate New York. A few years after moving to Rochester, and following his divorce (circa 1955) from Marguerite, Frans and Marjorie married. According to one observer, the "strong-minded Frans" had met his match in Marjorie who "could take care of him" (Gernhardt, 2011). By 1950, Frans became a naturalized U.S. citizen.

Wildenhain spent his mature professional years at RIT, including, at its end, the school's transition from downtown to a suburban campus. Just prior to his retirement, RIT moved to its new suburban campus, providing an architectural reminder of his Bauhaus roots. That he came to and stayed in Rochester was fortuitous as much for him as for RIT. For RIT, like the Bauhaus, was the product of blending: the Rochester Athenaeum, which was devoted to learning about developments in science and technology, and the Rochester Mechanics Institute, founded to provide

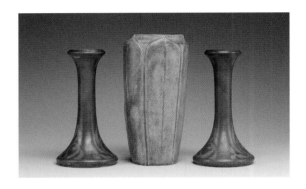

FREDERICK WALRATH
Candlesticks, Mechanics Institute, incised Walrath Pottery and 1911, 8.75 x 4.25 inches
Private collection

J. [JACOB] HILGERMAN
Vase, incised MI and dated 1918, 9.75 x 5 inches
Private collection

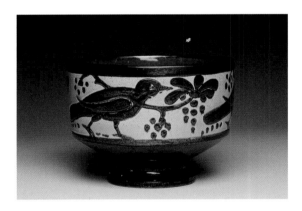

LULU SCOTT BACKUS
Incised and conjoined LSB, 5 x 6.75 inches
Private collection

CERAMICS AT THE MECHANICS INSTITUTE
BEFORE WILDENHAIN
Bruce A. Austin

Instruction in pottery (clay working or clay modeling as it often was called) was not new to the Mechanics Institute (MI), forerunner of Rochester Institute of Technology. Two ceramists figure prominently at RIT for 40 years prior to Wildenhain's arrival.

In 1902, Theodore Hanford Pond initiated the Department of Fine and Applied Arts at the Rochester Athenaeum and Mechanics Institute. Six years later he hired Frederick Emory Walrath of Jasper, New York, on the recommendation of Charles Fergus Binns, "the father of American studio ceramics" and founding director (1905–1931) of the New York State School of Clay-Working and Ceramics (now the New York State College of Ceramics at Alfred University). Walrath taught ornamental modeling and pottery classes (see Austin, 1993).

Walrath was an 1897 graduate of the Geneseo (New York) Normal and Training School with a diploma in teaching. He enrolled at the School of Clay-Working and Ceramics at Alfred a few years later. Though he never graduated, he developed a strong and lasting bond with Binns. Walrath taught at the Chautauqua Institution in 1903, won a bronze medal at the 1904 St. Louis Exposition, taught modeling and pottery at the University of Chicago, and worked contentiously during 1907 at Grueby Faience (Boston).

In April 1909, the Sunday *Rochester Herald* featured a two-page spread on the MI pottery studio, naming Walrath one of the nation's best potters. During the decade Walrath spent at the Institute, pottery making and modeling was made compulsory for its art students, Walrath successfully exhibited and sold his wares at Buffalo arts and crafts exhibits and in 1909, the Newark (New Jersey) Museum purchased two of his pieces for their permanent collection. Walrath left MI for a position as chief ceramist at Newcomb College in New Orleans in 1918.

From self-reported humble beginnings making mud pies in Ogden, New York, Lulu Scott Backus rose to become head of the Craft and Ceramic Department at Mechanics Institute beginning in 1918. Trained at the Brockport State Normal School, she completed the art and craft teacher training courses at MI studying under Pond's instruction and later studied with Binns at Alfred.

Initially a teacher in the Rochester elementary schools, Backus spent eight years as a professional jeweler. Following World War I, and at the beginning of her professional career at MI, she focused on rehabilitation and occupational ceramics therapy with soldiers. She won the Lillian Fairchild Memorial Award in 1927 for ceramics exhibited at the Memorial Art Gallery and exhibited widely, though mostly in New York State. Beginning in 1930, she turned her attention to adult education, using Institute facilities, when MI retrenched due to the Depression and eliminated ceramics from its curricula. A decade later, without the economic strains and with a new president, the ceramics department was revitalized and Backus returned as its head. Following World War II, as before, Backus organized classes in occupational therapy for returning soldiers, concluding her career in 1952 (see "Lulu Scott Backus," 1942).

training in technology and the industrial arts nested within a humanistic context. And, as at the Bauhaus, Frans found a professional partner with colleague Hobart E. Cowles (1924–1980): Frans focused on throwing, sculpting, hand-building, and surface decoration as a "master of form" (Gerhard Marcks' role), while Cowles taught technical subjects such as glaze and clay formulations, firing, and the history of ceramics as a "master of craft" (Max Krehan's role). Whereas Cowles was "very intense, seeing to the practical side of everything," Frans was "terribly funny. He'd sing opera—a wonderful life force that would move through the studio" (Jackson, 2011). "Quiet and mild mannered" Cowles lectured while Wildenhain would "waltz in and give demonstrations" (Jurs, 2011). Hirsch (2011) characterized Cowles and Wildenhain as equal halves of the same coin, though "they were never buddies," according to Jurs. And "Hobart was always a shadow to Frans" because of the latter's personality (V. Cartwright, 2011). An anonymous student recalled: "In the pot shop we were challenged and bullied and charmed by Frans and comforted and supported and guided by Hobart. I adored them both" (quoted in Cowles, 1980b). Another student remembers: "Frans was quite volatile whereas Hobart was just the opposite" (Clements, 2011). And yet another 1960 SAC ceramics graduate stated, "Frans couldn't have existed without Hobart Cowles, [who was] the consummate craftsman" (Jackson, 2011). Students Julia Jackson and Nancy Jurs each recall that Cowles worked with the students during the first part of the week, Frans the

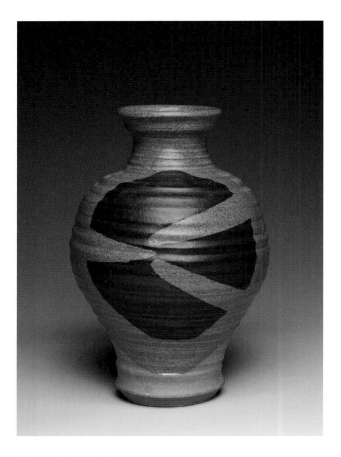

HOBART COWLES
12 x 7.5 inches
Private collection

"AMERICAN CRAFTSMEN"
Techmila, *1952, p. 13*
RIT Archive Collections

latter; on Wednesdays they overlapped and critiques were held. "Everybody was enchanted by Frans," Jackson reports, even though he was "very strict. He didn't give anybody an 'A.' His reasoning was that, 'If I give you an 'A,' it means you are as good as me'" (Jackson, 2011). At some point, she reports, other faculty helped to explain the grading system to Frans. At the end of each year there was a party for the students at Frans's house with beer and cheese; then the students moved to Hobart's nearby house for dinner (Clements, 2011; Jurs, 2011).

"American Craftsmen" made its RIT student yearbook debut in the 1951 *Techmila* (pp. 12–14) along with the initiation of the school's Crafts Club, and included a headshot of Wildenhain and a separate photo showing him working with two male students "attaching handles to ceramics." Even earlier, a May 1951 *Popular Mechanics* article billboarded the School's arrival at RIT, "a down-to-earth school." Heavy on photographs and lighter on text, the author emphasized the professional, the applied, the "paying" dimensions of SAC's curriculum at RIT: "Production training—the making of salable articles—is not sneered at in this school Instructors emphasize the sale of craft articles. Students are lectured on pricing and market trends by experts in the various fields." And, despite SAC's newness to RIT, "Most alumni find their craftwork profitable as soon as they leave school" (Eris, 1951, p. 143).

Housed in the old, abandoned Reynolds Library in downtown Rochester, a three-story, four-fireplace Italianate-

style mansion on Spring Street, near the Bevier Building and across from an ice rink, the School now occupied three times the space it previously had at Alfred (Gordon, 1982, p. 223; see too Wolfard, 2003, p. 18). The potters worked in a space adjacent to the house, all with kick wheels and gas-fired kilns, in what previously had been a stable: "We each had our own stall, the perfect size for doing our work" (Fina, 2011). The 1951 *Techmila* (p. 13) introduced and explained the new craftsmen to readers: "Behind the new green and red door of the S.A.C. works a mighty little group. It's a little corps of fifty people who consider themselves one big family whose might lies in its creative contexts and educational hands. In this family's house there are many rooms from basement to the attic that are filled with the tools for their creative work." In the mid '50s, then-undergraduate student Henry Gernhardt recalls small classes of "maybe seven other students" (Gernhardt, 2011). A graduate student who attended from 1966–68 remembered a small, tightly-knit group of 14 or 18 in her cohort; they had to walk through the wood and metal shops to get to the ceramics studio (Clements, 2011). The "rooms" *Techmila* referenced included "the brains" (faculty) along with the four craft programs: woodshop, textiles, metal workers, and the "mud slingers." And, finally, "from eight to five each day this mighty little S.A.C. family, R.I.T.'s newest, shapes its future with enthusiastic skill. We acknowledge their contributions to modern design" (p. 14).

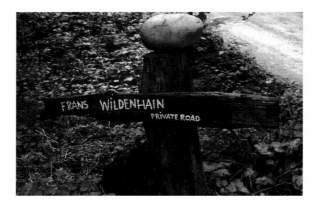

SIGN AT THE WILDENHAIN DRIVEWAY
Bushnell's Basin, circa 1975
Unidentified photographer. This is a later version of the sign; Wildenhain's students report the earlier version was spelled "Privat."
RIT Archive Collections,
Paul Rankin collection in memory of Lili Wildenhain

FRANS WILDENHAIN
Watercolor, cityscape purported to be Rochester,
17 x 22.5 inches, signed F. Wildenhain
Private Collection

While Rochester lacked in San Francisco cosmopolitanism, it still was a far cry from the secluded Pond Farm. Deeply and conservatively businesslike—*Smugtown, USA*, as journalist G. Curtis Gerling descriptively titled his book on Rochester's 1930s–'50s business and social era—the city was populated by such captains of industry as George Eastman, John Jacob Bausch, and Henry Lomb. Like the big cities, Rochester was not without its artistic rivalries. As perhaps a measure of the city's maturity, conflict—"muted hostilities," as city historian Blake McKelvey characterized them—existed between the Rochester artistic community's traditionalists (the Genesee group) and modernists (the Arena group) and was one feature greeting Wildenhain. "Fortunately," McKelvey writes, the tensions between the two groups "were dissipated by the timely arrival in 1950 of the School for American Craftsmen [T]his group of talented craftsmen ... included several artists of distinction who quickly won recognition and admiration from all factions. One of their number, Franz Wildenhain, trained at the Bauhaus in Weimar, captured several prizes for his ceramics at the Finger Lakes Exhibitions, received the Fairchild award in 1953, and regularly entered his works in Arena shows" (McKelvey, 1970, p. 12).

Indeed, soon after arriving, Wildenhain made a nonchalantly flamboyant mark on the Rochester art and education scene. *Democrat and Chronicle* art critic Jean Walrath described his theatrical presentation at a 1954 Memorial Art Gallery demonstration: Wildenhain "cut a hunk

from a mound of clay ... spinning it up from the earthen mass into a tall shape of symmetry, and seemingly perfect, even thickness." Continuing, "'Just a matter of muscle power and coordination,' Wildenhain explained modestly." Then, after passing a demonstration piece to front-row spectators, "he crumpled and discarded it" (Walrath, n.d.).

"Comfortable" and "familiar" must have described the Rochester that Wildenhain met. Certainly this was the case in terms of the School for American Craftsmen's curriculum. The 1953 *Techmila* (p. 15) explains: "As a student enters the school, he automatically becomes a journeyman. This gives him the right to send articles which he makes to the America House, which is located in New York City." For items that were sold at America House, the yearbook reports, the student craftsmen determined costs associated with their production, reimbursed RIT for any of its expenses, and split the remaining profit between the student and Institute. The RIT-SAC model was similar to that used long before in New Orleans at Newcomb College, which emphasized "the production of pottery for sale" (Forster, 2010, p. 145).

The local morning newspaper's art critic reported: "Much testing of materials goes on at the School for American Craftsmen of Rochester Institute of Technology, where Wildenhain teaches pottery making. Resulting formulas are filed like recipes for future use. But for Wildenhain's own work, the mixing of elements for glazes is an intuitive matter. He disregards the formulas and picks his materials with a

FRANS WILDENHAIN WITH STUDENTS
Techmila, 1955, p. 15
RIT Archive Collections

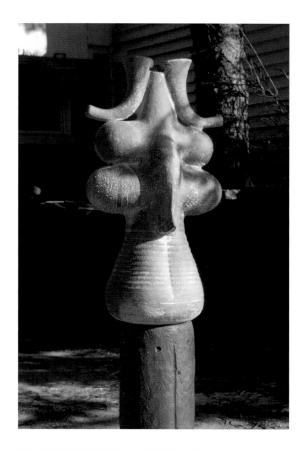

FRANS WILDENHAIN, "JINOA," 1964
Unidentified photographer. RIT Archive Collections,
Paul Rankin collection in memory of Lili Wildenhain

let's-see-how-this-works attitude. The results have charmed gallery judges the country over. Wildenhain pottery travels with the best company in the realm of art" (Walrath, n.d.). There was strictness in the studio classroom that was not mirrored by the artist's own practice—because, of course, the artist was a Master. But, as some of Frans's students would later report, the critic had been fooled by Frans's "act." In fact, Frans's notebooks dating from the 1950s reveal careful, precise, and detailed notes about his glazes formulas and pot firings. A September 1, 1960, entry, for instance, reads in part: "Result: All right, probably under-fired" (private collection).

Hirsch (2011) underscores the journalist's report, noting Wildenhain's strength was form, "not glaze [and] not color." Another student suggests Wildenhain had "a limited palette" for his glazes (V. Cartwright, 2011). And a 1955 transcript of Frans's address to the New York Ceramic Society Meeting reveals this statement: "I admire those with high knowledge of chemistry, but a good potter can buy his glaze and a lousy potter can make his own glaze. That has nothing to say—it is how you use your medium" (quoted in Boylen, 1989, p. 16). Boylen's (1989, p. 15) review of several Frans's notebooks concludes: "He had a strong conviction that in pottery basic form came first, that surface was secondary and should not be a dodge or distraction." But a review of other notebooks and diaries of Frans's only partially confirms Hirsch's and Boylen's assessments; as early as the mid-'50s and

throughout the mid-'70s, notebook entries and occasional texts contradict any such conclusion. Another of Frans's students, from the early 1960s, reports that Frans "was mostly concerned with form [but] he was constantly testing glazes. He was a fabulous glazer, with a huge repertoire of colors and glazes, but he never talked about his strategy for glazing." She continues, "He had magic in the way he could handle clay and was a serious potter, with such dignity and love of the whole thing: clay, glaze, fire, the process" (Fina, 2011).

To a student, Wildenhain claimed, "My work is now, please do not write about my past, it is not important" (Feldman, 1963, p. 28). But, to a reporter, Margaret Stolze, while Wildenhain prepared for a 1970 Shop One show of his paintings made while in Japan and ceramics fired at his home studio, he discussed the "striking" difference between his 1970 pieces and previous work. Wildenhain pointed out to the reporter that in 1970 he used little glaze on his pottery. "Sculpture and pottery should be form, not a background for color." He said he preferred to let the material influence the object's design: "It should look like clay, not like something else. It should have the quality of clay—clay is pliable, it bends, it is worked with the hands, there are imperfections that happen in the work." Stolze reported, "He considers the 'finished' smooth appearance of his earlier work as limiting, an attempt at perfection which when it is finished is 'done,' a design that could have been executed in any one of several other materials." She attributed this to the "Bauhaus

philosophy" of "less is more" (Stolze, 1970, p. 11). Ceramics experts will recall the turn-of-the-century example of Biloxi potter George Ohr and his "mud babies"—many of which later in his career also went intentionally unglazed.

Whether he was or was not interested in glazing and decoration, whether he would or would not discuss his past creations or compare contemporary work to previous efforts, seemed to depend upon the moment at which he was asked or who was doing the asking. Or, perhaps he was simply being enigmatic. His teaching practices and living arrangements reveal an extension of the mystery without solving it.

Reports of Wildenhain's teaching and his teaching manner suggest a certain rigor and, at times, roughness (see Norton, 1985, p. 55). One student remembers some of his "more sensitive" mid-1950s peers objecting and taking offense to Frans's sometimes harsh, direct critiques of their work, though he did not and felt as though he benefitted from it (Sax, 2011). Frans was not unaware of his manner. Before attending a 1976 Thanksgiving dinner, he recorded the following in a notebook: "We will go to Naples [New York]—Thanksgiving at The Mill [School of Arts and Crafts]. General observation—try to be nice, understandable, cooperative. But somehow I miss. Possible I ask too much. Why I go there? I know beforehand I will be disappointed or bored" (Wildenhain, November 21, 1976). But later he concludes: "After all, it wasn't so bad."

Frans's teaching style, whatever students thought of it, might be charitably characterized as a stream of consciousness. Angela Fina, a mid-'60s M.F.A student,

FRANS WILDENHAIN
Pencil drawing, 17.25 x 22.5 inches, signed in pencil FW
Private collection

says, "He was generous with us—he'd have us all out to his house—but he never formally taught us" (Fina, 2011). Still, she says, "I learned more from him than I did anyone." Henry Gernhardt, a 1956 SAC graduate, states he "took up ceramics as a way to make a living while I was painting" (2011). However, he came to embrace ceramics, though he describes studio classroom instruction from Frans as "sparse." He reports: "Frans would come into the studio and give a demonstration of how to do something. Then he'd expect us to practice making the same thing until we got it." The teaching involved a lot of wheelwork and was "more an apprenticeship followed by a critique" (Gernhardt, 2011). Still, Gernhardt appreciated and benefitted from Frans's teaching, since it "went beyond how to make clay objects and included sculpture, drawing, and painting," mutual interests of both Frans and Gernhardt. In a similar vein, Fina suggests Frans taught by example: "respect for the materials, processes, getting up in the morning and going to work all day, making pots as a worthwhile, dignified endeavor that you should be proud of" (Fina, 2011).

Hirsch (2011) notes he "taught using metaphorical stories; he was very charismatic and mesmerizing." One student remembered: "His discipline was Germanic in the purest, harshest, best sense. Compromise was the one obscenity, sloth the unforgivable sin" (quoted in Cowles, 1980b). There was little patience for excuses and none for amateurism or "arty" experimentation: "When I teach, I insist that students make a pot the way I make a pot—later

on they can change" (quoted in Boylen, 1989, p. 15). "As freshmen, Wildenhain, in the German tradition, required his students to throw seemingly endless teapots and cups; they "had to throw at least 100 before they got a good one" (Feuerherm, 2011); after two years at SAC, "they must be able to be potters—then start life and their own development" (Boylen, 1989, p. 15; see too Boylen, n.d.). "Everything was a test," says Hirsch (2011), "of your character, your talent, your ambition." Levin describes a teaching style most generously associated with gruffness: "Making pottery required discipline and devotion; laziness, disappointments in one's personal life, or physical ailments, along with flawed pots and 'artsy-craftsy' thinking, would not be tolerated." Another former student remembers him as "a very giving, open person" whose personality might vary depending upon the situation and each person's role (e.g., as a student or fellow teacher). "He did provocative things to see how people would handle the situation," she said (Clements, 2011), though perhaps not all were aware of Frans's strategy. Wildenhain seemed to intentionally use fractured English malapropisms for humorous effect such as accusing students of holding "preconfused ideas." And some women recalled being advised by him to leave ceramics for more promising careers as Kodak secretaries or belly dancers when their school productions weren't what they could be (see Levin, 1985 repeating an anonymous anecdote reported in Cowles, 1980b). Frans's student, Julia Jackson (2011) stated, "Frans didn't like women in his shop." And Angela Fina says,

SAC FACULTY AS SHOWN IN THE 1961 *TECHMILA*
Geraldine Uschold (seated) and from left: Hobart Cowles,
Karl Laurell, Michael Harmes, Frans Wildenhain, Harold Brennan,
Hans Christensen, Tage Frid
RIT Archive Collections

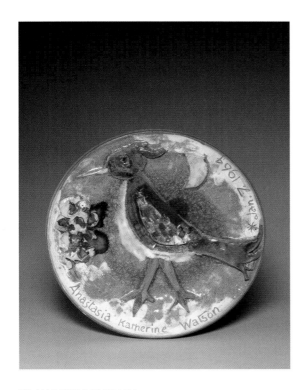

FRANS WILDENHAIN
Commemorative plate, 1964, 12 inches
Private collection

"Women students had to prove themselves times ten" to Frans (Fina, 2011). Nancy Jurs (2011) remembers him as "much more critical of the girls." Virginia Cartwright, a mid-'60s graduate student, had been accepted at Cranbrook but came to RIT because of Wildenhain, whom she met as an undergraduate. One day, she reports, Frans left an apple for her at her wheel and for no others. Still, she acknowledges, Frans was more difficult with women students. But his RIT and Shop One colleague and fellow artist Kurt Feuerherm perhaps explains more: Frans "liked independent women" and didn't want them getting married, distracted and wasting their time—time better spent creating ceramics (Feuerherm, 2011). The gruffness with his female students, then, seems driven more by concern for them wasting their time than his; which is not to say the recipients found this endearing.

A 1963 newsprint-style booklet produced by Bill Feldman to fulfill requirements for a BFA from the School of Photography at RIT offers another view. Feldman presents black and white portraits of an avuncular-looking Wildenhain, very much immersed in and focused on creating a spectacular 200-foot mural for the National Library of Medicine. Feldman's text describes Wildenhain as having "a special sort of inoffensive self-confidence in his work" (Feldman, 1963, p. 26). Separately, one Wildenhain student reported: "I was a very lucky woman to have a teacher like Frans [He] respected your own thoughts and capability, never looking down on your efforts and limitations" (quoted in Cowles, 1980b).

Wildenhain taught by example. Harold Brennan quoted fellow SAC faculty member Jack Prip on Wildenhain's work ethic in a 1958 *American Artist* profile of three Rochester craftsmen: "A lot of craftsmen wonder how Frans manages to get so much done. He works! He doesn't talk about what he's going to do this week or next with a project or an experiment that seems promising—he's doing it—early in the morning or late at night—when more verbal craftsmen are asleep" (Brennan, 1958, p. 40). Georgia potter Ron Meyers remembers: "Frans's whole life revolved around his work, and it was inspiring to see how his work and environment reflected his awareness and concern for nature and life itself. He lived with great gusto and spirit. It was the sum of all of this, his total enthusiasm for work and life, that I was to be most inspired by" (quoted in Berman, 1995, p. 4). Frans's godchild reported him once saying to her father, a University of Rochester biophysicist: "You do your work with your head; I do my work from my heart" (Markson, 2011).

In 1955 Frans and Marjorie moved from an apartment above an old carriage house at 3 Strathallan Park (Gernhardt, 2011; 1952 Rochester City Directory) to Bushnell's Basin. A dozen miles east of Rochester, Bushnell's Basin is a moody, bucolic location where fog seems to settle and linger for longer than elsewhere. There, out in the country, and a short distance off a rural two-lane road, they restored a small house and built a studio, nestled in the woods near a pond and surrounded by wildlife. Wildenhain purchased the property, once part of a sheep farm, from the

ALL THAT REMAINS OF FRANS WILDENHAIN'S BUSHNELL'S BASIN HOME, FALL 2011
Set inside the hand hewn beams are Wildenhain tiles.

somewhat quirky Selden automobile family. George Selden, a patent lawyer to George Eastman, filed for a patent for an automobile in 1879 that was granted in 1895, and he was the self-proclaimed inventor of the gasoline propelled automobile who engaged in a protracted if quixotic legal battle he eventually lost (see Barnes, 1981). Marjorie Selden, from whom Wildenhain purchased the property, seemed in some ways to be his match and a kindred spirit; she is described by one as "mannish" in appearance, frequently wearing heavy woolen clothing and often smoking a corncob pipe (Markson, 2011). The original structure, Feuerherm (2011) recalled, had been assembled by Mrs. Selden from salvaged architectural elements: "bits and pieces she took from Third Ward homes" that had little insulation and was always cold. "She saved everything she could," reported Henry Gernhardt (2011), who helped Mrs. Selden assemble the structure. At least four others characterized the structure as a "chicken coop" (V. Cartwright, 2011; Jackson, 2011; Markson, 2011; Poole, 2012). Bill Sax, Frans's apprentice in the late 1950s, remembers the structure's living quarters as comprised of two bedrooms, living and dining room, a tiny kitchen and small showroom (Sax, 2011). The studio, though, which was new construction and designed by architect Bart Valvano, was generous in size with a bank of four nearly floor-to-ceiling windows along one long brick wall, each window comprised of three ganged panes that overlooked the pond and permitted in streams of sunlight. A student remembered Frans repeatedly telling the story of Mrs. Selden: "She was in her 70s and had built the house out of

pieces from other homes all by herself. [And the lesson to be learned from the story was:] This is what a single person can do if determined" (quoted in Cowles, 1980b).

A 1970 profile described the home as having a living room fireplace that he designed and built. It was furnished with an ebony inlaid table (Jackson, 2011) and a set of chairs created out of axe handles with leather slung seats, all by sculptor Wharton Esherick (Keyser, 2011), one of Wildenhain's friends (Jackson, 2011; Keyser, 2011). There was a two-foot high jar carved by Wendell Castle and a six-foot tall wrought iron candlestick created by Gerhard Marcks (Stolze, 1970, p. 11; Jackson, 2011). Esherick and Wildenhain met when each had his work presented at the 1961 Brooklyn Museum of Art's Masters of Contemporary Craft exhibit: "The two men hit it off and, over the next several years exchanged pieces—a stool for dinner plates, a tray for a pot. Franz gave Wharton a tall, somewhat anthropomorphic, sculpted pot for his 80th birthday" (Bascom, 2011).

A decade later, sprawling suburbanization encroached—but sensitively—on the Wildenhains' out-of-the-way abode. Alerted to the availability of vacant property by Frans, art patrons and friends Dr. Michael and Mrs. Nicoleta Watson moved in 1966 from Rochester's tony East Avenue to Bushnell's Basin. There they had constructed a 4500-square foot modernist-style home designed by Esherick that was a short, comfortable stroll past the pond and through the woods from Wildenhain's home. Esherick stayed with Frans during the home's construction (Clements, 2011). The

structure features a brilliant white stucco exterior, soaring ceilings, broadly curved walls, and Wildenhain's brown-colored tiled floors at the entryway and on the kitchen and breakfast room floors. Because of his own woodworking experience, Michael Watson also knew Esherick; indeed, far more than a hobbyist, Watson's furniture designs echo Esherick's aesthetic and were displayed at Shop One (Markson, 2011). Set on an 11-acre parcel, the house was geographically close enough that Frans would stop in for dinner three or four times weekly; the Wildenhains and Watsons were personally close enough that in 1967 they traveled together to Nicoleta Watson's homeland, Greece (Markson, 2011).

The School for American Craftsmen grew and prospered at RIT. The 1959 *Techmila* reports: it "has made rather startling history itself. It was announced in the spring, by Mr. H. J. Brennan, department head, that beginning in the summer of 1959, a program of study leading to the Master of Fine Arts degree would be instituted" (p. 249). Additionally, the special advantage to the graduate degree was that up until this time, anyone wishing an advanced degree would have to leave the state to obtain one. And noted here is a "Junior Year Abroad" program for SAC students to be initiated in the 1959–60 academic year. The next year, the yearbook introduced the Student Society of Designer Craftsmen, what the Craft Club evolved to, perhaps distancing itself from any pejorative connotations associated with "craft" (p. 89). In the 1961 edition, *Techmila*

LILI WILDENHAIN
Textile, "Moon, Letchworth Park," 1977, 12.5 x 9 inches
Signed in pencil

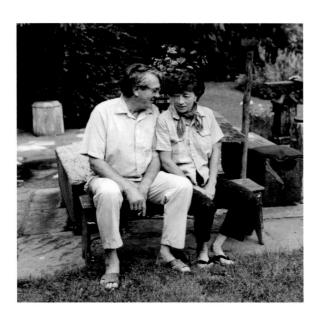

FRANS AND LILI WILDENHAIN ON THE PATIO OF THEIR BUSHNELL'S BASIN HOME
Unidentified photographer. Paul Rankin collection

reports "An old, rather shabby looking building located on our campus produces some of the world's most beautiful and appreciated creations in both wood and metal" (p. 24). Wildenhain is pictured in a suit and tie, with eyes closed, at the center of a faculty portrait.

CHANGE

In 1967, Marjorie Wildenhain died. Two years later, on November 21, 1969, Frans married the gregarious Elisabeth (Lili) Brockardt Rankin, an émigré from Aussig, Czechoslovakia, a weaver and textile artist, yoga instructor, and student of Zen (Norton, 1985, p. 55). They had met the year before at the World Crafts Conference in Lima, Peru ("Memorial Celebration," 2004). A friend described her as "refined, very delicate," in contrast to him: "kind of like a bull, like his pots—they were not refined but they had a presence" (Poole, 2012). Together they had traveled to Japan and Asia, also in 1969, though she was then married to her first husband, Charles, and living in Kansas. Wildenhain's roller coaster ride, though, had one more hill and dip before concluding. In 1968, RIT moved from center city Rochester to its new campus in suburban Henrietta.

Set in the middle of a flat field, surrounded by other flat undeveloped fields, the new campus environment was distinctly different from that of the downtown campus with its 1911 Bevier Building designed by Claude Bragdon and the surrounding late-Victorian homes and tree-lined streets. But the architectural style of the campus's new buildings

must have seemed to Wildenhain a bit like coming home. Home to the Bauhaus he left four decades earlier. The same home that excluded his wife, their mentors, and drove them to America. By the time of RIT's relocation, Wildenhain's reputation was firmly established. Locally, he repeatedly won awards for ceramics and paintings at the annual Rochester Finger Lakes Exhibition at Memorial Art Gallery. And by the time of his death he had participated in more than 200 one-man and group exhibitions. His work was included in prestigious American and European museums as well as private collections. Named Master Craftsman by the Boston Society of Arts and Crafts (1952), Wildenhain was a jury member at numerous shows and exhibits throughout his career, was a two-time winner of the Lillian Fairchild Award, and earned a Guggenheim Foundation Fellowship in 1958 to study the relationship between ceramic walls and architecture. In 1975 he was awarded Fellow of the American Crafts Council Collegium of Craftsmen (see Levin, 1984 and Frans Wildenhain, 1975). In a 1979 notebook he crisply outlined (literally) his career and art with the letters A, B, and C beginning with California in 1950 and Rochester in 1979: A. pottery, B. Tile—décor and C. sculpture (Wildenhain, 1979b).

Harold Brennan paid tribute to him and his work at two 1975 exhibitions: "Frans's life has been his art He has never followed fads, or taken the convenient or materially rewarding roads that lead to the spurious success of the artistic marketplace" (Frans Wildenhain, 1974, p. 7 and

1975). Earlier, in 1958, Brennan described Wildenhain "as a potter in the sense that one would speak of Leonardo da Vinci as a painter" (Brennan, 1958, p. 39). Memorial Art Gallery's Director Harris K. Prior considered him "the 'dean' of ceramic artists in the United States," and representatives from the Museum of Contemporary Crafts and Alfred University likewise offered laudatory testimonials (Frans Wildenhain, 1974, p. 6).

Wildenhain's largest and, arguably, most dramatic works were created when few such works existed, aside from the Federal Art Project's (FAP) pieces: wall murals. One outcome of the progressive reform movement's New Deal was the FAP, which had as its goal democratizing art by sponsoring and disseminating a particular ideology of American culture. Situated in public places such as airports and government buildings (e.g., post offices), a common theme of FAP art, including the murals, was "a celebration of human mastery over nature and of scientific and industrial progress" (see Grieve, 2009, pp. 104–105). Medical science was one such subject and three of Wildenhain's murals addressed it.

Murals offered a large-scale canvas allowing for graphic presentation in ceramics what otherwise would be confined within a more modest-sized frame. (See Sims, 2011, pp. 58–60 for discussion of mosaic murals in the 1950s.) A quarter century earlier, he had entered the Bauhaus with the intention of becoming a painter (Norton, 1985, p. 49) and the move to Rochester afforded an opportunity to achieve

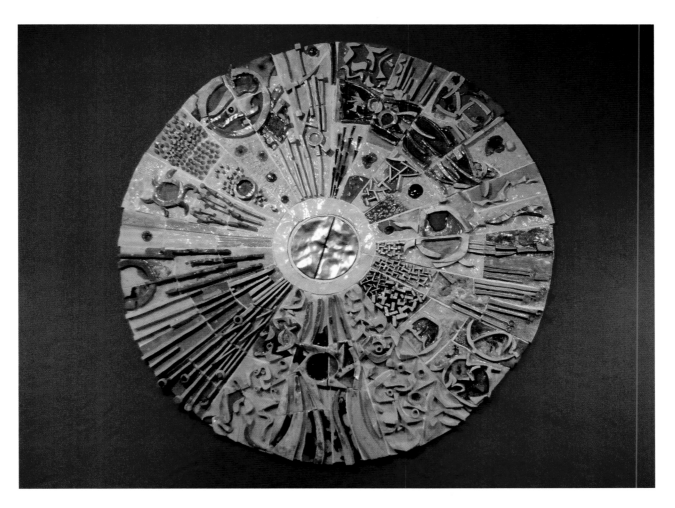

**DETAIL OF THE STRASENBURGH
LABORATORIES MURAL**
Jefferson Road, Henrietta, New York
As photographed in 2011

by novel expression the goal. Too, the turn toward mural work dovetailed with Wildenhain's artistic growth as the form-function and mass manufactured utilitarian orientation of his Bauhaus education yielded to the more sculptural, the more abstract, and the less "practical." The earliest report of his interest in mural work appears in a December 4, 1953 issue of RIT's student newspaper, *Reporter* ("Craftsmen Do Part"). The story indicates Frans, Hobart Cowles, and student Fred Myers were designing "a mosaic mural that may be twenty feet long" for the "main waiting room" of a new Irondequoit school. No record of any such mural could be located and onsite visits to three temporally correct school buildings found no evidence of any such installation.

The first completed (1959) mural was commissioned by R. J. Strasenburgh Laboratories for the lobby of its new facilities outside of Rochester on Jefferson Road, the "Miracle Mile" (Smith, 1959)—coincidentally, a location within five miles of where RIT would relocate. Centered by an emblem for the sun, the mural measured 14 feet high by 110 feet long and was comprised of abstract figures, plants, crystals, and laboratory apparatus, representing the history of medicine. Hobart Cowles collaborated with Wildenhain, suggesting and developing glazes (Levin, 1984, p. 12). Writing in *American Artist*, Rochester journalist Virginia Jeffrey Smith (1959) proclaimed "the greatly increased interest" and Rochester historian Blake McKelvey the "fresh new interest" in outdoor sculpture, and other art forms on public view, each singling out Wildenhain's

work. The Strasenburgh commission followed Wildenhain's winning of a Guggenheim Fellowship and Wildenhain took a leave of absence from RIT to complete the work. The mural "prompted other businessmen to undertake similar embellishments" (McKelvey, 1970, p. 18).[7] Levin (1988, p. 276) asserts Wildenhain and Ruth Duckworth "were among the first to explore the possibilities for a large expanse of clay on the wall." A draft letter composed by Wildenhain argues: "The architect should consider the muralist from the beginning." Ever the Bauhaus student, he continues, "Both the architect and the muralist should be aware of their combined effort and their involvement as a total commitment." But, he notes, "often" the muralist's "contribution is an afterthought—to fill in where he, the architect, got lost" (Wildenhain, 1979). The extent to which Wildenhain and the architects collaborated is unknown, though the letter suggests a certain disappointment on his part.

At the National Library of Medicine in Bethesda, Maryland, one architectural element was "characteristic of the age we live in, [and] particular consideration had to be given to bomb blast effect where it might influence structural design" (Kilham, 1961, p. 406). The early '60s structure is described as "'a graceful, floating concrete shell of 9,500 square feet' …. It is severe and solid yet soaring and challenging in design" (Mohrhardt, 1962, p. 235). More than half the building is below grade and its atomic bomb-"proof" design prompted some to call it "the Fort Knox of health

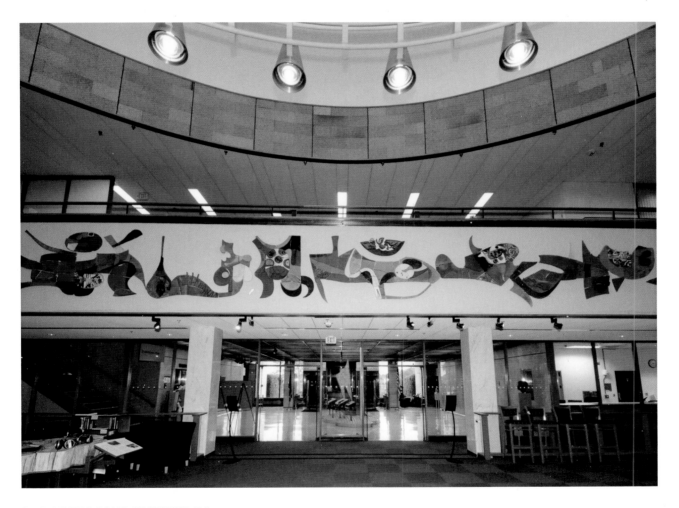

ONE OF THE FOUR SECTIONS OF
THE NATIONAL LIBRARY OF MEDICINE MURAL,
Bethesda, Maryland. Photograph courtesy
of Stephen Greenberg, 2011

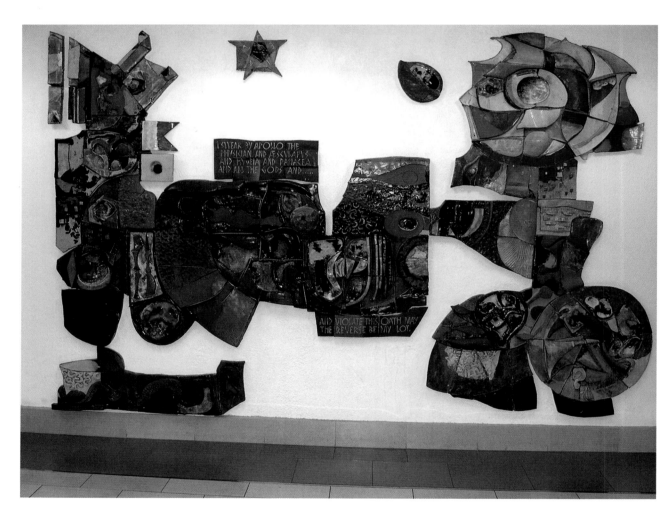

MURAL CREATED FOR OVERLOOK HOSPITAL
Summit, New Jersey, 1966
As photographed in 2011 by Bruce A. Austin

information" (Maryland Historical Trust, 2000, section 8, p. 1). A contemporary observer noted the building was constructed such that following a nuclear attack, its roof and ceiling would fall covering the library's valuable contents—though the people would be dead (Greenberg, 2011). Art, in other words, was not the first priority. Nonetheless, the mural, or frieze, composed by Wildenhain for the Library's rotunda would win him an unprecedented second Lillian Fairchild Award (see Collins, 1975, p. 10).

The face of the Library's mezzanine balcony was Wildenhain's palette. On it he composed a 900-piece, 208-foot long abstract mural; the six-foot tall mural covers each of the four 52-foot long walls enclosing what originally was the card catalogue room. Wildenhain rented space at RIT's 50 W. Main Street building in downtown Rochester (R. Cartwright, 2011) where the clay was assembled following a model. Working with Bill Sax, who applied the clay to board, Frans carved the clay (Sax, 2011). Taking 14 months to complete, the ceramics were all fired in the gas-fired kiln at Wildenhain's Bushnell's Basin studio, assembled and numbered at the downtown location, and then crated and trucked to the Library. Begun in 1960, the mural was installed in June 1963; at Wildenhain's request, Bill Feldman photographed the installation. Today, unfortunately, the mural is blocked from view as the card catalog space has been repurposed as an exhibition area (Greenberg, 2011).

In 1966 he created a smaller, more compact mural for the lobby of Overlook Hospital in Summit, New Jersey.

Measuring almost 10 feet tall by 13 feet wide, the mural was funded by the Florence Murray Wallace Fund. The medical theme established at the previous two installations was continued, including fragments of the Hippocratic Oath (see Levin, 1984, p. 13) and the inclusion of Overlook's naval signal flags representing, "We stand by to assist."

At the new RIT campus, Wildenhain installed an 8 by 28 foot mural, "Allegory of a Landscape," at the cave-like entrance to Ingle Auditorium, in the RIT Student Alumni Union. Differing thematically from the previous works, the mural is an abstract bird's-eye view of the Finger Lakes geography. The project was not without drama.

Correspondence between Wildenhain and Aileen Webb (all in a private collection) reveals planning for the mural began 16 months after the campus opened and six months before Frans's retirement. On January 8, 1970, she writes: "I want to see you about a possible mural in the Institute that I think you've probably heard rumors of," noting she will attend a Trustee meeting two weeks later. Frans writes Mrs. Webb on February 8 that Dean Brennan initiated a conversation about the mural and, "The price we agreed on was 15 thousand." Two weeks later (February 24) he writes her again: "What I would like to hear from you is a confirmation of the commission for the RIT mural so that I can go ahead with my design and planning." A month later, on March 20th, she replies: "The funds that Frank Benz [RIT's vice president of business and finance] thought were available apparently are not but I feel so strongly, not

only that I am committed to you but for the future it is of vital importance for us to have a piece of work of yours on campus, so I would like to suggest that instead of your being paid in a lump sum when you are finished that I pay you $250.00 a month for a period of probably forty months, which seems like a long, long while. This would bring the total of what you received up to $10,000. When that has been met we can then discuss whether the additional $5,000 could not come from the Institute itself. I believe that by then it could."

In an undated note written on a scrap of paper, perhaps to himself or as a partial draft for a letter, Frans worries, "What if I die before" completing the mural and expresses uncertainty about how Webb's suggested monthly payments might affect his retirement pension and Social Security. Now age 65, retirement was certain. A year after the correspondence began, Frans again expresses concern for the project, writing to Webb, "I have had only a verbal agreement from Mr. Benz to go ahead" (January 18, 1971) and wonders whether Arthur Stern has "any responses or suggestions from his side." Stern, a tireless RIT booster, had led the $18 million campaign to fund the new campus and served as chairman of the Board of Trustees from 1961 to 1976 (Gordon, 1982, pp. 256, 342).

By February 1971, the project's future seems tenuous. On February 1, Webb writes to the now retired Frans: "I cannot get any commitment for funds from the Institute," despite, she writes, what Benz previously had told her. She notes,

DETAIL, "ALLEGORY OF A LANDSCAPE," ENTRY TO INGLE AUDITORIUM
Student Alumni Union, RIT

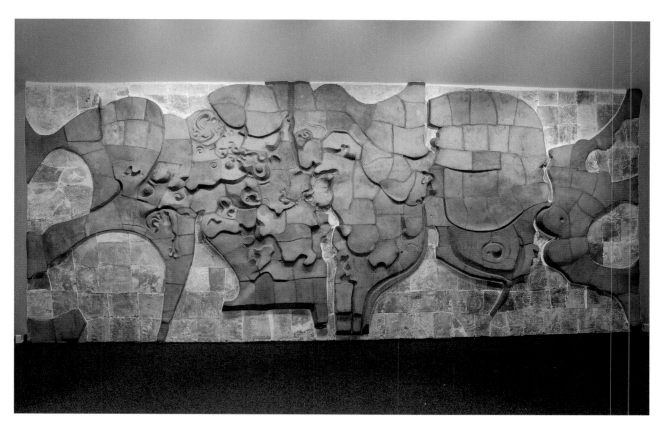

**"ALLEGORY OF A LANDSCAPE,"
ENTRY TO INGLE AUDITORIUM**
Student Alumni Union, RIT
8 x 28 feet, 1971

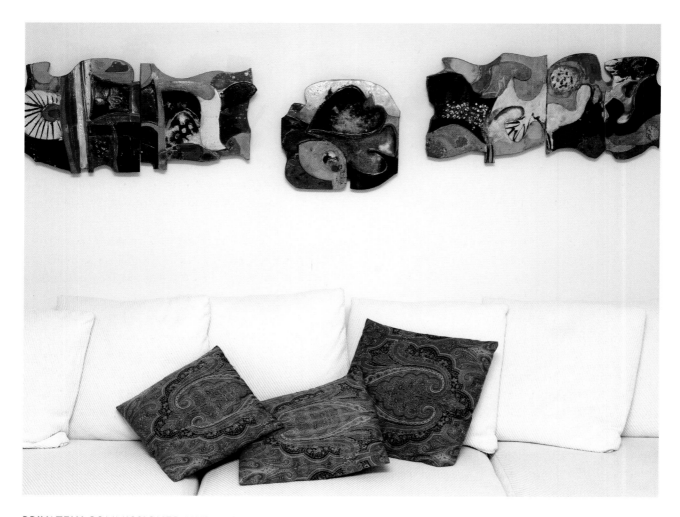

**PRIVATELY COMMISSIONED MURAL ORIGINALLY
INSTALLED IN A FAYETTEVILLE, NEW YORK, RESIDENCE**
From left: 28.25 x 12.5 inches, 13.75 x 13.5 inches, 27 x 13.5 inches

Benz has left RIT and "the very difficult financial picture of the Institute has become apparent [and] the Institute will not commit themselves to any further financial outlay." Webb suggests a reduction of the project's cost from $15,000 to $12,000, indicates the Institute will not pay even that lower amount and that she cannot pay any more than $5,000 over the next few years. She concludes by suggesting an alternative of "one large panel" or "three long panels" that she could pay for.

On March 26, 1971, Mrs. Webb writes Frans to indicate the impasse has been resolved: "I think our present arrangement is most satisfactory and will stick." She encloses a check for $1,000 as a first installment and noting she "hope[s] to pay it all on a quarterly basis by the end of the year or a year and a half." Addressing his earlier concern, she concludes: "I think that you do not have to think about this in connection with your Social Security, as I believe that you are acting as an independent contractor in the creation of a work of art, but I suppose you better check with your lawyer about this." Three months later (June 22, 1971), Dean of the College of Fine and Applied Arts Robert H. Johnston writes to Frans about the mural. Johnston confirms the proposed fee of $15,000 and indicates Mrs. Webb's advance to Frans of $1,000. He requests a drawing, a "rough sketch since this will help us gain final approval of the whole idea. Non-visual people are more likely to look more favorable upon something when they can see the idea in front of them." On June 11, Frans writes Webb acknowledging her $1,000, notes

Johnston had visited her in New York, and reports "the money was found."

At the very end of the year, on December 26, 1971, Frans writes Mrs. Webb: "Obediently I inform you that finally December 23 in the afternoon at 12:30 the mural was finished. It took me quite a time, physical effort and spiritual strength to come so far.... It was you who selected the cavern like place at the Ingle Auditorium which is so fittingly well chosen for this special work of mine and it was your generosity which made this statement in clay for me possible."

At least three other large-scale murals and one smaller-sized mural are known to exist. The smallest mural was a private commission for a Fayetteville, New York, residence. The three larger-sized murals were created in the mid-1970s when Wildenhain taught summer classes at the Naples Mill School of Arts and Crafts, a school was created by Bruce Lindsay, one of his RIT students (1964–69). It offered glass blowing, fiber arts, blacksmithing, sculpture, photography, and drawing and painting courses from 1971 to 1979. One mural, a tall vertical, had been carved on a horizontal surface and then its elements separately fired (Harris, 2012). Wildenhain and his Naples Mill students created the piece in the Silver Bullet building that housed the ceramics classes, across the street from the Mill. A second, a long, slender horizontal piece measuring approximately 15 feet, was installed on the exterior side of a nearby barn and was designed and constructed in collaboration with the Naples

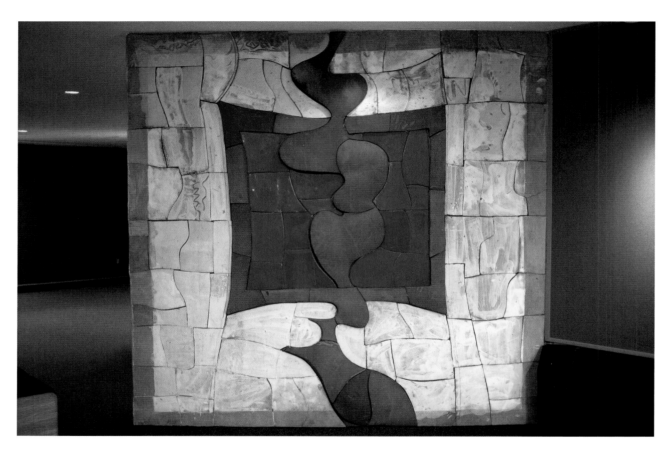

MURAL CREATED FOR LOCK HAVEN UNIVERSITY
Sloan Fine Art Building, 1974, 8.3 x 8.3 feet
Photograph courtesy of Rick Lilla, photographed in 2012

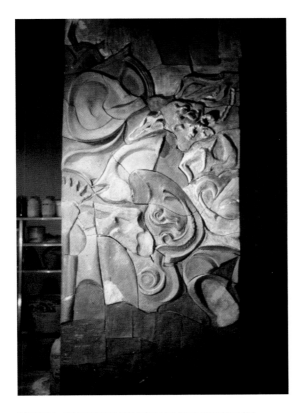

**MURAL CREATED BY FRANS WILDENHAIN
AND STUDENTS ATTENDING THE NAPLES MILL
SCHOOL OF ARTS AND CRAFTS**
*Shown inside the "Silver Bullet," circa 1975, 10.5 x 4.5 feet
Unidentified photographer. RIT Archive Collections,
Paul Rankin collection in memory of Lili Wildenhain*

Mill students. And the third, and probably the final, mural was created by Wildenhain and Naples Mill students for Lock Haven (Pennsylvania) University's Sloan Fine Arts Building, where Dean Johnston previously had chaired the Fine Art Department; Wildenhain references this work in several of his notebook entries (December 8, 1975; January 21–February 21, 1976). "Building a mural is like walking up a ladder," Wildenhain said to a Naples Mill colleague. "You can skip a rung, but the mural will always know which rung you skipped" (Poole, 2012).

The architectural style for RIT's new campus was Brutalism and its nearest architectural relative the van der Rohe-designed campus for Illinois Institute of Technology (see Wetherald, 2004). With European roots and acclaimed there, some suggest Brutalism is a subset of "bunker architecture" (see Monteyne, 2011, pp. xviii–xix). Popular in the 1960s, the style wasn't entirely new to Rochester. Louis Kahn's 1959 commission for the First Unitarian Church produced just such a design. But there had been nothing of the scale previously, as with the new RIT Brutalism campus. And at RIT, brick construction rather than raw concrete stood in "contrast to the purist white and glazed forms, and artificially smooth surfaces, of a prewar modernism that had been championed by LeCorbusier and others" (Monteyne, 2011, pp. 242–243). Brutalism, especially as embodied by the ganged RIT buildings "expressed a new solidity in materials and massing, and a new parsimony in fenestration" and represented "a struggle between the glass box and the

solid mass within the discussion of architectural modernism" (Monteyne, 2011, p. 160). The Cold War's bunker mentality and its architecture served similarly and as well civil defense and public protection purposes and the political climate of the 1960s; to the present, an "urban myth" on campus is that the architectural style and campus layout was intended to quell student unrest so popular then at other universities. Today, we note, the "bomb shelter" functions as well following the 9-11 terrorist attacks. And there was more. For the Bauhaus influence on campus extended beyond RIT's architectural style to include decorative arts and public art: the twin bronze planters by Harry Bertoia, and two works by Josef Albers, one of Wildenhain's Bauhaus teachers—"Loggia Wall," an 8-foot by 50-foot brick mural, and "Growth and Youth," 18-foot square painted murals at opposite ends of the lobby in the campus's administration building.

CONCLUSION

On June 30, 1970, Frans retired from SAC. One source asserts a forced retirement due to jealousy expressed by RIT administrators toward other nearby craft schools perceived as competing with SAC (Lindsay, 2011). Another indicates a mandatory retirement policy for faculty who reached 65 years of age (Martin, 2012). He remained artistically active, sketching, for instance, scenes from day trips to western New York.[8]

Nearly three decades after Wildenhain's departure from California, and shortly before his death, a Memorial Art Gallery text accompanying an exhibit of work by three prominent School for American Craftsmen—Albert Paley, Wendell Castle, and Wildenhain—noted, "There must be some elusive, unacknowledged force that draws great craftsmen towards Upstate New York" (Chambers, 1979, p. 1). In the instance of Wildenhain, the forces are somewhat less mysterious, though other elements of his life are, indeed, elusive. A lifelong friend who knew him especially well in the 1950s and '60s remembers him as "very talented, an excellent teacher, a very strong person who had a lot of opinions and was a rather difficult personality for a lot of people" (Feuerherm, 2011). But, reports Hirsch (2011), although "he had a seamless, holistic life, [weaving together] his work, his art, and being a role model as an artist-teacher, he was disdainful of contemporary ceramists [all the] while keeping an eye on them." A March 7, 1976, Wildenhain notebook entry reports on an overseas visitor: "Mr. [Garth] Clark from England. Writes a book about pottery. Tried to pull out of me everything what [sic] I know about the Bauhaus Is there influence on my work. Yes and no. Influence of Am. Potters? Peter V. [Voulkos]—yes, Not formal but knowing there is an individual working out West with whom I have an affinity" (Wildenhain, 1976).

Hirsch reports that when artists visited SAC for lectures and demonstrations, "Frans would be noticeably asleep."

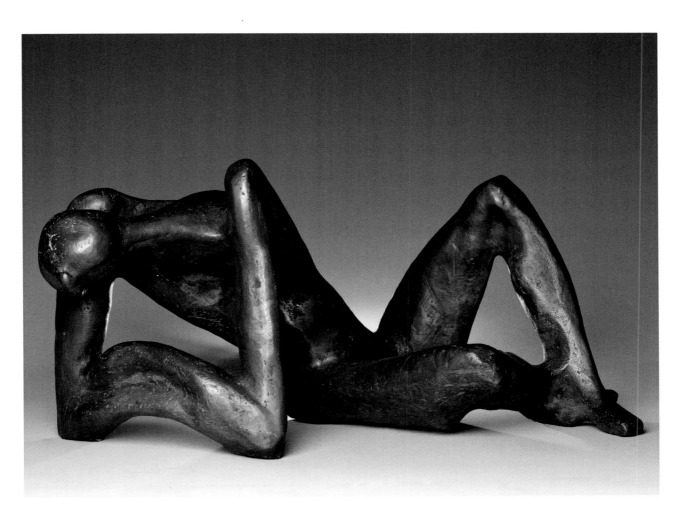

FRANS WILDENHAIN
Bronze, 9 x 20 x 11.5 inches

And he suggests that Wildenhain never played—or never learned to play—the political game, "never had gallery representation," seemed to like being a "big fish in a tiny pond" and refused to understand the value of networking. Barbara Cowles, who worked with Wildenhain at Shop One, reports, "Frans could never understand why he wasn't better known. He didn't know how to sell himself" (Cowles, 2010). Frans's March 7, 1976, notebook entry reads: "Differences between Craftsmen and Artists: Craftsmen go to conferences. They were always depressing [to me]. Couldn't take them seriously. Unproductive. Except Peru where I have found Lili" (Wildenhain, 1976). Regarding commercialization and financial success, on January 11 he writes: "Sensual awareness makes life worthwhile and affects your bloodstream. I became a potter—not a banker" (Wildenhain, 1976).

Nearing the end of his life, an ostensibly cranky Wildenhain refused to complete a questionnaire about crafts. He explained: "It's like a cross-examination at a Police Station to beat confessions out of the culprit. [But] sitting down—with a table between us I would answer your questions in a lengthy personel [sic] way. Frank and honestly. A written statement is incriminating." In the same letter, he refers to its recipient, Lois Moran, Executive Director of the American Craft Council, as "a charming girl and dear person to me" (Wildenhain, 1978). Push. Pull. A late March 1976 notebook entry reveals a more reflective and appreciative

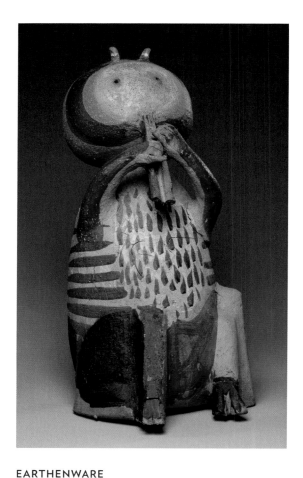

EARTHENWARE
23 x 8 x 10 inches, reduction fired
The American Craft Council used a silhouetted image of the flute player on ACC stationery as part of its 1980 promotional membership drive.

writer: "Mrs. [Aileen Vanderbilt] Webb, through you—your vision, ambition—I came to Rochester. I know that you were instrumental [in getting me] to come to this place I gave something, I received a lot. I know you are very clear. I know I am very fussy. Still, I love you for all you have done for the development of American crafts" (Wildenhain, 1976). And correspondence to Robert Brown at the Archives of American Art (March through August, 1979, all in a private collection) reveals Frans's interest in preserving his legacy by donating his personal papers and career records. Following Frans's death, letters written by Lili as well as colleague and Shop One co-owner Ronald Pearson, Lloyd Herman of the Renwick Gallery, Susan Donovan of Memorial Art Gallery, Paul Smith of the Museum of Contemporary Crafts, and Peg Weiss at Syracuse University advocate and explore exhibition and book proposals for Frans's work as well as thoughts on preserving the Bushnell's Basin home as a historic landmark.

Reviewing his life, one begins to suspect Wildenhain had a contrary, and counterproductive, view of fame. Perhaps he felt it due him, yet he did little to stimulate that kind of attention. And perhaps he was insecure, though observers might not have been able to detect this. Given an opportunity, as with various encounters with critics and reporters, he seemed to almost shun or mock the spotlight and dismissed serious consideration of his work. And, again, there seems to be a parallel to another, older, and during his

time, under-appreciated potter, George Ohr. The turn-of-the-20th century Biloxi artist carefully cultivated an eccentric persona for both for himself and that which he created. Success and recognition for Ohr didn't arrive until more than half a century after his death (see Lippert, 2010). In a September 1976 entry in his notebook, Wildenhain writes: "Potters in an absurd situation. Publicity. Magazines. Shows, etc.—Fed. Aid—everyone will be in front. The bandwagon is a train. Getting it brings in attention, saturation, boredom. I wish more would jump off. Potters should have birth control" (Wildenhain, 1976).

As age and illness began taking a physical toll, he recorded this on March 23, 1976: "The bending over becomes a process. Clay is becoming heavier. The heart is pounding. The breath short. Vision loses its awareness and more. You are getting old dear Frans" (Wildenhain, 1976). The undated last page in his 1979 notebook, where he outlines his career (above), also notes the following: "One philosophical problem—Suicide, judging whether life is or is not worth living" (Wildenhain, 1979b).

On January 25, 1980, Frans died of bone cancer. The angry, spiteful quotation that begins this chapter seems as much a measure of Frans's insecurity as his envy. And by 1976 his assessment of Marguerite had softened considerably, as one of his notebook entries reveals: "When I think about the time at P.F. [Pond Farm] and S.F. [San Francisco], it was like a dream. I was the dreamer and you

my big dream girl. You gave me so much more [than] you realized. When I have to be thankful—and I am—it's to you …. You were always someone I admired and more" (Wildenhain, April 14, 1976). Indeed, Marguerite did take his name and she did make it famous. But the fame hadn't reached its height, at least not in 1950. Together, though separately, each made the name synonymous with an aesthetic born abroad and then adapted and matured for a new home at mid-century. And the friction between Marguerite and Frans, not wholly artistic, produced a heat that persists: "I know you went your way and I went mine. Nothing can change this. We are just on our own and still part of [an] unerasable past."

NOTES

[1] Coincidentally, also in 1924, thousands of miles removed, in Fairport, New York, painter Carl Peters was awarded the University of Rochester's very first Lillian Fairchild Award. Wildenhain would win this award in 1953 and again in 1963, the only person to achieve a dual award. Also coincidentally, Lillian Fairchild worked briefly (circa 1910) for Van Briggle Pottery in Colorado Springs, Colorado, while unsuccessfully seeking to recover from tuberculosis (see Collins, 1975, pp. 3–4).

[2] Form didn't always follow function and "superfluous" ornamentation was hardly absent from Sullivan's designs. See, for instance, Sullivan's elaborate façade for the Carson Pirie Scott department store in downtown Chicago.

[3] Neither Stickley nor Hubbard's products were economically accessible to all, especially their workers. For a case study of Roycroft's product price structure see Austin (1994).

[4] Throughout, Frans and Marguerite's first names are used for sake of clarity, not familiarity.

[5] Gordon Herr's 1939 letters to Jane Herr are reprinted in Schwarz and Schwarz (2007, pp. 268–280). The independence between Frans and Marguerite was later mirrored in a nearly identical fashion by Frans and his third wife, Lili. Though they frequently and widely travelled together, traveling solo was not uncommon (Rankin, 2011).

[6] Richard Hirsch (2011), one of Frans's last graduate students, uses a slightly different and perhaps more robust metaphor: the university as incubator. On art patrons see Toffler (1973), pp. 167–181.

[7] McKelvey (1970, p. 18) notes the Strasenburgh mural won Wildenhain his second Fairchild Award.

[8] In a 1974 notebook comprised mostly of pencil sketch drawings, one page contains his notations for the 1975 RIT Bevier Gallery catalog specifying "one picture on one page" and that the catalog "should be mostly picture[s] … 30 or 40 full page pictures" (in fact there are 35) and "the cover should have only my name on it, big or small, or a picture and the name only" (Wildenhain, 1974). The images should be composed in such a way to "give justification to the object, contrast rich dramatic—not softy unclear."

REFERENCES

Austin, Bruce A. (1993). "Rediscovering Frederick E. Walrath." *Arts & Crafts Quarterly*, Part I (no. 2), pp. 20–23, 41; Part II (no. 3), pp. 22–23, 25.

Austin, Bruce A. (1994). "Product Price Structure at the Roycroft and the Creation of Consumer Culture." In Marie Via and Marjorie B. Searle (Eds.), *Head, Heart and Hand: Elbert Hubbard and the Roycrofters* (pp. 149–155). Rochester, NY: University of Rochester Press.

Barnes, Joseph W. (1981). "Rochester and the Automobile Industry." *Rochester History*, 40, (2 and 3), April and July.

Bascom, Mansfield (2011). Letter to Bruce A. Austin, November 1.

Berman, Rick (1995, December). "Ron Meyers: Thirty Years." *Clay Times*, pp. 4–5, 10.

Boylen, Michael (1989, December). "Frans Wildenhain: Master of Form." *The Studio Potter*, 18 (1).

Boylen, Michael (n.d.). Manuscript. Collection of Barbara Cowles.

Brennan, Harold J. (1958)."Three Rochester Craftsmen." *American Artist*, 22 (6), June, pp. 36–43, 87–90.

Cartwright, Roy (2011). Email to Bruce A. Austin, November 14.

Cartwright, Virginia (2011). Telephone interview with Bruce A. Austin, November 30.

Chambers, Bruce W. (1979). "Foreword." In *Paley Castle Wildenhain*. Rochester, NY: Memorial Art Gallery exhibition catalog, August 24–October 7.

Clements, Tarrant (2011). Telephone interview with Bruce A. Austin, October 14.

Cloutier, Dane Steven (2007). "Marguerite Wildenhain: Bauhaus to Pond Farm." *Marguerite Wildenhain: Bauhaus to Pond Farm* (pp. 11–19). Santa Rosa, CA: Sonoma County Museum, exhibition catalog, January 20–April 15.

Collins, Rowland L. (1975). "The Lillian Fairchild Award, 1924–74." *University of Rochester Library Bulletin*, 29 (1), Autumn, pp. 1–12.

Cowles, Barbara (1980a, April/May). "A Frans Wildenhain Collection." *American Craft*, 40 (2), pp. 30–33, 84–85.

Cowles, Barbara (1980b, June). "Frans Remembered." Unpublished manuscript. Collection of Barbara Cowles.

Cowles, Barbara (2010). Personal interview with Bruce A. Austin, April 1.

"Craftsmen Do Part for New School" (1953, December 4). *RIT Reporter*, p. 3.

Donhauser, Paul S. (1978). *History of American Ceramics: The Studio Potter*. Dubuque, IA: Kendall/Hunt.

Eris, Alfred (1951, May). "They Learn Crafts for Careers," *Popular Mechanics*, 97, pp. 143–146.

Feldman, Bill (1963). "A Man." Unpublished newsprint pamphlet, Rochester Institute of Technology.

Feuerherm, Kurt (2011). Telephone interview with Bruce A. Austin, October 4.

Fina, Angela (2011). Telephone interview with
Bruce A. Austin, November 8.

Forster, Ken (2010). *Alternative American Ceramics,
1870–1955: The Other American Art Pottery*. Atglen,
PA: Schiffer Publishing.

Frans Wildenhain: Retrospective (1974). Binghamton:
State University of New York at Binghamton,
University Art Gallery, exhibition catalog,
December 1, 1974–January 5, 1975.

Frans Wildenhain: A Chronology of a Master Potter
(1975). Rochester: Rochester Institute of
Technology, Bevier Gallery, exhibition catalog,
October 18–November 7.

Gerbic, Peter (2011). Telephone interview with
Bruce A. Austin, December 12.

Gernhardt, Henry (2011). Telephone interview with
Bruce A. Austin, October 31.

Gordon, Dane R. (1982). *Rochester Institute of
Technology: Industrial Development and
Educational Innovation in an American City*. NY:
Edwin Mellen Press.

Greenberg, Stephen (2011). Telephone interview with
Bruce A. Austin, October 19.

Grieve, Victoria (2009). *The Federal Art Project
and the Creation of Middlebrow Culture*. Urbana:
University of Illinois Press.

Harris, Robert (2012). Telephone interview with
Bruce A. Austin, February 6.

Hirsch, Richard (2011). Personal interview with
Bruce A. Austin, October 24.

Jackson, Julia Browne (2011). Telephone interview with
Bruce A. Austin, November 1.

Jurs, Nancy (2011). Telephone interview with
Bruce A. Austin, November 10.

Keyser, William (2011). Telephone interview with
Bruce A. Austin, November 2.

Kilham, Walter H., Jr. (1961). "Housing the Library,
Part II: The New Building." *Bulletin of the Medical
Library Association*, 49 (3), July, pp. 403–410.

Krakowski, Lili and Cowles, Barbara (n.d.). "The Making
of Heirlooms." Unpublished manuscript. Collection
of Barbara Cowles.

Levin, Elaine (1984). "Frans Wildenhain," pp. 7–19. In
Wildenhain. Rochester, NY: Memorial Art Gallery
exhibition catalog, October 27–November 25.

Levin, Elaine (1985, February). "Frans Wildenhain."
Ceramics Monthly, 32 (2), unpaged.

Levin, Elaine (1988). *The History of American Ceramics,
1607 to the Present: From Pipkins and Bean Pots to
Contemporary Forms*. NY: Harry N. Abrams.

Lindsay, R. Bruce (2011). Personal interview with
Bruce A. Austin, December 7.

Lippert, Ellen J. (2010). "George Ohr: Mad Potter,
Marketing Genius." *Style 1900*, 23 (1), Spring,
pp. 48–55.

"Lulu Scott Backus" (1942). *Bulletin of the American*

Ceramic Society, 21 (5), May 15, pp. 61–64.

Mainzer, Janet C. (1988). *The Relation Between the Crafts and the Fine Arts in the United States from 1876 to 1980*. Unpublished doctoral dissertation, New York University.

Markson, Anastasia (2011). Personal interview with Bruce A. Austin, October 23.

Martin, Kathleen (2012). Email to Bruce A. Austin citing RIT *Faculty Manual and Personnel Policies* circa 1970, February 6.

Maryland Historical Trust (2000). "Internal NR- [National Register] Eligibility Review Form." February 16.

McKelvey, Blake (1970). "The Visual Arts in Metropolitan Rochester," *Rochester History*, 32 (1), January, pp. 1–24.

"Memorial Celebration: Lili Wildenhain" (2004, February 7). Unpublished document compiled by Paul Rankin, Rochester, NY. Collection of Robert Johnson, unpaged.

Mohrhardt, Foster E. (1962). "A Building for the National Library of Medicine." *Libri*, 12 (3), January, pp. 235–239.

Monteyne, David (2011). *Fallout Shelter: Designing for Civil Defense in the Cold War*. Minneapolis: University of Minnesota Press.

Norton, Deborah (1985). "Frans Wildenhain." *American Ceramics*, 4 (2), pp. 48–55.

Poole, Ken (2012). Telephone interview with Bruce A. Austin, February 1.

Rankin, Paul (2011). Personal interview with Bruce A. Austin, November 11.

Sax, Bill (2011). Telephone interview with Bruce A. Austin, November 7.

Schwarz, Dean (2004). *Marguerite Wildenhain: A Diary to Franz*. Decorah, IA: South Bear Press.

Schwarz, Dean (2007). "Foreword." In Dean and Geraldine Schwarz (Eds.), *Marguerite Wildenhain and the Bauhaus: An Eyewitness Anthology* (pp. 13–14). Decorah, IA: South Bear Press.

Schwarz, Dean (2011). Telephone interview with Bruce A. Austin, September 6.

Schwarz, Dean and Schwarz, Gerry (2004a). "Foreword." In Dean Schwarz, *Marguerite Wildenhain: A Diary to Franz* (unpaged). Decorah, IA: South Bear Press.

Schwarz, Gerry and Schwarz, Dean (2004b). "Afterword." In Dean Schwarz, *Marguerite Wildenhain: A Diary to Franz* (unpaged). Decorah, IA: South Bear Press.

Sims, Lowery Stokes (2011). "Rothko and the Four Seasons Commission: A Parable of Art and Design at the Mid-Twentieth Century." In Jeannine Falino (Ed.), *Crafting Modernism: Midcentury American Art and Design* (pp. 56–83). NY: Abrams.

Smith, Virginia Jeffrey (1959, October). "Frans Wildenhain's Ceramic Mural," *American Artist*, p. 20. Shop One collection. University of Rochester, Rush Rhees Library, Department of Rare Books and Special Collections, Rochester, NY.

Steele, Tim Tivoli (1992). "School of the Pond Farm Workshops: An Artists' Refuge." *A Report*. San

Francisco Craft and Folk Art Museum, 10 (2), p. 3.

Stolze, Margaret (1970, February 26). "In Studio with Frans Wildenhain." *Brighton-Pittsford Post,* pp. 1, 11.

Thill, Rudolf (2007). "The Guild Systems of Germany." In Dean and Geraldine Schwarz (Eds.), *Marguerite Wildenhain and the Bauhaus: An Eyewitness Anthology* (p. 53). Decorah, IA: South Bear Press.

Toffler, Alvin (1973). *The Culture Consumers: A Study of Art and Affluence in America.* NY: Vintage Books.

Walrath [Jean] (n.d.). "Wildenhain's Potter is Art— and 'Muscle Power.'" *Democrat and Chronicle,* clipping. Rochester, NY, Memorial Art Gallery archive.

Wetherald, Houghton (2004). "The Campus as Architectural Canvas." In David Pankow (Ed.), *View It! The Art and Architecture of RIT* (pp. xi–xxii). Rochester, NY: Cary Graphic Arts Press.

Wildenhain, Frans (1974). Unpublished notebook. RIT Archive Collections, Paul Rankin collection in memory of Lili Wildenhain.

Wildenhain, Frans (1976). Unpublished notebook. RIT Archive Collections, Paul Rankin collection in memory of Lili Wildenhain.

Wildenhain, Frans (1978). Letter to Lois Moran, March 16. http://www.aaa.si.edu/collections/viewer/frans-wildenhain-to-lois-moran-1807).

Wildenhain, Frans (1979a). Letter to Peter Schneider. http://www.aaa.si.edu/collections/images/detail/frans-wildenhain-to-peter-schneider-1782

Wildenhain, Frans (1979b). Unpublished notebook. RIT Archive Collections, Paul Rankin collection in memory of Lili Wildenhain.

Wildenhain, Marguerite (1973). *The Invisible Core: A Potter's Life and Thoughts.* Palo Alto: Pacific Books.

Williams, Ben F. (1968). "Introduction to the Artists and Exhibition." *Pottery of Marguerite Wildenhain: A Selection of Her Recent Work.* Raleigh, NC: North Carolina Museum of Art, exhibition catalog, February 11–March 3.

Wolfard, Clara (2003). "Perspective on Art and Community: A Personal Odyssey." *Rochester History,* 65 (3), Summer.

Wolfe, Tom (1981). *From Bauhaus to Our House,* NY: Farrar Straus Giroux.

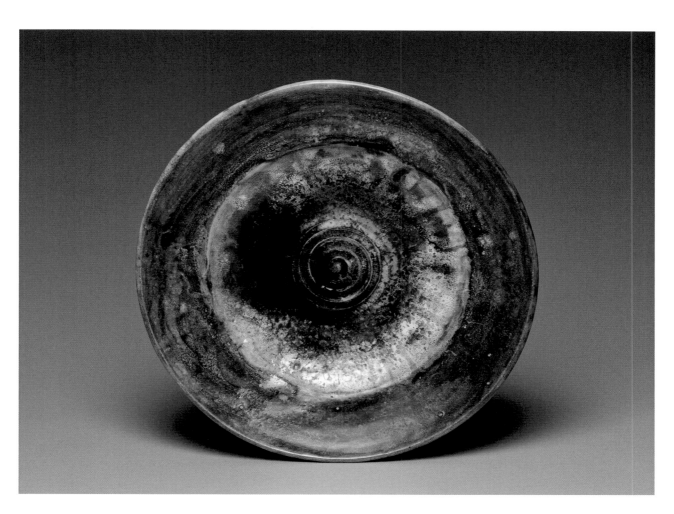

EARTHENWARE
2.25 x 14 inches, reduction fired

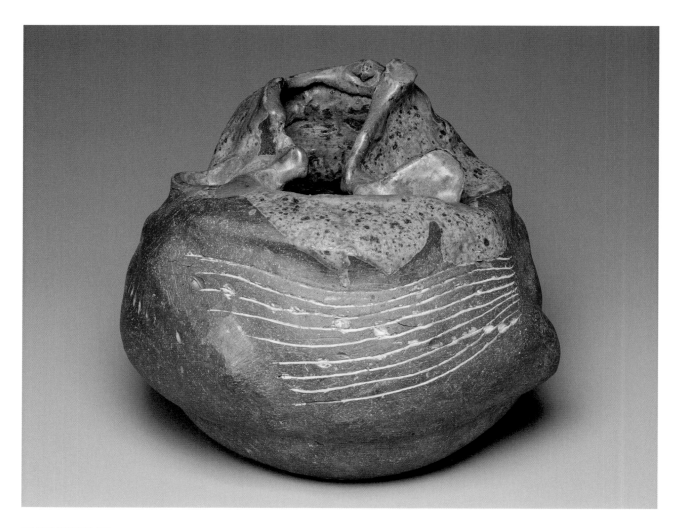

EARTHENWARE
10.5 x 11 inches, reduction fired

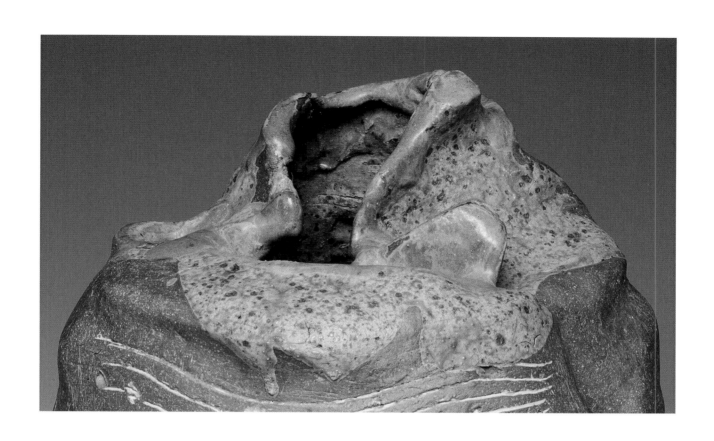

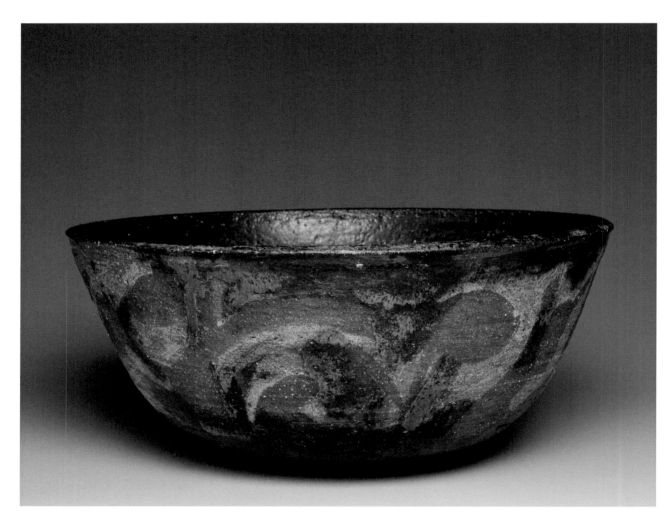

STONEWARE
6.5 x 15 inches, reduction fired

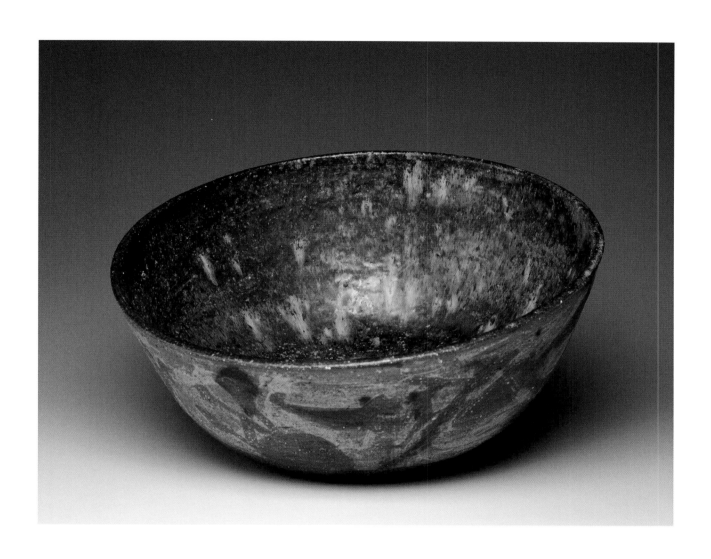

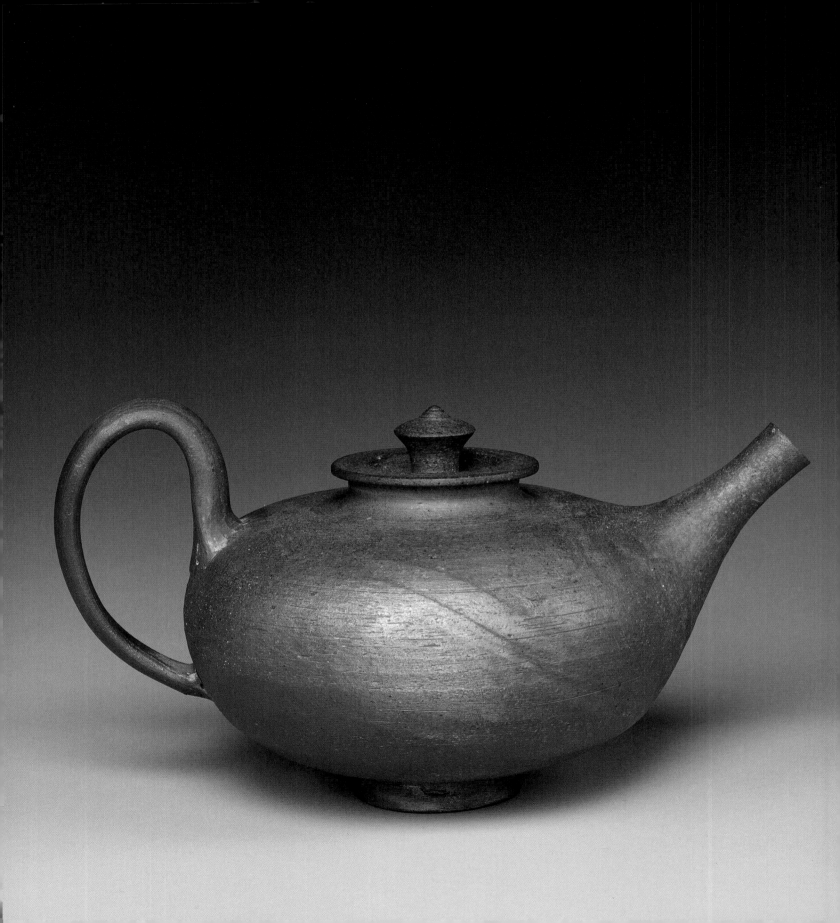

3

CRAFT EDUCATION AND THE FIRST THIRTY YEARS OF THE SCHOOL FOR AMERICAN CRAFTSMEN

BECKY SIMMONS

Established during a post-World War II revival of handcrafts, RIT's School for American Craftsmen (SAC) emerged during a pivotal moment in the history of 20th-century crafts. This essay traces the early history of SAC and examines social, artistic, and economic factors, paying particular attention to the development of crafts as a field of artistic endeavor; then connects these external developments to the educational philosophy and goals of the School. SAC's unique educational program was created and sustained by founder Aileen Osborn Webb and first director Harold Brennan, both of whom steered the School through its early years.

AILEEN OSBORN WEBB

The School for American Craftsmen owes its nearly 70 years of existence to the vision of Aileen Osborn Webb, an exceptional New Yorker with a special interest in crafts.

STONEWARE
5.5 x 9.5 x 6.5 inches, reduction fired

Born in 1892, Webb came from an affluent family with a social conscience. Her father, an avid art collector, served on the Board of the Metropolitan Museum of Art, and paintings and sculpture were displayed in the Osborn home. Webb's private school education exposed her to the arts, where she was taught to paint as part of a girl's complete education. She also had some education in the crafts, learning enameling; she later took up ceramics on her own.

During the Depression, Webb worked with local committees in Putnam County, New York, on WPA (Works Progress Administration) related projects to sell handicrafts made by the rural population. Looking to build on this initial effort, Webb and her colleagues called a meeting of New England craft leaders to discuss other possibilities for marketing handmade goods. Out of this meeting came the Handicraft Cooperative League of America, later called the American Craftsmen's Cooperative Council, which established a venue where craftspeople could sell their products in a populated metropolitan area. A second organization, the American Craftsmen's Education Council (ACEC), was formed in 1943 to educate "craftsmen in the problems of selling and of standards" (Cumming, 1970, p.7).

THE STATE OF CRAFTS AND CRAFT EDUCATION IN THE UNITED STATES

Webb's passion for education in the crafts centered on three major themes: the need for a revival of the "hand arts," lost due to the proliferation of mass-produced goods; a loss of

PANEL FROM A DARTMOUTH COLLEGE EXHIBITION ABOUT THE SCHOOL
Winter 1944
RIT Archive Collections

EARTHENWARE
8 x 8.75 inches, reduction fired

understanding of the need for creative design at a high level; and the opportunity to make a living through crafts.

The ACEC, which became the American Crafts Council (ACC) in 1955, was the first national organization dedicated to crafts. Public interest in fine crafts had been brewing since the 19th century, and the ranks of amateur craftspeople had been growing as people found leisure time to devote to artistic endeavors. The country was dotted with local groups of amateur craftspeople and guilds and community schools proliferated as institutions such as the Philadelphia Museum School of Industrial Art offered a variety of craft courses. A number of educational institutions, including universities, colleges, and trade schools, had offered craft programs for years. Most were put in place to train students in design and materials for work in industry. The ACEC brought these disparate activities together under one umbrella organization.

In the 1940s, museums began to take notice of crafts; artists found a means of expression and the public discovered and began buying. A national exhibit at the Baltimore Museum of Art in 1944, "An Exhibition of Contemporary American Crafts," brought together craftspeople from all over the United States. Museum curators chose a mix of work, reflecting the major areas of craft work: utilitarian and traditional forms, work for industry, and more contemporary "experimental" work. Nationally known figures, including Marguerite Wildenhain of Pond Farm and ceramist Glen Lukens, as well as beginners,

represented by students from the crafts division of the School of Design in Chicago, were invited to exhibit. Two subsequent major undertakings by the Museum of Modern Art made up another piece of the revival and movement of crafts to the national stage in this period. The Museum published a series of how-to craft books in its Art for Beginners Series, including one on ceramics and one on jewelry that became very popular. And in September 1946, the Museum opened "Modern Handmade Jewelry," the first exhibition to examine contemporary craft jewelry as an emerging art form. The exhibit featured well-known sculptors Alexander Calder and Jose de Rivera and painter Richard Pousette-Dart at a time when many painters and sculptors were turning to crafts.

FOUNDING OF SAC

When the American Craftsmen's Educational Council was founded, there were a number of crafts education programs at colleges and institutions around the country, including Alfred University, Rhode Island School of Design, Cranbrook Academy of Art, the California School of Arts and Crafts, and the Boston Museum School. Many programs were part of existing art schools, and some, like the program at Alfred, had a more industrial focus. What would set SAC apart was Webb's intention to train and develop highly skilled craftspeople who would move easily into a lifelong profession, earning them a good living.

Webb astutely married her idea to a national need, building on a tradition of using crafts for occupational therapy, particularly for soldiers who had seen combat. After World War II, the GI Bill guaranteed a college education to returning veterans and SAC took advantage of this, initially offering its classes to those veterans. SAC opened in 1944 at Dartmouth College, affiliated with the college's Student Workshop (DCSW), which provided liberal arts students at Dartmouth a place to experiment with and learn crafts. Virgil Poling, founder of DCSW, was director and craftsman-in-residence and acted as training director of SAC. The six-month program offered classes in ceramics, woodworking, metalcrafts, and textiles. The curriculum was practical and flexible, and students could work at their own pace, with a series of examinations that would allow them to progress from Beginner to Apprentice to Craftsman and finally, to Master Craftsman. Eventually the program grew to two years, with formal semesters, although no degrees were conferred. Students were trained to produce a "good product," through training in design, technique, and proper use of materials. Instruction in production methods, coupled with business training, would prepare graduates for employment in a studio, in industry, or as teachers. The production training, in particular, was considered essential and students worked afternoons on objects for real clients with faculty acting as foremen and students as apprentices. Students were paid based on their stage in the program. In

**SAC INSTRUCTOR ERNEST BRACE (BACK)
AND STUDENT GEORGE ALEXANDER
AT ALFRED UNIVERSITY**
RIT Archive Collections

addition, disciplined workmanship, pride in work, and a full appreciation of a cooperative workshop would be developed. The program sought to develop the skills to make a living "through vocational and specialized training in Manual Industry and the Hand Arts," where Manual Industry meant "employment on all level of skills in craft production" (School for American Craftsmen [catalog], n.d., p. 1).

An essay titled, "Crafts in Our Time," published in the School's catalog (School for American Craftsmen [catalog], n.d., p. 1) noted that the "survival of fine crafts" depended on "new concepts and definitions" that would "establish a permanent place for crafts in the industrial world." Craftspeople, as leaders of a new movement, would reinvigorate standards of design and workmanship, revive American craft traditions, and contribute their expertise to methods of mass production, echoing aspects of the Bauhaus tradition. Referencing the principles of the older Arts and Crafts movement, the catalog emphasized craftwork as revitalizing "a traditional way of living," one that would bring students "spiritual and financial independence." This marriage of the idealistic and practical was a hallmark of the program.

By the end of the war, SAC had 30-plus students. Neither Webb nor the administration and board of Dartmouth ever intended Dartmouth as its permanent home; the School had planned to move out into the community. This never developed, and with the return

of its own students from the war, Dartmouth needed the space back. As agreed upon by Webb and Dartmouth, non-veterans and women also had been accepted into the program and so Dartmouth, open only to men, would not be suitable for the long term. Webb thus began casting around for a new home and found it in Alfred, New York, at Alfred University.

THE MOVE TO ALFRED

SAC's association with Alfred afforded it a true university-based home, as the program became part of the College of Liberal Arts. Webb later wrote that she saw this association of the Liberal Arts with the "Hand Arts" as an educational innovation that was a credit to both SAC and Alfred (Aileen Osborn Webb to W. Ellis Drake, Nov. 9, 1948). The curriculum was refined and was offered as a two- and four-year program. The two-year program led to a certificate, and students enrolled in the College of Liberal Arts could join the School in their third and fourth years and earn a Bachelor of Science degree. Coursework included extensive shop training, production planning, and design and marketing; a required art history course was added later. Frances Wright Caroé, daughter of Frank Lloyd Wright, who also directed America House, the Craft Council's New York City retail store for crafts, served as Administrator and Manager of Production and Marketing. In 1948, the faculty included Edwin Blanchard Brown (design); Ernest Frank Brace (woodworking); Laurits C. Eichner, Philip Morton, and

Charles Reese (metalwork); Ethel Irene Mitchell (weaving); Linn Phelan and Herbert H. Sanders (ceramics); Robert H. Savage (wrought iron); and Thomas F. McClure (sculpture). The faculty members all were established artists, with a mix of academic credentials, individual expertise in their medium, and time spent in industry. In 1948, Caroé left to give her full attention to America House and Harold Brennan was named director.

Metalworker John Prip, who joined the faculty in 1948, enjoyed teaching at Alfred. He appreciated the attitude of optimism and openness to experimentation at SAC and admired Brennan, as "understanding and sympathetic towards the whole idea of the place." Prip particularly enjoyed the students; the GIs, especially, were a hard-working, gifted group, many of whom came with little experience in crafts, but who as older men purposefully devoted their energy to their schooling (Brown, 1980).

Repeating themes stressed earlier, the Alfred catalogs idealistically emphasized that craftsmanship offered a way of life that would be "spiritually satisfying" and "financially sustaining." The craftsman would fill a "cultural and educational gap" and would "lead the way to an artistic appreciation by the public of the possibilities in manual creations." And finally, "The tradition of craftsmanship will be perpetuated and become a living part of all contemporary life" (School for American Craftsmen [catalog 1948–1949], 1948, p.4). Alongside these more elevated goals, careful training would simultaneously develop design skills,

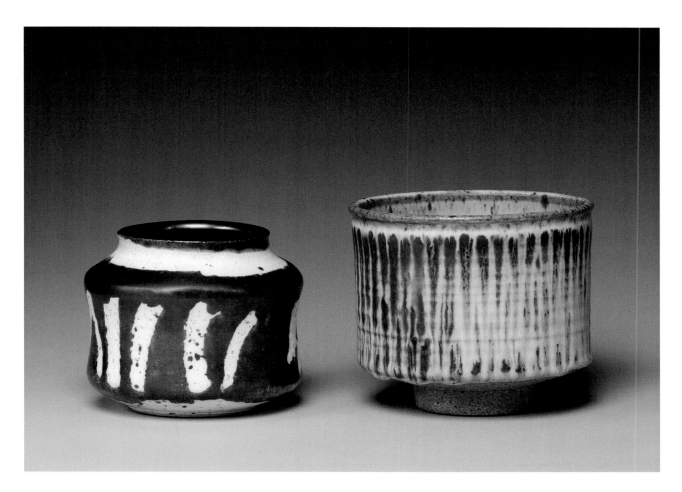

LEFT: **EARTHENWARE**
4.25 x 5 inches, oxidation fired

RIGHT: **EARTHENWARE**
4.75 x 5 inches, reduction fired

disciplined workmanship, efficient work habits, and marketing skills. Design covered creative work, but also included techniques of execution, shop production, and understanding markets and contemporary trends.

Within a year of the move to Alfred, problems arose due to overlap and incompatibility between the existing New York State School of Ceramics, which was part of Alfred University, and SAC, which was part of the College of Liberal Arts. Although the president of Alfred, Dr. J. Edward Walters, fully supported the mission of SAC, when he stepped down in 1948, the new president was persuaded that Alfred should not have competing ceramics programs. In 1949, the Board of Trustees voted to part ways with SAC.

NEW VIGOR AND PURPOSE

One year later, the School for American Craftsmen moved to RIT. RIT President Mark Ellingson had persuaded Webb that RIT was the right fit for the School (Cumming, 1970, p. 18). Ellingson had been expanding RIT's degree programs, adding a program in photography in 1930 and a School of Printing in 1937. SAC also fit well with RIT's career focus. Ellingson noted in local papers that RIT had been considering a crafts program for some time, and planned to merge its current ceramics program into SAC. Negotiations moved quickly and smoothly, and decisions made by the boards of both organizations occurred within a few months. The ACEC pledged funding for 10 years, ensuring the School started on firm economic ground. Webb was made a member of RIT's Board of Trustees. A letter to Webb from

HAROLD BRENNAN VIEWS AN EXHIBITION AT STATE TEACHERS COLLEGE
New Paltz, New York, circa 1957
Neil Croom, photographer, RIT Archive Collections

STONEWARE
15 x 19.5 x 3.25 inches, reduction fired

Ellingson on behalf of RIT's Executive Committee noted "very great enthusiasm" for SAC's move to RIT (Ellingson to Webb, personal communication, May 23, 1949). In the press, Ellingson was quoted:

> It is significant, we feel, that the development of education for hand craftsmen should be well perpetuated in surroundings and atmosphere wherein the youth of Rochester and from the nation and world have already long sought and acquired technological knowledge and skills. ("National Crafts School," 1949, n.p.)

Once SAC was installed at RIT, Webb stepped back and handed over full administrative authority to Harold Brennan, who had moved with the School. Brennan's background was in design and architecture and he had earned both bachelor's (1932) and master's (1941) degrees at Carnegie Institute of Design (now Carnegie Mellon University). As he noted in a 1970 interview, although he gravitated to the arts, he did not see himself as an artist; he was too verbally inclined, and so instead gravitated toward teaching (Converse, 1970, p.33). Webb hired him from his position at Westminster College in Pennsylvania, where he had taught art history, eventually rising to Chairman of the Department of Art.

Brennan was an excellent choice to steer the School. As an administrator, he worked well with the faculty. He had great respect for creative artists and this was evident in how he treated them. He had no doubt that craftspeople were artists. Brennan believed in allowing the faculty great

freedom to run their own programs and later noted that he allowed "administrative changes and adjustments to occur naturally" (quoted in Converse, 1970, p.35).

Brennan also possessed the intellect to articulate a vision for the School and he was responsive to outside developments. He paid close attention to the many changes taking place at a time when the art/craft and education spheres were evolving and ensured the School progressed as well. During his 22-year tenure at RIT and Alfred, Brennan strengthened the image of the School from its somewhat modest beginnings, and brought about a greater awareness of the program. He excelled at promotion and was a persuasive writer; publishing articles throughout the Fifties and Sixties, he wrote often of the School. He also made a name for himself in the field, giving lectures on crafts education, writing articles and reviewing exhibitions in *Craft Horizons* and other publications, and serving on exhibition juries. Even when reviewing exhibitions or discussing craft education, he fostered the School's reputation as a center for the field. Looking back in 1970, he said: "What I dreamed about was a really outstanding school, in the field of arts and crafts, a school where teachers and students would work in close communion, where work would be a joy" (Converse, 1970, p. 37).

An RIT Board committee was formed to "foster growth and development" of SAC through fundraising (Minutes, RIT Board of Trustees, June 27, 1949, p. 29). Brennan and

Webb remained in frequent and friendly contact, but the Council no longer had any direct oversight, as it previously had, when the School was run by a Board of Managers consisting of ACEC members and representatives from the larger institutions. SAC had found its home.

According to Brennan, SAC's reception at RIT was positive, and the process of restarting at RIT went very smoothly. Ellingson gave department heads considerable latitude, and Brennan was free to move forward and plan as he saw fit (Smith, 1972, n.p.). The facilities were more than adequate, with shops for each of the four areas. These well-equipped quarters offered students firsthand and specific experience in producing work. Coursework was given in basic art and design, as well as the history of art, and SAC maintained its own library, with periodicals and books for reference by the students. An economics course taught elementary business practice, business organization, and international trade and taxation. Instruction in production and marketing was offered, imparting practical knowledge of pricing and bookkeeping, and including maintaining awareness of current market trends and styling. The goals of the program were not substantially modified from what they had been at Dartmouth. SAC's catalog stated that students would "realize the value of good work habits, a sense of design, and technical skills of a high order." SAC graduates would possess the education and experience to move into a professional career designing, producing, and marketing their work. Wherever they eventually chose to work, SAC graduates

**SCHOOL FOR AMERICAN CRAFTSMEN BUILDING
WASHINGTON STREET, ROCHESTER**
Circa 1963
RIT Archive Collections

would succeed, thanks to the program's professional training (*Bulletin of the School for American Craftsmen*, 1950, p. 25).

An important part of the program was the student-run Journeymen group. Students worked cooperatively to produce and market products to consign at America House and other venues. The Journeymen functioned as an affiliate of the ACEC, benefiting from practical advice as well as access to the store. The group, overseen by a board of directors, chose and priced pieces to sell. Any profit made could be kept wholly by students. It was believed that selling and earning some money from their work would give students a valuable experience to put to use once they graduated.

"A REALLY OUTSTANDING SCHOOL"

With a new home and new faculty, Brennan determinedly set about building on Webb's initial work to create a program where the creativity of the artist, the importance of technique, and acquiring the skills to make a living would receive equal billing.

Themes of fundamental importance to Webb and the ACEC dominated the early RIT SAC catalogs, including her belief that craftspeople should play an essential role in the artistic and cultural development of modern society. Well designed and skillfully made objects would enrich society, contributing to the national culture and economy by setting styles and leading fashion. Craftspeople would aid industry

through a finer understanding of design and the possibilities and limitations of materials. SAC's first RIT catalog states:

> In recent years there has been an increasing tendency to re-evaluate the ability of machine technology to satisfy the material and aesthetic needs of man. From this evaluation has come an increased appreciation of the craftsman's contribution to technology, industry, and art. (*Bulletin of the School for American Craftsmen*, 1950, p. 8)

Until the move to RIT, Webb and the ACEC were mainly responsible for guiding SAC, and the School's promotional materials retained the stamp of the goals of that organization while at Dartmouth and Alfred. Once at RIT, Brennan assumed more responsibility for managing and charting the direction of the program.

The SAC faculty put in place in the early years contributed greatly to the initial reputation of the School. They came with extensive experience and advanced degrees, long exhibition records, and experience as directors of well-known craft enterprises and design work in industry. Among those present in 1950 were Tage Frid, a woodworker who had been educated in Copenhagen and who went on to achieve a national reputation; the award-winning metalworker John Prip, who had set up his own metal business in Copenhagen and was hired in 1948 by Brennan; Linn Phelan, who had operated the famous Rowantrees and Linwood Pottery in Maine; Olin Russum, Jr., who

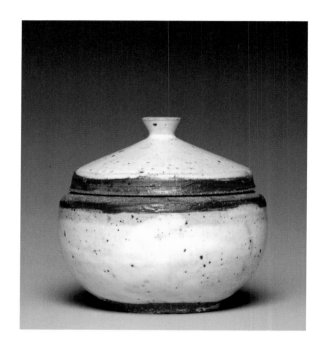

STONEWARE
5.25 x 5.25 inches, reduction fired

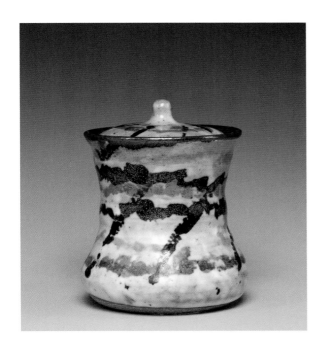

STONEWARE
5.5 x 4.75 inches, reduction fired

had an M.F.A. from Claremont College and a national exhibition record; Mitzi Otten, born and educated in Vienna and member of the Austrian "Werkbund," who had an international exhibition record, including exhibitions in Paris and London and at the Metropolitan Museum of Art; and design teacher Fred Meyer, who had studied at Cranbrook, receiving an M.F.A. in 1948 with an extensive exhibition record at major museums in the United States. Otten and Phelan left soon after the move to Rochester, and Prip later left to team up with former SAC student, Ronald Pearson, in their own business. Prip recommended Hans Christensen, a 32-year-old silversmith in Denmark who was the head of George Jensen's model department, to guide SAC's metal department.

In 1950, Brennan looked to Europe again for one important hire: German, Bauhaus-trained Frans Wildenhain. Christensen's and Wildenhain's long tenures at SAC would put a permanent stamp on the School, shaping many students and cementing SAC's reputation.

In the early 1950s, the world of professional crafts and craft education was still small, but about to burst open. The ACEC had an important role both guiding and supporting crafts in the United States in the 1950s and 1960s, mainly through the magazine *Craft Horizons*, and the retail shop America House. *Craft Horizons* in particular, was a place for discovery and the transmission of new ideas and information. At the forefront of thinking by craftspeople in this period were concerns about craft as art, the definition of design,

and connections to industry. Discussion of craft production as distinct from art making and the inherent limitations of producing for industry or even for clients were aired. Were these limitations a compromise or a challenge? How much control should the designer have? The tug of artistic expression and freedom from any practical constraints was strong, and these discussions and appearance in the literature may have affected the curriculum at SAC.

The production and business portion of SAC's program changed—classes covering marketing, pricing, and other practices disappeared and the trips to America House were no longer made after the late '50s. The curriculum began to turn away from the more practical aspects of making a living. Former SAC faculty member William Keyser noted that the production class at RIT changed somewhat in this period, with a shift from producing multiples to creating single pieces: formulating a concept, creating drawings, and scheduling time as if the student were making a single work for a client (William Keyser, interview with the author, January 12, 2012). Brennan and SAC seemed able to make room for varied philosophies toward crafts and educating students. Brennan didn't seem to favor any one type of artist/craftsperson. Individuals working with traditional forms practiced and taught alongside more free-thinking artists. Brennan saw this contrast of styles as stimulating for the faculty. Ceramist Wildenhain, although sometimes working in more utilitarian forms, was not bound by tradition. Due to his initial training at the Bauhaus under Paul Klee and

Josef Albers, among others, he considered himself an artist first. He later studied ceramics at the German State School of Fine and Applied Arts, becoming a Master Craftsman in 1930. He made both functional pieces and sculptural work, freely experimenting with forms and glazes; this embrace of experimentation and restlessness characterized much of his artistic practice. Wildenhain said: "The first consideration is form, and I approach it as a kind of abstract sculpture—to feel and interpret the shape simply as a shape and not as a description of reminiscence" (Brennan, 1958, p. 42).

By contrast, metalworker Hans Christensen focused exclusively on technique and traditional forms and was more "ordered" and "disciplined." Christensen trained in Denmark, his birthplace, and firmly held to his Scandinavian roots and craft traditions. In a 1958 article, Brennan observed that Christensen did

> not inhibit the emergence of individuality, personal insight and expression that are the hallmark of the creative mind ... he sees material process and the specific requirements of function, not as limitations, but as opportunities for the development of forms, drawn out of the unique properties of silver.... In his work, material, form, function, and productive method are seen as a beautiful and coherent entity. (Brennan, 1958, p. 43)

Brennan quoted Christensen as one who did not approve of some contemporary jewelry, believing that there was "too strenuous a search for novelty," moving too much toward

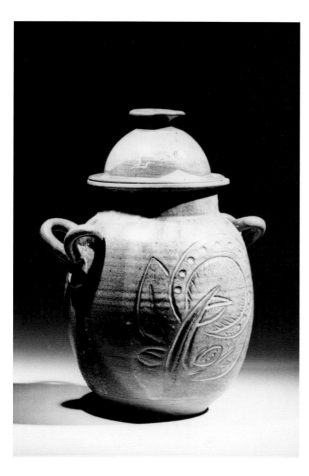

LIDDED JAR BY HOBART COWLES, CIRCA 1950
RIT Archive Collections

sculpture with "forms suggestive of exaggeration and strain" (Brennan, 1958, p. 43). Both manners of working were valued by the art world, as Christensen and Wildenhain each had one-man shows at the Albright Art Gallery in Buffalo in 1960.

Well-known textile artist Karl Laurell graduated from SAC in 1950 and ran Plymouth Colony Farms weaving shops before striking out on his own as a freelance designer and textile consultant. He was commissioned to weave fabrics for New York's Cloisters, exhibited in MoMA's 1950 "Design for Use" exhibition, and frequently was called upon to lecture and give demonstrations. He joined the SAC faculty in 1953 with a national reputation already firmly in place. He embraced tradition and maintained close ties to industry, but was open to new possibilities for fabrics. Brennan noted:

> He is first a craftsman and a rational one. It is apparent that Laurell has been excited by new fibers, and by the endless possibilities of yarn combination suggested by weaving theory, but his major interest is in finding the means of getting more serviceable and interesting fabrics into use. (Brennan, 1958, p. 90)

Faculty member Hobart Cowles received an M.F.A from Ohio State University and started to teach at SAC in 1951. He was known for his unique glazes and textures and continuously produced ceramics in a functional vein. He believed that pots should "possess some humanistic characteristics" and disliked "pots that look tortured." He believed that pots should and could communicate "the

unpleasant" or "the disgusting," but he personally preferred "the communication of the pleasant" (Szabla, n.d., pp. 4–5). He had a strong scientific side and developed a reputation as an expert in the chemistry of glazes. He exhibited widely, including at the Museum of Contemporary Crafts and at the World's Fair in Poznan, Poland.

Faculty teaching styles reflected the strengths of the individuals. Cowles was venerated by students and beloved for his open manner; students knew they could take questions and problems to him and receive thoughtful answers. His temperament balanced that of the more forceful and opinionated Wildenhain, who was known for challenging students, sometimes harshly. Cowles's strength as a teacher was his technical grounding and his dedication to the students. Students in the ceramics program were required to make their own glazes. He believed in the importance of technique, telling a reporter in 1970: "Here we feel that art will come from the proper grounding in the technique, craftsmanship, and the understanding of the materials" ("RIT's SAC," 1970, n.p.).

Wildenhain, interested in fundamentals of a different type, emphasized the individual student's growth as an artist:

> As teacher, my chief aim is to develop maturity, and to lead my students to understand that the important thing is not merely to copy procedures or forms, but to rediscover methods and to find in them creative possibilities. (quoted in Brennan, 1958, p. 42)

MFA STUDENT HERO KIELMAN WORKING IN THE SAC METAL SHOP
RIT Archive Collections

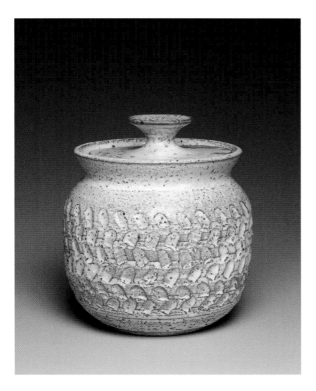

STONEWARE
8 x 6 inches, reduction fired

According to 1971 SAC graduate and current RIT professor Rick Hirsch, Wildenhain didn't push a particular aesthetic viewpoint, but did require his students to question every aspect of their work and to push themselves. Wildenhain was the consummate artist and a role model for the students, but students did not tend to copy his work outright. He expounded a philosophy of the seamless lifestyle of the artist, living through his art. He did teach technique, but with a twist. In one exercise he would make a pitcher and have the students copy it, to test their skill and technique (Rick Hirsch, interview with the author, Jan. 10, 2012), but he wasn't simply asking them to just copy the pitcher. He wanted them to use that process to learn about themselves. Student Angela Fina drew inspiration from his respect for work and his attitude toward clay—he opposed "any sort of preciousness" and he counseled students against becoming too upset when "things went wrong" ("School for American Craftsmen: 25 Years at RIT," 1976, p. 4).

SAC graduate Jere Osgood worked with woodworkers Frid and Michael Harmes. He related that the two made a good team. Harmes, born and trained in England, was careful and precise, and required detailed drawings from the students, while Frid was a little freer in his approach to teaching, although "gruff" (Gold, 2001). Keyser characterizes Frid as more of a technician, while Harmes was a designer craftsman (Cooke, 2003). The faculty may have had widely divergent artistic practices, teaching styles, and

backgrounds, but to Brennan, they were "all artists" (Brennan, 1958, p. 46).

When SAC arrived at RIT, students received an A.A.S. degree. Initially just a two-year program, students could opt for three. RIT began awarding four-year degrees in 1955, and a master's program began in 1957. The addition of the B.F.A and M.F.A. programs forced Brennan to rethink SAC's goals. The 1957/58 catalog description includes education objectives for SAC, likely due to articulating them in anticipation of a Middle States Association accreditation process undertaken for the first time in 1957. In his 59/60 annual report, Brennan noted that faculty had to rethink the curriculum to accommodate the M.F.A. students, with more emphasis on critiques and evaluating work. These new objectives underlined the artistic, rather than technical and production, aspects of the program for the first time. The goals were "to stimulate creative imagination and technical invention," "to develop knowledge of process and command of necessary skills," and "to foster appreciation not only of the crafts, but the related arts." Together, these seem to signal a shift in philosophy, one in line with new ideas circulating at the time about craft education and crafts. Craft education was undergoing change. In the 1940s, SAC was unique in its focus on developing artistic training, technique, and earning a living. By 1957, acquiring a skill and making a living no longer were its central mission.

THE SCHOOL FOR AMERICAN CRAFTSMEN FACULTY AS PRESENTED IN RIT'S 1964 YEARBOOK, *TECHMILA*
From left, Wendell Castle, Hans Christensen, Donald Bujnowski, Hobart Cowles, Martha Cragg, William Keyser, Harold Brennan, Frans Wildenhain
RIT Archive Collections

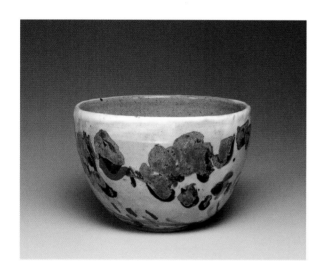

EARTHENWARE
6.25 x 8.75 inches, reduction fired

Brennan had pulled together an all-star lineup by 1960, and could proudly publicize a distinguished faculty actively making work, winning awards, and exhibiting widely in national and regional craft shows. They lectured, served on exhibition juries, and were well known in their fields. Wildenhain had been awarded a Guggenheim Fellowship in 1958 to study architectural applications of ceramics. Ronald Pearson, a student under Philip Morton when SAC was at Alfred, had received recognition for his distinctive sculptural jewelry. He recently had won an award of merit for his silver brooch in the groundbreaking "Fiber, Clay, and Metal" exhibition at St. Paul Art Center in Minnesota, and his commissions included liturgical pieces for Eero Saarinen's MIT chapel. Hans Christensen's designs in the Scandinavian idiom were revered, and his many commissions included the United States Figure Skating Association trophy. Hobart Cowles was known as an authority on ceramic glazes and woodworker Tage Frid had achieved national recognition for some of his architectural interiors. Michael Harmes created work reminiscent of the Arts and Crafts aesthetic and had recently designed and supervised the execution of the interiors and furniture in new government buildings in West Nigeria. Karl Laurell had served as one of the primary speakers at the groundbreaking Asilomar conference for craftspeople in 1958 and appeared regularly in the pages of *Craft Horizons*. His work continued to receive acclaim.

Many SAC graduates had gone on to highly successful careers. Frid's students included noted studio furniture maker and teacher Jere Osgood; Alphonse Mattia, a successful teacher with works in major museums; and Bill Keyser, who returned to teach at RIT. Many of Christensen's early students went on to prominent careers in the American silver industry, among them Burr Sebring, who became director of design for the Gorham Company; Colin Richmond, design manager of Oneida Silversmiths; and Stefan Siegel and Ed Zatursky of International Silver. Other students in the metals program who achieved prominence include Olaf Skoogfors, known for his collage-like jewelry made up of complex juxtapositions of different parts; and husband and wife Svetozar and Ruth Radakovich, who were leaders in an early trend toward biomorphic, sculptural treatment of forms. They later became internationally known for their jewelry and sculpture. Another person who came through SAC in the early Fifties was furniture designer Paul Evans, who gained notoriety for designing highly unusual sculptural furniture, much of it incorporating metal. A 1950s student of Wildenhain, Henry Gernhardt, taught at Syracuse University for many years, and has had a successful career, receiving many awards and participating in numerous exhibitions. In 1960, SAC students received an invitation from the Addison Gallery of American Art to show in Art Schools, USA 1960, a 10-year survey to illustrate the future direction of the arts in the U.S.

The primary objective of SAC was still the education and development of professional designers and craftsmen, people capable of earning a living executing works in their own studios, as teachers or with industry. The program differed from others in its Bauhaus-like openness to design of manufactured goods as a profession and retained a focus on design, technique, and professional opportunities. In fact, these strengths pointed to the unique nature of the School and provided a way to differentiate SAC from other programs where crafts were more integrated with the fine arts.

NEW DIRECTIONS

Starting in the mid-1950s and continuing well into the Sixties, ideas and trends from the art world began to filter into the somewhat insulated world of crafts. *Craft Horizons*, as the official organ of the American Crafts Council, and the only magazine for the field, had a large influence on the burgeoning craft movement. The magazine's national focus raised awareness among craftspeople of events in other regions, and it served as their primary communication tool. In addition, Rose Slivka, who assumed the position of chief editor in 1959, had a hand in identifying and defining new trends in crafts. Slivka championed the challenging and the avant-garde, and in editorials and articles she had ample opportunity to articulate a vision of the "new American craftsman." She followed artistic developments closely and

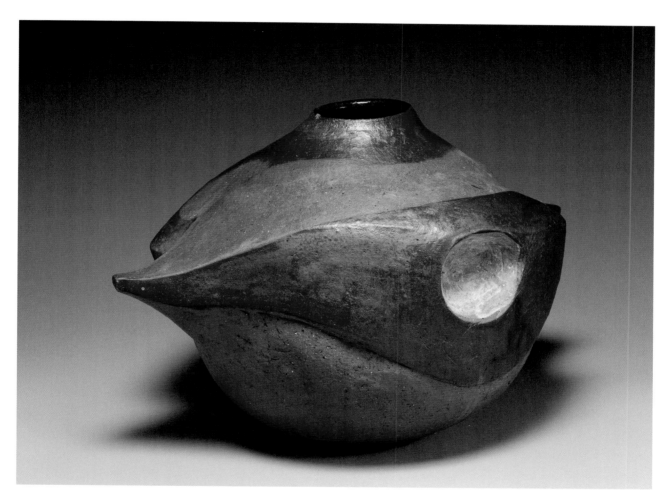

STONEWARE
13.5 x 21 x 9.5 inches, reduction fired

her enthusiasm for the experimental was clear in her writing. She continually mentioned craftspeople breaking with tradition, praising their efforts at suggesting "new meanings and possibilities." Her language included such phrases as "unique American mood of expression," "exuberant bold irreverent" and "ambivalence toward technique." She saw these new craftspeople as intellectuals who could just as easily have studied painting or sculpture as crafts. They were graduates of universities where, as students, they studied painting and sculpture alongside design and craft techniques. Crafts, like art, need not adhere to functional dictates but could "satisfy aesthetic and psychological urgencies" (Slivka, 1964, pp. 10–11, 32–33, 112).

A series of exhibits called "Young Americans," sponsored by the ACC from 1950–69, also was highly influential. Practitioners, students, and educators all paid close attention to the choice of artists and works, and recent graduates and those new to the field were eager to be a part. Reviewers combed the exhibitions for innovative new work, looking for trends. In a review of the 1962 show, former student and SAC faculty member Ronald Pearson found a refreshing "search for new forms of expression" and "inventiveness" in some of the work. Artists were moving toward "simple forms" and "increased use of texture and detail, resulting in works of greater complexity." He singled out the work of SAC graduate Roland Senungetuk, who later became one of Alaska's best-known artists, and noted that the "Scandinavian influence now tends to be a restraining force on American

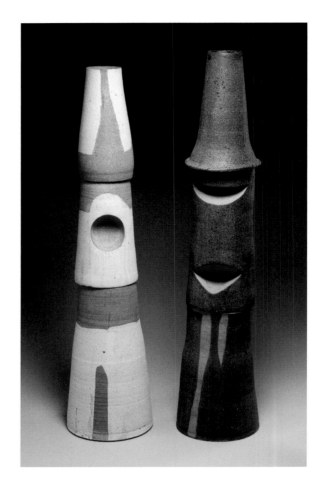

LEFT: **EARTHENWARE**
46.5 x 11.5 inches, reduction fired

RIGHT: **EARTHENWARE**
48.25 x 11 inches, reduction fired

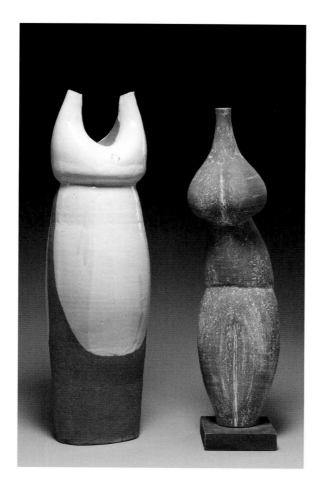

LEFT: **STONEWARE**
33 x 8 inches, reduction fired

RIGHT: **EARTHENWARE**
31 x 7.75 inches, reduction fired

craftsmen." SAC was well represented—faculty member and woodworker Wendell Castle as well as recent graduate Bill Keyser had works chosen for the exhibit, as did Al Wardle, a 1954 graduate of the metals program. Keyser also won an award for his piece, a sleek walnut and aluminum jewelry chest (Pearson, 1962, p. 13).

Brennan, too, obviously aware of new trends, began to make an increasingly sophisticated argument, mainly in the pages of *Craft Horizons*, about craftspeople as artists, craft education, and SAC's program. In a 1956 article, he pointed out the cross fertilization of art and craft and emphasized the inherent artistic nature of crafts. He used the designation "designer-craftsman," popular in this period to distinguish the new practitioner, and saw new "vigor, purpose, and beauty" in crafts:

> Today the craftsman has become interested in a new dimension in his work: the exercise of creative invention and imagination. Respect for skill and artisanship continues, but the craftsman has added a growing interest in design Today the designer-craftsman is no longer content to copy the work of his predecessors, nor are his customers satisfied with designs handed down from generation to generation They are true art forms reflecting the creative vision of the designer-craftsman who shapes them.

Brennan approached the subject again four years later in another article in *Craft Horizons*. He seemed to be taking

stock of SAC's curriculum as he wrote of the expanding renaissance of crafts in the U.S. and the contributions of SAC graduates working in their own studios, in industry, as educators, and as administrators of crafts programs. He wrote that, "Crafts, if they are to achieve any purpose beyond manual dexterity, are art forms," although he still grounded this art and design in "familiarity with material, process and technical skill." But he also noted that SAC's curriculum included significant coursework in drawing, two-and three-dimensional design, and the history and criticism of art. The last was key to broadening the students' education and stimulating new ideas and impressions upon which to draw. He was still underlining a more orderly melding of function, material, and process very much influenced by the tenets of Scandinavian design and the faculty who brought this sensibility to the School, but wanted to push the students beyond more traditional forms. These contrasting views on the program could point to a tension between the popularity of the more refined Scandinavian model and a traditional focus of the School, and these newer ideas. Modifying his description of the program, he wrote that SAC had "bridged a gap successfully between education and training," to become a

School that strongly emphasizes creative purpose, acquaintance with materials and process as a basis for the expression of design, respect for skill and

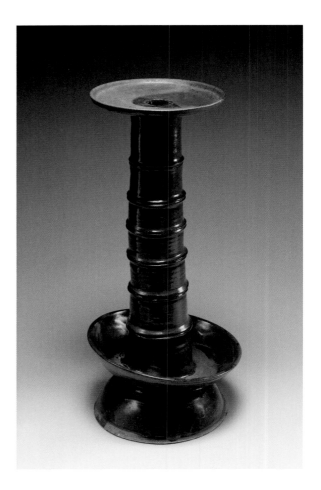

STONEWARE
22.25 x 9.75 inches, reduction fired

THE SAC WOODSHOP AT THE "NEW" CAMPUS
Circa 1970
RIT Archive Collections

technical excellence, recognition of the importance of constant evaluation, self-criticism and the belief by the student craftsman that the crafts are indeed art forms where creative imagination brings into coherent order material, process and function. (Brennan, 1960b, p. 24)

Furthering this thinking, the SAC 1962/63 annual report indicated that efforts that year lay in "continued effort to refine, focus, intellectualize and enrich" course content. In the same vein, students were now required to take a course called "Creative Sources," and two- and three-dimensional design courses alongside all the students in fine arts programs at RIT, giving the crafts students more exposure to other aesthetic ideas as they mixed freely with students in the fine arts, illustration, and design programs. SAC was responding to the times.

The sometimes passionate debate surrounding the definition of a craftsman, the function of design, and the importance of technique continued into the Sixties. In concert with these discussions, the work of faculty and students at SAC continued to evolve. And the student body changed as well. Metalworker and former SAC student and faculty member Ronald Pearson noted that the first generation were thinking in terms of how much money they could make, while Prip lamented that contemporary students didn't know how to produce and didn't know how

to work with industry (McDevitt, 1964, p. 22). That aspect of their education had been lost. He doesn't specifically mention SAC, but worried that the craft as art object was "bordering on the bizarre and crude" from a desire to experiment and be different.

Even with all the new work, new ideas, and art world influence, the program at SAC continued to tolerate multiple approaches, and there was no one dominant form or style. Some faculty and students gravitated toward production work, while others focused on creating individual art works. Functional work lived alongside expressionist and more sculptural work. However, new, younger faculty began to arrive, mainly American and graduates of craft and art programs touched by the new trends. Textile designer and weaver Don Bujnowski joined the faculty in 1961, replacing Karl Laurell. A 1952 SAC graduate, with a B.S in education from Buffalo State and an M.S. from the University of Minnesota, he had left to work for well-known designer Dorothy Liebes in New York City and then in Gloversville, New York, as a designer and stylist in the knitting mills. He continued to design fabrics and embroidery pieces as well as weave large-scale installation tapestries while he was teaching. He exhibited nationally in the "Young Americans" exhibition series and group shows at several universities. Bill Keyser, who had attended SAC from 1959 to 1960, returned to teach in 1963. He replaced his mentor, Tage Frid, who left after 12 years.

Michael Harmes, a faculty member since 1959, left at the same time as Frid and Brennan hired Wendell Castle, a 1958 graduate of the M.F.A. program at the University of Kansas. Castle's undergraduate degree was in industrial design. He then went to graduate school and moved into sculpture, gravitating toward wood sculpture, before making furniture pieces. He wrestled with the idea of sculptural woodworking and the possibility of being categorized as a craftsman rather than a fine artist (Brown, 1981). Ultimately this duality to his background turned out to be just what Harold Brennan was looking for. The program had been oriented toward Scandinavian design and more traditional furniture techniques, reflecting Frid's training and the popularity of Scandinavian design in the '50s. But the style was beginning to fall out of fashion, and Brennan wanted to encourage more contemporary design, as well as introduce more theory into the curriculum, leading him to hire people pushing technical and aesthetic boundaries of their craft. Castle's search for new furniture forms certainly accorded with Brennan's intentions. Castle quickly began to receive national attention for his sculptural furniture fabricated using a combination of lamination and sculpting and his notoriety in turn boosted RIT's reputation.

Trained in fine arts, Castle believed drawing constituted the foundation of art making and made the practice a centerpiece of his teaching. According to Keyser, they both tried to encourage students to work further in the design

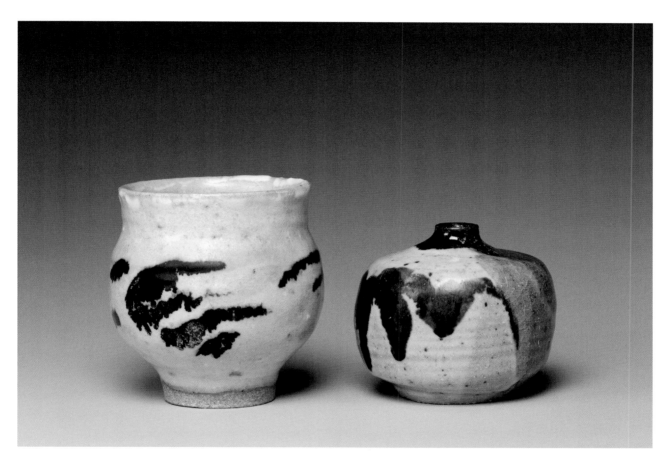

LEFT: **EARTHENWARE**
4.75 x 4.5 inches, reduction fired

RIGHT: **STONEWARE**
4 x 4.25 inches, reduction fired

phase, to consider multiple ideas and then choose from among the most developed. Students worked one morning a week in the drafting room, sketching out plans for designs, and the faculty circulated through and discussed the work. Castle and Keyser also tried to expose them to multiple aesthetic directions, and began showing slides of sculpture as well as furniture. Keyser related a classroom exercise centered on creating a piece of furniture around a found object, to force the students to design around something that wasn't their own idea. Keyser also liked to suggest sources and to send students to the library to look at books and periodicals (William Keyser, interview with the author, January 12, 2012). According to Keyser, formal critiques were not part of the wood program when he was a student. Faculty would speak to students individually about a project. So they introduced critiques for the undergraduate, bringing another practice from fine art programs to the woodshop. These two men put a different stamp on the woodworking program and heralded changes to come. Alumnus Bob Worth, a 1966 graduate of the School, later credited Keyser and Castle for encouraging his interest in structure and sculptural form. He noted, "I think like a sculptor and deal with forms in space" ("School for American Craftsmen: 25 Years at RIT," 1976, p. 5).

Brennan addressed issues related to the increase in students in a memo to staff in 1965. Enrollment had "nearly doubled from the early years, and our character has changed. Our initial goals were ... [to] produce craftsmen only, and now increasingly, our students are preparing for teaching or for industry. Also in recent years, [there has been] considerable grad enrollment, and this means [the] presence of students of a different character" (H. Brennan, Memo to Faculty, May 3, 1965). Grad students generally were more interested in pursuing careers in education, were more mature, and required more intense interaction with faculty. This likely challenged faculty and students alike, as they adapted to the expansion.

At the same time, there was the added burden of preparing for program changes and new facilities that were to open on RIT's Henrietta campus in 1968. Mark Ellingson and the Board of RIT had made the historic decision in 1961 to move the entire campus from downtown Rochester to a brand new suburban campus with plenty of acreage. Due to the post-World War II boom in education, RIT had experienced substantial growth and the old campus was no longer viable for projected growth. The planning preoccupied Brennan and the faculty throughout the mid-Sixties, requiring many hours drawing up detailed statements of need and numerous meetings with architects. All the attention to the new campus had an adverse effect on the attention given to teaching and curriculum matters.

After settling into the new facilities in 1968, the atmosphere of the program changed. Facilities on the old campus had been small, and in adapting to the layout of

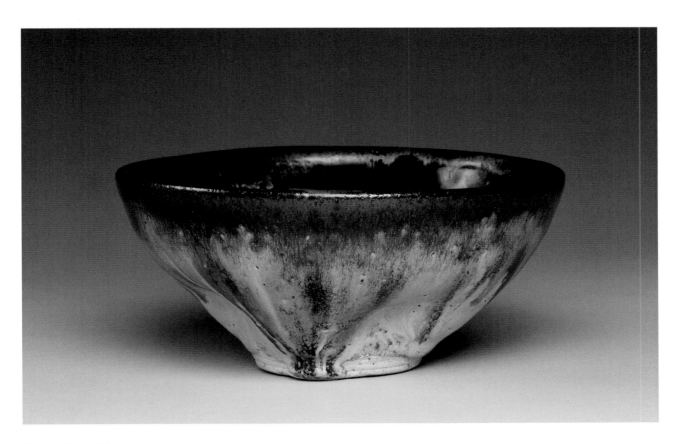

EARTHENWARE
3 x 6.25 inches, oxidation fired

what previously had been a large home and then a library, created a labyrinth of individual workshops, forcing faculty and students to regularly pass through the other shops, with many opportunities for conversation. An exhibit space in the front gave students a place to stage exhibitions, allowing the different shops to mix socially and see each other's work. The gallery also had provided the School a public face in a busy city neighborhood. In contrast, each shop on the new campus had its own distinct entrance, which resulted in a loss of intimacy and contact. Furthermore, SAC no longer had its own dedicated exhibit space, leaving students and faculty feeling isolated from the community and cut off from the energy of the city. Even Shop One, which had served as a meeting point for the Rochester crafts and arts community, was left behind.

It took several years to grow accustomed to the new surroundings. But despite some misgivings, all agreed that the new facilities were a step forward. Space, equipment, tools, and materials were generously available, offering students and faculty an environment conducive to learning.

By the late 1960s, arguments over what constituted the artist, the craftsman, and the artist-craftsman and the issues surrounding production, waned. The groundbreaking work of the '40s, '50s and '60s had brought acceptance of the permeability of art and crafts. Crafts appeared in museum exhibitions, and the public was buying both high-end and less expensive pieces. The tension between crafts

as functional objects and crafts as art no longer was a preoccupation.

When Castle left in 1970, he was replaced by Doug Sigler. A 1964 SAC graduate, Sigler designed and fabricated furniture and sometimes ventured into more sculptural pieces. He enjoyed working with highly figured wood, and relished the technical challenges. He also arrived with teaching experience at Penland School of Crafts and Haystack School of Crafts. Both he and Keyser were very interested in teaching students the skills needed to function as professionals and make a living producing work, including efficient working and marketing. A devoted teacher, Sigler even made trips to craft shows with students to allow them to experience selling their work. He would assist them with tending booths. Both Keyser and Sigler exposed students to industry by giving them real-world problems. At one point, the Gunlocke furniture company was brought in to present a problem to juniors to create a design that could be mass produced.

Frans Wildenhain was invited to jury the "Young Americans" exhibition in 1969, which was back after a seven-year hiatus. The catalog essay noted that the "largest, most overall influence on today's young craftsmen is the fine arts" (Young Americans 1969, 1969, p.3). The primary concern was with aesthetic values in themselves, rather than aesthetic values as an outgrowth of utilitarian purpose. SAC added a course in contemporary art and the journeyman's piece, harking back to an earlier era, was no longer required. The

ROBERT H. JOHNSTON
Circa 1975
RIT Archive Collections

idea of preparing for a trade or of crafts as handwork had an equally "antique" sound. Students saw themselves as artists. Even with the changes and shifts in goals of the program, the curriculum itself remained remarkably unchanged from the '50s through the '70s. "Materials and Processes" was still taught for the first three years, along with design and drawing. The latter two classes changed with the times and the interpretation of the faculty member, but the basic framework remained in place, giving students grounding in the fundamentals and allowing faculty the freedom to approach the subject from their own perspectives.

The movement from producing craftsman to artist found full expression at SAC when Albert Paley was hired in 1969. At this point in his career, Paley was garnering a reputation for his innovative jewelry, which combined exquisite craftsmanship with daring, large, body-conscious forms. He approached the pieces as sculpture, pushing jewelry from more contained forms into a dialog with the body. Although a recent graduate of Tyler School of Art, he already had a sizeable exhibition record. His success continued to contribute to the reputation of SAC.

A NEW DIRECTOR

Harold Brennan retired in 1970 after more than 20 years administering SAC and serving as Dean of the College of Fine and Applied Arts. A national search brought Dr. Robert H. Johnston to RIT. He had a background in fine

arts and a Ph.D. in Ceramic Archaeology. He also was a practicing ceramist. He instituted some important changes, including removing the directors of the two major Schools in the college—SAC and the School of Art and Design— and consolidating their administration in the dean's office. This ostensibly was to bring the two faculties and Schools together, and encourage more interaction. He made subtle changes to SAC's curriculum, broadening the coursework by allowing students greater freedom to include other craft and art courses, and encouraged them to branch out into other areas, such as business. The design course sequence would now include classes outside SAC in the Design Program as well as one-on-one design with craft faculty back in the individual shops. Similar to Brennan, Johnston believed that making design a more integral part of the program would improve students' work (Johnston, 1973, p. 4). He looked to develop a more unified program through the integration of design, drawing, and crafts concepts, to create balance between abstract-theoretical and applied aspects of design.

After the free-wheeling Sixties ended, there was a bit of a pendulum swing back to an interest in traditional and more functional crafts, as notions of going back to the land, to more elemental human work, took hold. This shift also fueled an interest in indigenous crafts and historical processes and people turned outward to other cultures for inspiration. In woodworking, Keyser and Osgood brought

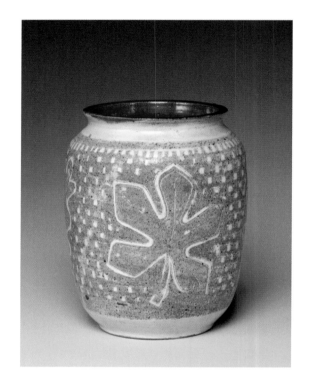

EARTHENWARE
7.75 x 6.25 inches, reduction fired

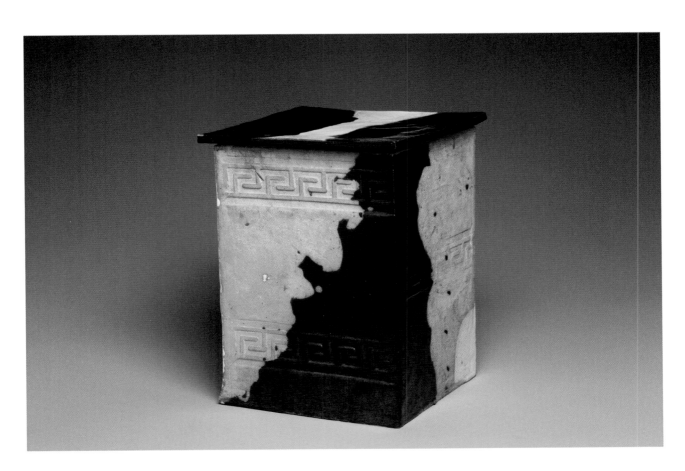

EARTHENWARE
12.75 x 9.5 inches, reduction fired

the focus back to craftsmanship, teaching students to plan and execute around a particular time frame, preparing them for producing work professionally.

A new SAC program in glass blowing was approved in 1972. Glass had gained in popularity in the 1960s, with a number of institutions inaugurating programs, including Alfred University in New York State and the Rhode Island School of Design. Tom Kekic, owner and operator of Bristol Glass Works, and former head of the Ceramics Department at Nazareth College, was brought in to teach glass blowing. His education included an M.F.A in Ceramics from Pratt Institute. He had built his own furnace, and had experience with fundamental glass techniques, particularly with blown glass. Stained glass was briefly offered, and within a few years, cold glass working techniques, such as lamination and sculpting, became part of the program.

The basic philosophy of the School remained remarkably consistent in the face of changes occurring in the craft sphere. In a 1973 article on the School (Bonham, 1973, p. 22), Don Bujnowski noted that the original concept of the concentration on a single discipline and "learning by doing" had not been altered. The curriculum remained open enough to allow for interpretation while teaching fundamentals in order to graduate students with a certain level of skill.

Along with a new director, several faculty changes occurred in the 1970s. Wildenhain retired, and Bob Schmitz, an expert on glazes, was hired. He had an M.S. from Alfred University and an M.F.A. from the University of Wisconsin. Castle left the program and woodworker Jere Osgood taught for three years. Osgood recently had been commissioned to design and prepare library furniture for the Johnson Wax Company in Wisconsin. Max Lenderman, a textile artist, came on board in 1973. He had a bachelor's degree from Indiana State University and Master of Fine Arts in Ceramics and Textiles from the University of Kansas. Prior to coming to RIT, he chaired the Weaving Department at Bowling Green State University in Ohio. Lenderman taught at RIT for many years and is known for his woven sculptural wall hangings. Paley left in 1973 and Johnston hired jewelry maker Gary Griffin. Like Paley, Griffin was fresh from graduate school at Tyler and already had an extensive exhibition record. He had experience as a welder and machinist and put his knowledge of tool and die making machines, lathes, shapers, and milling machines to use in making his innovative jewelry. The results were sophisticated, beautifully finished pieces with an unusual machine aesthetic. He later moved on to larger sculptural pieces that could more adequately be described as art. Despite these changes, the balance of the faculty remained intact. Christensen, Cowles, and Keyser were still teaching, and Schmitz and Lenderman both stayed for many years once they came on board.

SAC's reputation continued to spread through the success of its students. Many had moved on to teaching positions in colleges and universities, worked in industry, or

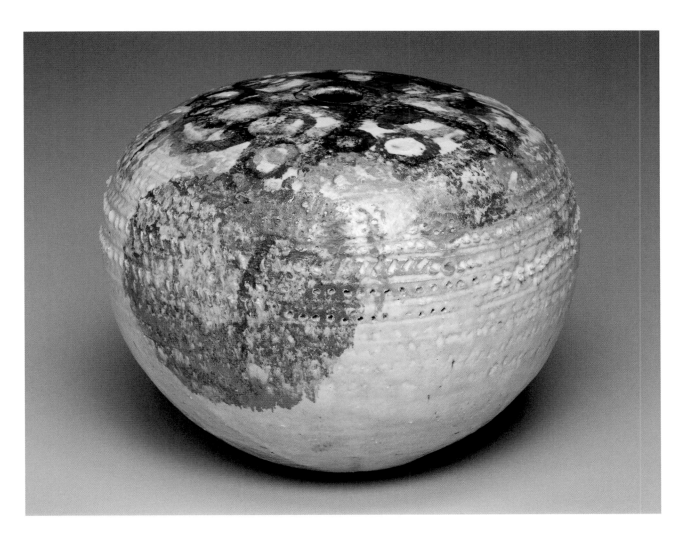

STONEWARE
8 x 9.5 inches, reduction fired

had become successful artists. Students had major teaching positions at RISD, Philadelphia College of Art, and the University of Wisconsin; and the Boston School of Artisanry, founded in 1975, was an RIT-centric enterprise. Dorian Zachai, a 1960 graduate of the textiles program, explored non-traditional textile processes and, with others in the '60s, moved into sculptural forms and received recognition for her groundbreaking works during that period.

25 YEARS AT RIT

SAC celebrated its 25th anniversary at RIT in 1976. Faculty, staff, and students of SAC and RIT had reason to look back proudly upon a very successful debut and youth. SAC had contributed in a substantial way to the post-World War II renaissance in crafts and could claim a leading role in the growth of craft education. The School, with its initial vocational focus, was unique among educational institutions. As the field grew and changed, SAC adapted. The caliber of the faculty remained remarkably consistent. All were productive and creative professionals and a number achieved national and international recognition. Brennan and Johnston both had favored individuals with professional and industrial experience, practitioners over straight academicians.

By 1975, the program must be viewed against the many competitor institutions with craft programs. The sheer numbers of programs made it hard for any one place to claim to be the "best." Each had its own reputation built

**AILEEN WEBB AT THE SAC
25TH ANNIVERSARY EVENT**
RIT Archive Collections

around the faculty, the curriculum, location, and graduate successes. SAC's reputation lived on as former students held faculty positions at colleges and universities across the U.S. Indeed, SAC was described as one of the best places to study crafts in *By Hand: A Guide to Schools and a Career in Crafts* (1974). A 1979 article in *Upstate Magazine* ("Learning a Craft,"1979, pp. 23–24), noted that most professional schools for wood crafting were staffed by grads or former SAC faculty, including Philadelphia College of Art, RISD, Boston School of Artisanry, and the Atlanta School of Art.

Craftspeople saw themselves as artists, whether producing dinnerware or abstract sculpture. The numbers who had entered the university system were much freer to experiment with materials and ideas, without the constraints of industry or buyers. Koplos and Metcalf speculated an "academic bias toward exhibition work rather than everyday objects may have set the scene for the intense experimentation that began in the 1950s" (Koplos and Metcalf, 2010, p. 255). This also brought about a flowering of new ideas flowing into crafts from multiple sources—from the other arts, other cultures, and historical processes. The administration, students, and faculty at SAC were certainly aware of and partook of these developments.

SAC owes its existence to Aileen Osborn Webb. She was its driving force in the 1940s and 1950s and it was her vision, administrative skills, and perseverance that created the American Craftsmen's Educational Council, the American Crafts Council, and eventually SAC. The School's early association with her contributed to SAC's reputation. The American Crafts Council brought disparate groups together and gave them a national organ—the magazine *Craft Horizons*, which reviewed major exhibitions, highlighted work by national and international artists, and raised the discussion of crafts to a level on par with the traditional fine arts of painting, sculpture, and printmaking. Her name is indelibly linked to the post-World War II expansion of crafts in the United States.

Harold Brennan also must receive recognition for his key role in the success of the School during the 22 years he led SAC. He worked ceaselessly to build a program that set high creative and academic standards, but also was relevant and responsive to changes in the field. He wisely chose an extremely talented and creative faculty. His intelligence, enthusiasm, and administrative skills made SAC a superior program that brought it to the attention of the field.

Giving the final word to Webb, her speech at the 25th anniversary of SAC at RIT urged the gathering to:

> Move in the vanguard of what the world is pushing you toward. If you do that, I think that the School and the graduates of the School will be a tremendous force throughout this country, standing foursquare and meeting the needs of their times, a great many years from now, just as they are doing today. (Webb, 1976, p.72)

REFERENCES

Bolger, Denise (1979, February 25). "Learning a Craft." *Upstate Magazine*, pp.18–23.

Bonham, Roger D. (1973, May). "Rochester Institute of Technology." *Ceramics Monthly*, 21, pp. 21–23.

Brennan, Harold (1956, January/February). "American Craftsman: 1956." *Craft Horizons*, 16, p. 9.

Brennan, Harold (1958, June/July/August). "Three Rochester Craftsmen." *American Artist*, 22, pp. 37–43, 87–90.

Brennan, Harold (1960a, Summer). "The Education of the Creative Craftsman." *Handweaver and Craftsman*, 11, pp. 13–14, 62–63.

Brennan, Harold (1960b, May/June). "School for American Craftsman." *Craft Horizons*, 20, pp. 21–24.

Brennan, Harold (1965, May 3). Memo to staff. School for American Craftsmen. Records, RIT Archive Collections.

Brown, Robert (1980, 1981). *Oral History Interview with John Prip*, Oct. 20, 1980 and Nov. 21, 1981. Archives of American Art, Smithsonian Institution. Retrieved from http://www.aaa.si.edu/collections/interviews/oral-history-interview-john-prip-12771

Brown, Robert (1981). *Oral History Interview with Wendell Castle*, June 3 and Dec. 12, 1981. Archives of American Art, Smithsonian Institution. Retrieved from http://www.aaa.si.edu/collections/interviews/oral-history-interview-wendell-castle-13011#transcript.

Bulletin of the School for American Craftsmen, 1950/1951. (1950). Rochester, NY: RIT.

Converse, Margaret (1970, October 18). "A Conversation with RIT's Retiring Dean Harold Brennan." *Upstate Magazine*, pp. 32–37.

Cooke, Edward S. (2003). *Oral History Interview with William Keyser, Jr.*, April 25 and May 2, 2003. Archives of American Art, Smithsonian Institution. Retrieved from http://www.aaa.si.edu/collections/interviews/oral-history-interview-william-keyser-jr-13114

Coyne, John and Hebert, Tom (1974). *By Hand: A Guide to Schools and Careers in Crafts*. New York: E.P. Dutton.

Cumming, Paul (1970). *Tape-recorded Interview with Mrs. Vanderbilt Webb at her Apartment: 340 East 72nd Street, New York City, May 7, 1970*. Unpublished manuscript. American Crafts Council Library.

Ellingson, Mark to Aileen O. Webb. (1949, May 23). Personal communication, RIT Board of Trustee Minutes, RIT Archive Collections.

Gold, Donna (2001). *Oral History Interview with Jere Osgood, September 19 and October 8, 2001*. Archives of American Art, Smithsonian Institution. Retrieved from http://www.aaa.si.edu/collections/interviews/ oral-history-interview-jere-osgood-13109

Johnston, Robert (1973). Annual Report, College

of Fine and Applied Arts, 1973. Unpublished manuscript. Annual Report Collection, RIT Archive Collections.

Koplos, Janet and Metcalf, Bruce (2010). *Makers: A History of American Studio Craft*. Chapel Hill: University of North Carolina Press.

McDevitt, Jan (1964, March/April). "The Craftsman in Production: A Frank Discussion of the Rewards and Pitfalls." *Craft Horizons*, 24, (2), pp. 21–28.

"National Crafts School" (June 21, 1949). *Times-Union*, n.p. Scrapbook Collection, RIT Archive Collections.

Pearson, Ronald (1962, July/August). "Young Americans 1962." *Craft Horizons*, 22, (7), pp. 10–21.

Rochester Institute of Technology. (1949, June 27) Minutes, RIT Board of Trustees.

"RIT's SAC" (1970, Dec. 24). *Greece Post*, n.p.

School for American Craftsmen (n.d.). [Catalog]. Hanover, NH: American Craftsmen's Education Council.

School for American Craftsmen (1948). Catalog 1948–1949. Alfred, NY: Alfred University.

"School for American Craftsmen: 25 Years at RIT" (1976). *RIT: A Publication for Alumni and Friends*, January/February, pp. 4–5 .

Slivka, Rose (1964, May). "The American Craftsman 1964." *Craft Horizons*, 24, (3), pp. 10–11, 32–33, 112.

Slivka, Rose (1970, December). "Affirmation: The American Craftsman 1971." *Craft Horizons*, 30, (11), pp. 10–11.

Smith, Leo (1972, Sept. 26). *Interview with Harold Brennan*. Oral History Collection, RIT Archive Collections.

Szabla, Joan A. (n.d.). "Made of Clay" or "Simply Sophisticated: The Ceramics of Hobart Cowles." Unpublished Manuscript, Hobart Cowles File, RIT Archive Collections.

Webb, Aileen O. (1976, February). "School for American Craftsmen Twenty-Fifth Anniversary." *Craft Horizons*, 36, (1), pp. 40–43, 71–72.

Webb, Aileen Osborn to Drake, W. Ellis (1948, Nov. 9). Personal communication. Archives and Special Collections, Alfred University.

Young Americans 1969. (1969). New York: American Crafts Council.

BECKY SIMMONS is Rochester Institute of Technology's archivist and Art Collection manager. Her recent publications include *Past Meets Present: Recovering the History of Women at Rochester Institute of Technology, 1885–1945; View It: The Art and Architecture of RIT*; and *Encyclopedia of Nineteenth Century Photography*.

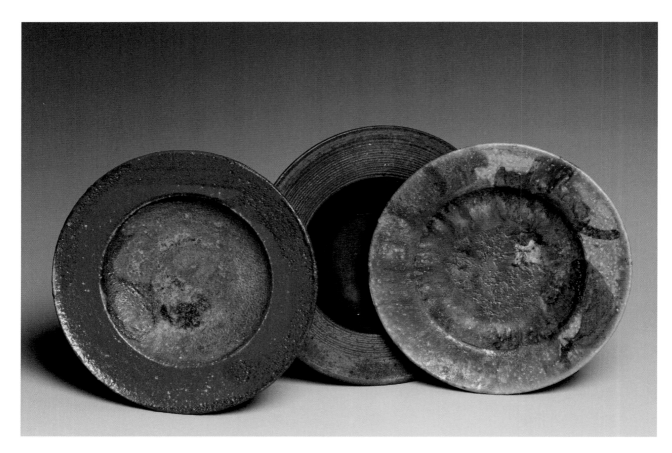

LEFT: **EARTHENWARE**
1.25 x 7.25 inches, reduction fired

CENTER: **EARTHENWARE**
1.25 x 7.5 inches, reduction fired

RIGHT: **EARTHENWARE**
1.25 x 7.25 inches, reduction fired

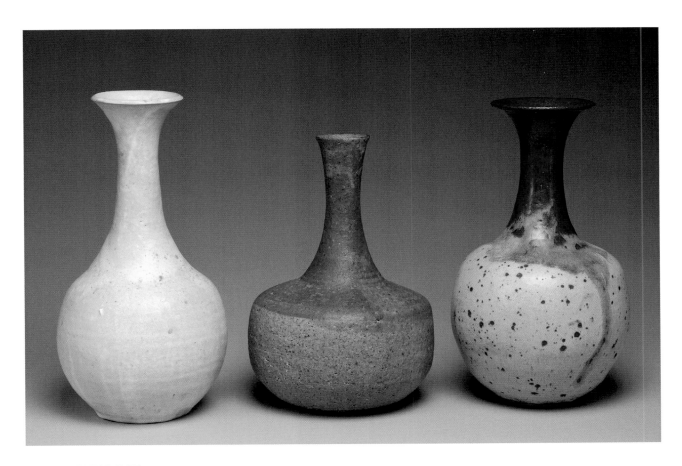

LEFT: **EARTHENWARE**
13.25 x 6.75 inches, oxidation fired

CENTER: **EARTHENWARE**
11.25 x 7.5 inches, reduction fired

RIGHT: **EARTHENWARE**
12.75 x 4 inches, reduction fired

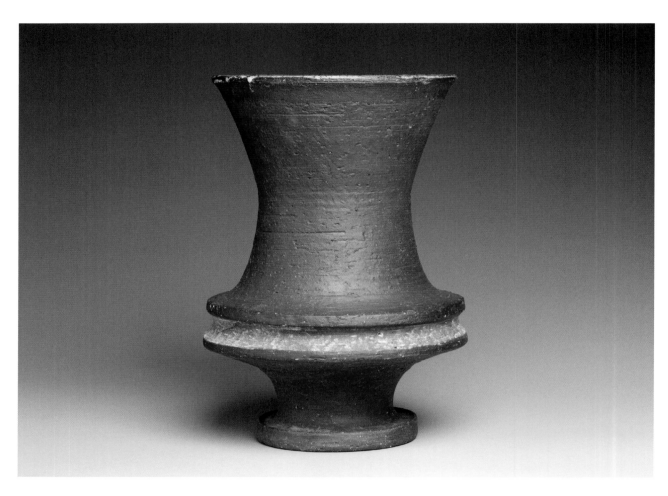

EARTHENWARE
11.5 x 7.75 inches, reduction fired

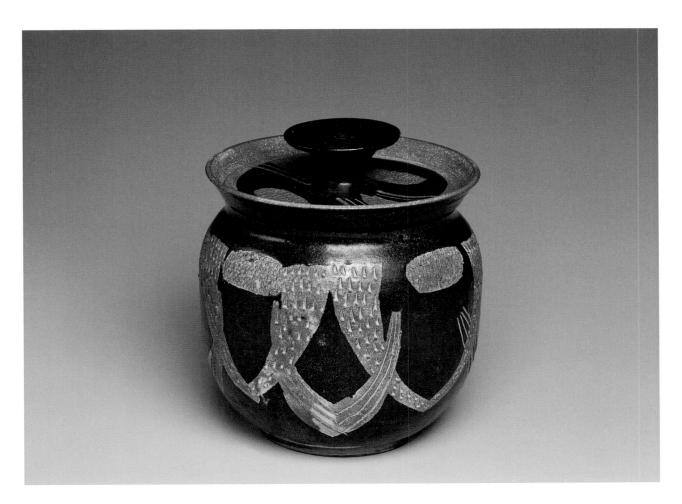

EARTHENWARE
7.75 x 6.5 inches, reduction fired

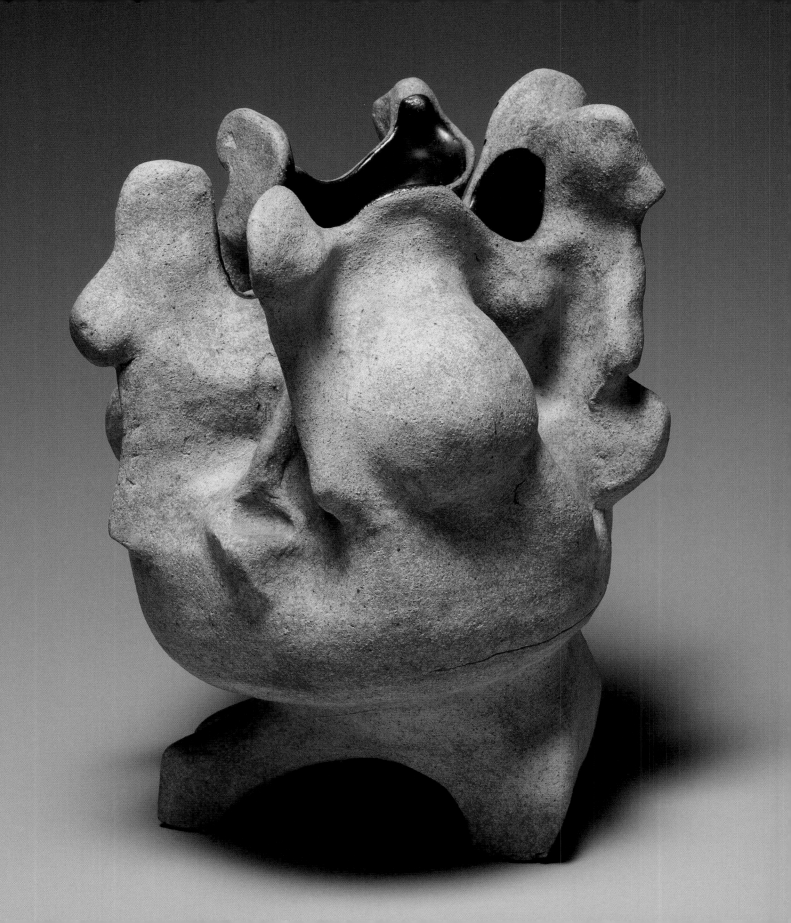

4

"NO MEDIUM FOR THE CRAFTSMAN UNSURE OF HIMSELF": STUDIO POTTERY AFTER WORLD WAR II

JONATHAN CLANCY

There is no material more satisfactory than clay; and no material can be more dangerous. A facile medium, immediately responsive, it allows more than most for trite and immediately pleasing effects. Mistakes can be hidden—too easily—under unrelated decoration. In other arts subject-matter may give strength and interest, at least for a time; in a basically abstract art like pottery, it cannot. Clay is no medium for the craftsman unsure of himself. (Mary and Edwin Scheier, 1953, p.4)

Mary and Edwin Scheier's 1953 reflection on the state of contemporary American Studio pottery contains the germs of many ideas that shaped ceramic practice in the second half of the 20th century. The rejection of "trite and immediately pleasing effects" was a clear break from many tenets of the Art Deco movement, which reveled in surface decoration and glitter. Of equal significance was

EARTHENWARE
12.25 x 11.5 x 9.75 inches, reduction fired

their insistence that ceramics was fundamentally an abstract art that required strategies of representation different from the traditional fine arts of painting and sculpture. Lastly, their conception of the craft as a means of self-expression ("no medium for the craftsman unsure of himself") was an idea that took on increasing importance as the century progressed. Frans Wildenhain worked within this broadly conceived movement. This essay frames the boundaries of ceramic productions within the United States so that a richer appreciation of Wildenhain's position within the field emerges.

Describing the practices of ceramists at mid-century in terms of a cogent movement or united field is a difficult task. Separated by geographical regions and ideological predilections, the notion of an artistic movement defined by formal qualities quickly becomes impossible. In hindsight, the varied strategies employed by potters in this period read as a reaction, whether consciously or not, to the glitz and glamour of the Art Deco period that preceded it. The Art Deco movement embraced an aesthetic of refinement, a turn toward the exotic, and an exuberant celebration of metropolitan glitter, but these ideas and decorative trends held less aesthetic value to potters' work by the late 1940s into 1950s. Whereas jazzy, precise designs preceded much of the fine and decorative arts in the decade before the Second World War, in those that followed, there began

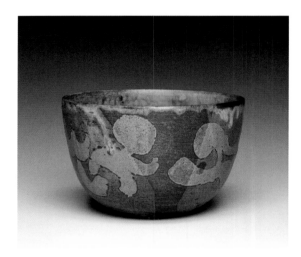

EARTHENWARE
4 x 6 inches, oxidation fired

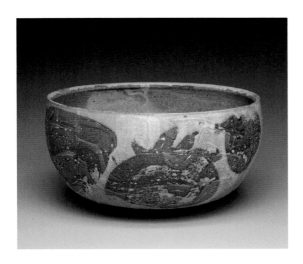

STONEWARE
6.75 x 11.25 inches, reduction fired

a distinct move away from this. As a whole, mid-century ceramists tended to employ simplified, often abstract decoration, an earthier palette in their glazes, and at times a deliberately rustic feel to their works. They rejected the decoration and luxurious materials that typified the work of the earlier generation. Although their strategies for achieving these goals and the processes they employed varied considerably, post-war studio ceramists generally favored an aesthetic that ran against the machined perfection of consumer goods and spoke to notions of utility, individual creativity, and handicraft.

Post-war pottery also shared an antipathy toward the mechanized modernism that the Art Deco period celebrated. For many Americans, even those eager to recapture the exuberance of the 1920s, the period of 1930–40 made it difficult to sustain enthusiasm about the economic and social aspects of mechanized modern life. Craft, in particular, became a way to reconnect with a simpler past and to assert some modicum of stability in, and control over, a world seemingly ruled by increasing speed and frenzy. The studio movement, like the Arts and Crafts movement earlier in the century, was a multifaceted reaction to the conditions of contemporary society that was manifested in design, rather than a set of unified design principles. Following the collapse of the financial markets in 1929, the disastrous drought and dust bowl—widely

attributed to the scale of mechanized farming in the Midwest—and finally the vast loss of life in World War II, it is no wonder that a generation that previously had embraced the benefits of mechanized modern life would seek comfort in handmade and individual items.

PRECURSORS: CERAMICS AND CERAMIC EDUCATION BEFORE THE WAR

In rejecting the decorative and ideological tenets of the Art Deco movement, some American ceramists looked to the Bauhaus functionalist aesthetic and the clean lines of the modernist International Style. Arriving in the United States through both direct contact and indirect channels such as publications and exhibitions, this style remained an option for studio potters before and after the war. The emigration of talented ceramists such as Austria's Gertrud and Otto Natzler and Germany's Marguerite Wildenhain, all of whom came to America to escape Hitler's expansion across Europe, provided a direct channel for these ideas to be transmitted. These artists, steeped as they were in the European modernist aesthetic, produced elegant, simple shapes, and directed their energies toward glazes and functionality.

The Natzlers were among the earliest prominent potters to arrive in the United States as a result of Nazi expansion. The couple rose to prominence following their silver medal award at the Paris Exposition in 1938, news

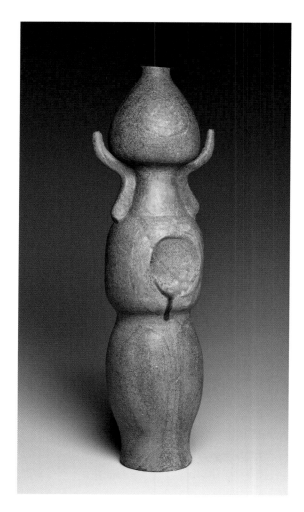

STONEWARE
17.75 x 5 x 4 inches, soda fired

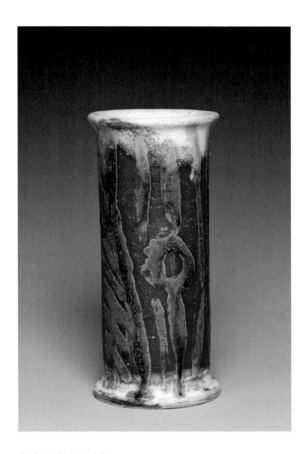

EARTHENWARE
9.25 x 4.25 inches, oxidation fired

of which they received in the morning mail on March 11, 1938 ("Artist Potters," 1939).[1] Unfortunately, any pride they felt in their achievement soon was overshadowed by the annexation of Austria by Hitler, and the arrival of German troops into Vienna later that very evening. The Natzlers were comparatively lucky; they secured passports within six months and made their way to the United States, eventually setting up in Los Angeles. Both carried the maximum amount of cash allowed by Nazi law—12 dollars—but they brought their pottery wheel, too, and soon were among the important studio potters in America. In an unprecedented string of successes, the couple's ceramics took first prize in the Ceramics National in 1939, 1940, and 1941.

Their arrival in the United States helped define an aesthetic for pre-war ceramics and the couple remained a vital force in American ceramics throughout the post-war period. Essentially self-taught, the couple perfected the use of simple, dignified forms—vessels with paper-thin walls thrown by Gertrud—covered in Otto's masterful and often complex glazes. As Otto wrote in 1966: "Our aim has been purist: we limit ourselves to form and its organic integration with the glaze. There are no unnecessary dramatics, no superficial ornaments, no superimposed deformation" (Natzler, 1966, preface). Through exhibitions and illustrated examples of their work, their aesthetic remained popular well into the 1950s and '60s. In addition to bringing a new style of potter's wheel that afforded a new control of throwing

pots to the emerging California ceramics movement, the couple also helped foster the skills and careers of many other ceramists, such as Beatrice Wood and Laura Andreson, both of whom took lessons from Gertrud in the 1940s to strengthen their skills on the wheel.

Equally important to the ceramics of this period was the arrival of Marguerite Wildenhain, who fled Nazi Europe and settled in the United States by 1940. Trained in the Bauhaus aesthetic, Wildenhain worked under Gerhard Marcks and Max Krehan until the school moved from Weimar to Dessau in 1926, when she left to head the ceramics department at the Kunstgewerbeschule in Halle-Saale. By 1933, when it was evident that nowhere in Germany was safe for either Jews or artists, she and Frans moved to Holland and opened their own pottery. This venture proved to be short-lived as well; the increasing German aggression throughout Europe soon made Holland a target for the Nazis. Wildenhain, because of her French passport, was able to leave before the invasion of Holland on May 10, 1940.

Eventually settling in California, Wildenhain in 1942 joined Pond Farm, an artists' colony established by Gordon and Jane Herr to the north of San Francisco. Her refined Bauhaus aesthetic and insistence upon the functionality of vessels were a touchstone for many ceramists throughout her long and varied career, and her arrival in California in the 1940s helped secure the reputation of the West Coast as a vital center of American ceramics. Describing her work in an exhibition at Scripps College in 1945, *Los Angeles Times*

art editor Arthur Miller wrote: "Smash hits of the show are the superb stoneware pieces by Marguerite Wildenhain of Guerneville All her work shows strength refined by taste" (Miller, 1945, p. C1). Even as late as 1981, Robert Arneson—the father of Funk ceramics—referring to her as "the grand dame of ceramics," recalled his pilgrimage to meet her as his career was starting, and the clarity with which she made him consider his options: "Are you going to be a teacher or a potter, young man? You better make up your mind. You can't do both" (Arneson, 1981). Although none of her students would achieve her level of recognition, Wildenhain remained someone to whom ceramists of virtually all interests and persuasions continually sought advice; she was the consummate craftsperson, and a lifelong advocate for ceramics education. Wildenhain's importance to mid-century pottery lies in her strength as a technician and advocate for the craft of ceramics, more than in the enduring presence of her Bauhaus aesthetic. In hindsight, however, her teaching philosophy could not foster the type of self-expression that dominated the field in the second half of the century.

In contrast to those driven from Europe by the Nazis, Finnish-born Maija Grotell came to the United States well before the war, arriving in 1927 with the hope of finding economic opportunities not available to her in Finland. A relentless worker, Grotell's early career brought opportunity and recognition. A full decade before she accepted the position at Cranbrook Academy of Art, for which she is best known, her impact was evident. Adept with the wheel—a

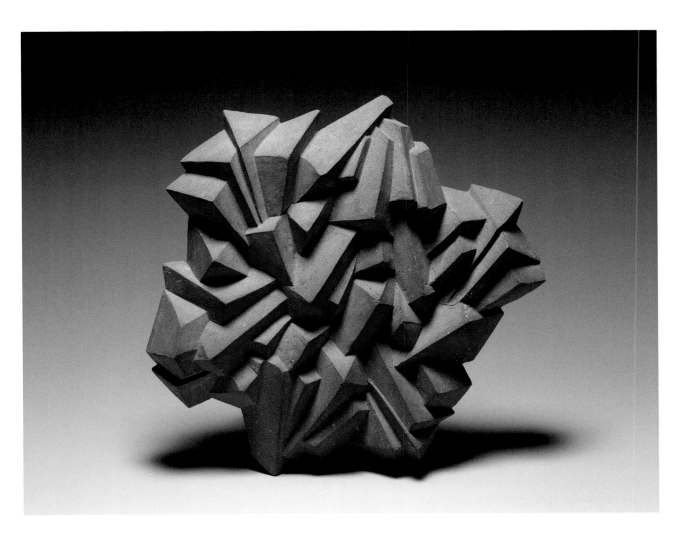

STONEWARE
20 x 20 x 3 inches

rarity at the time—Grotell quickly rose to prominence both as a teacher and artist. She became the first art instructor at the Rutgers School of Ceramic Engineering, received a certificate of excellence in Cleveland in 1931, and two years later received an "honorable mention" at the Ceramics National in Syracuse (Eidelberg, 1983, p. 220). In September 1938, she joined the Cranbrook Academy as professor of ceramics.

Grotell, perhaps more than any other instructor of the period, developed a teaching method at Cranbrook that fostered individual self-expression and produced an impressive roster of students who worked in a variety of styles. In contrast to Wildenhain's narrow aesthetic vision, Grotell encouraged students to develop their own styles— even to the point of hiding her own work from them—and promoted ceramics as a vehicle for self-expression. Although her style was formed in the decades before the war and did not react much to developing trends, her ability to recognize talent in her students made her among the most important teachers for the development of ceramics in this era. Leza McVey and Toshiko Takaezu, both students and assistants of hers, would evolve into important ceramists on their own after working with her.

BERNARD LEACH: TRADITION, CRITICISM, AND THE STRUGGLE FOR INNOVATION

American potters and students have also asked me for practical criticisms of their work. There seem to be certain weaknesses which are widespread—handles which are

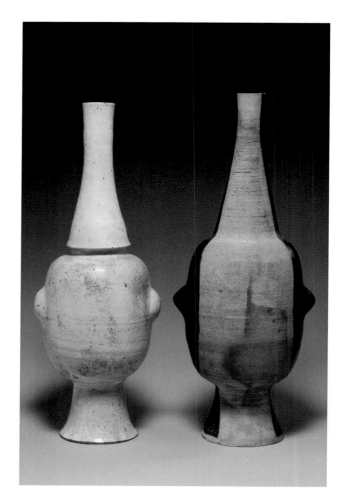

LEFT: **EARTHENWARE**
28 x 8.75 x 9.5 inches, reduction fired

RIGHT: **EARTHENWARE**
29.5 x 9.5 x 10.9 inches, reduction fired

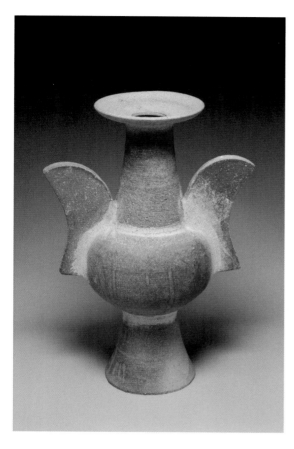

EARTHENWARE
18.25 x 12.5 inches, reduction fired

obviously stuck on ... teapot spouts which are either goiterous or camel-like The major thrown forms often strike me as unarticulated and uncertain (Bernard Leach, 1950, p. 19)

Despite the strength of teachers and exhibitors in the United States, critical reception of the American Studio Pottery movement throughout the 1950s was decidedly mixed. Practitioners and critics seemed aware that a new aesthetic was emerging in the post-war period, but opinion was divided as to its merit. It was during this period that Bernard Leach, an influential English ceramist and author, emerged as the most vocal critic of American ceramics. Following his 10-week visit in 1950 and a four-month tour throughout the United States in 1952–3, Leach authored a series of articles dismissive of American pottery. His first critique came in the article "American Impressions" published by *Craft Horizons* in the winter of 1950:

> Americans have the disadvantage of having many roots, but no tap-root, which is almost the equivalent of no root at all. Hence American pots follow many undigested fashions and, in my opinion, no American potter has yet emerged really integrated and standing on his own feet I have seen so many stoneware or pseudo-stoneware pots from coast to coast which are mixtures, Bauhaus over Sung, or Sung over Bauhaus, free form, unintegrated.

Leach professed that, "When society is in confusion or decay the artist and the potter have to find what truth and beauty they can for themselves" (Leach, 1950, p. 18–9).

But his solution, somewhat contradictorily, was not for Americans to look inward, but to look—as he had—to the East for inspiration.

If the East, for Leach and others in the period, served as the wellspring of formal artistic inspiration, equally important was the notion of the East as a polar opposite to post-war Western civilization. Through aesthetic mimicry and an adoption of methods, Leach used the East as a corrective capable of curing Western society's ills. Following his second tour, he informed readers of *Everyday Art Quarterly* of America's dangers:

> ...we have become cogs in the machine we have invented. This is most apparent in America where mass-production, speed, size and the dollar criterion have resulted in the highest ratio of nervous breakdowns, ulcers, and insanity. (Leach, 1953, p. 11)

From Leach's humanist viewpoint, pottery was not simply a reflection of a maker's talent, but a cooperative, socializing force by which to blunt the destructive march of an increasingly technical and mechanized society. "Under the pressure of fear and competition our peculiar instrument, science, has launched us into the Age of Atomic Fission and even after two world wars the existing philosophies have failed to provide man with an adequate and practical reply to brute force. We hang on the edge of the abyss hoping we may escape disaster" (Leach, 1953, p. 11).

Leach's Japonisme—restrained forms and glazes, quiet proportions, and above all a sense of functionality—emerged

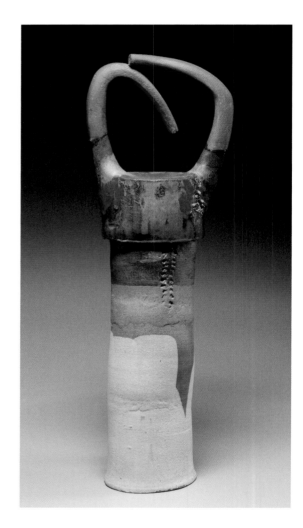

EARTHENWARE
40.75 x 13 x 6.5 inches, reduction fired

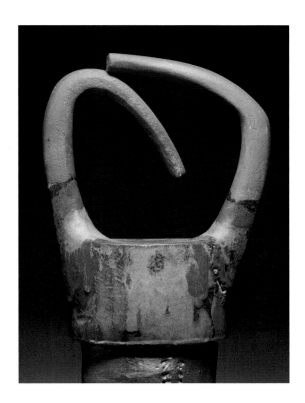

as one of the aesthetics that ushered in the post-war period in American ceramics. For some potters, such as the husband and wife team of Warren and Alixandra MacKenzie who apprenticed with him in England, his impact was evident in both decorative terms and in their process. Like Leach, they sought to ameliorate the effects of mechanization in their own work but did not necessarily advocate the abolition of all machinery. The difference that they, and many others, drew in this regard was not the use of machinery or tools, but the skills and feeling of those using them. "Let the same tool be used by a craftsman who allows the feel of his materials to control the way in which he cuts or pulls or beats with the tool and the products will bear the stamp of the human hand and mind. Working with materials rather than on them is a beginning toward an integrated hand expression" (MacKenzie and MacKenzie, 1953, p. 13). Japonisme, in this regard, stood for harmony, integration, and a quiet dignity that served as the polar opposite of a world dominated by cacophony, frenzy, and mechanization.

Leach may have believed he could alleviate the pernicious effects of society through an essentially Orientalizing fantasy, but for many American potters this historicism seemed an aesthetic dead end. Citing "one prominent potter," an editorial in *Ceramics Monthly* ("The Larger Picture," 1953, p. 9) questioned the viability of this position. "The mesmeric effect of his potter's wheel, the American reverence for mellowed English craftsmanship and a tap root transplanted to the Orient have all contributed to

a strong impact—an impact that has hushed experimental voices. While craftsmanship has improved under [Leach's] influence, and the folklore of pottery has been immeasurably enhanced, a robust quality of originality is wanting."[2] Although Leach found followers sympathetic to his beliefs in the United States, his aesthetic found increasingly less traction with the emerging group of American ceramists committed to fostering new aesthetics.[3]

Instead of Leach's criticism deterring the emerging movement or realigning it into a singular style, Americans sought diverse strategies for self-expression. Potter Leza McVey's statement in the same issue of *Everyday Art Quarterly* that featured Leach and the MacKenzies summed up the resolve of American ceramists who rejected the paternalistic tone of Leach's condemnations and saw little in his work worth following. "Ceramics," she wrote, "is a challenging and highly responsive medium—the one best suited to expressing the forms I have in mind, and the forms I feel the need of as part of my everyday visual and tactile pleasure." Describing her approach as "purely personal," she continued: "Quite frankly I am more than a little weary of the pseudo-Oriental. No vital period in history has been content to express its needs in the quotation marks of a previous period" (McVey, 1953, p. 20).

One solution to escape the deadening effects of historicism that many found in Leach's work was to embrace modern, abstract decorative technique. Pablo Picasso, who had begun experimenting with ceramics in the late 1940s, served as a model for many potters of how to integrate modern decorative impulses with traditional ceramic forms. His ceramics, or more precisely his adoption of the medium, served as a bridge between the traditional role of the potter, and that of an artist who, using ceramics as a medium, could explore his expressive potential in a way not traditionally accepted in the ceramics community.

DECORATION AND DESIGN: FINE ARTS IN CLAY CULTURE AT MID-CENTURY

In this mid-century perhaps the tide is turning again, away from the purely cold forms of the last few years to something warmer and more colorful. The individual—his likes and dislikes, the richness of his inner life, his love of his home, his ego, his selfishness if you like—will reassert himself.
(Aileen O. Webb, 1953, p.9)

In contrast to the basic tenets of the modernist movement that encouraged an absence of applied decoration in favor of clean forms and geometric patterning, some American ceramists rejected this notion in favor of decoration, applied design, and even whimsy. Unlike the geometric and cubistic surface decoration on Art Deco ceramics, potters in this period looked toward artists like Picasso, Joan Miró, and the surrealists, and to the process of automatic drawing. In so doing, they freed themselves from

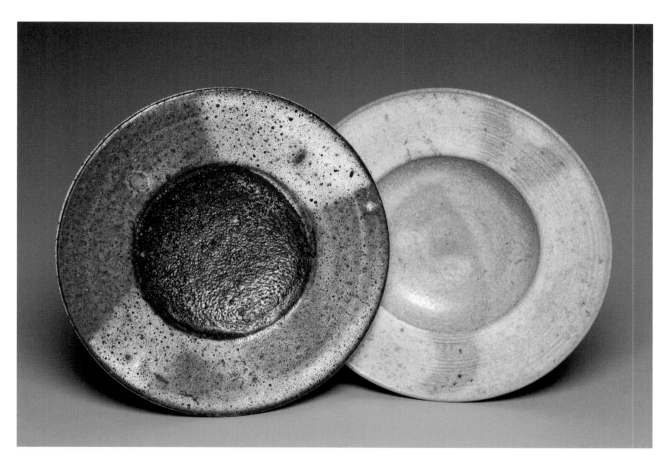

LEFT: **EARTHENWARE**
1 x 7.75 inches, reduction fired

RIGHT: **EARTHENWARE**
1.25 x 7.25 inches, reduction fired

the rigidity and rectilinear qualities that had dominated pre-war decoration, and embraced a vernacular of curving lines, biomorphic shapes, and fluidity.

Antonio Prieto (1912–67) must be counted among the most influential designers and teachers of this period. A constant presence in ceramic exhibitions until his untimely death in 1967, Prieto taught at Mills College (1950–67) and disseminated his ideas directly to students. The Spanish-born potter came to the United States in 1916 and, like many ceramists of the period, later studied at Alfred University. In 1946 he was teaching at the California College of Arts and Crafts, and by the following year had begun to establish his reputation as one of the nation's leading ceramists. He exhibited regularly at the Ceramic Nationals from 1947 until his death, and won a number of prestigious awards that solidified his position as teacher and artist. In 1952, he represented the United States at the International Conference of Potters and Weavers at Darlington Hall in England, an event organized by Bernard Leach. He was awarded a silver medal at the First International Ceramics Festival in Cannes, and later in his career was awarded a Fulbright Fellowship (Koplos and Metcalf, 2010, p. 222).

Prieto's vessels were modern interpretations of traditional forms—he often produced elongated forms with very narrow necks—but the decoration on his vessels mirrored the biomorphic curves of surrealist designs and contemporary fine art. Seemingly indebted to the work of Joan Miró, whom Prieto met in Spain later in life, and

whose work was well known through publication and print, American ceramists began to favor softer, curving lines and planar forms. Equally evident in the designs of other ceramists like Edwin and Mary Scheier (below), this aesthetic marked an important turn away from earlier decorative schemes, and an embrace of decoration that modernism generally eschewed.[4] Like many of his contemporaries, Prieto's work progressed during his career, beginning with an exploration of decorative possibilities and culminating with explorations of shape and form that were more widespread by the 1950s.

While some viewed modern art movements as the method for abstracting their designs and enlivening their work, others looked to the primitive past for inspiration. This strategy had formed the basis of many modern movements, but American ceramists often bypassed the 20th-century distillations and drank directly from the source. Already evident as a trend by the late 1940s, one reviewer noted, "American potters show the same initiative as American painters. They have learned a good deal from modern Archaeology.... Primitive gaucheness seems at this moment delectable" (Adlow, 1947, p. 6). Mary and Edwin Scheier, who were among the early adopters of this design strategy, figured prominently in its dissemination through their exhibitions and the publicity their work garnered.

Throughout their long careers, the Scheiers' work in ceramics exhibited a number of different styles—from purely utilitarian glazed wares to surrealist abstraction to totemic

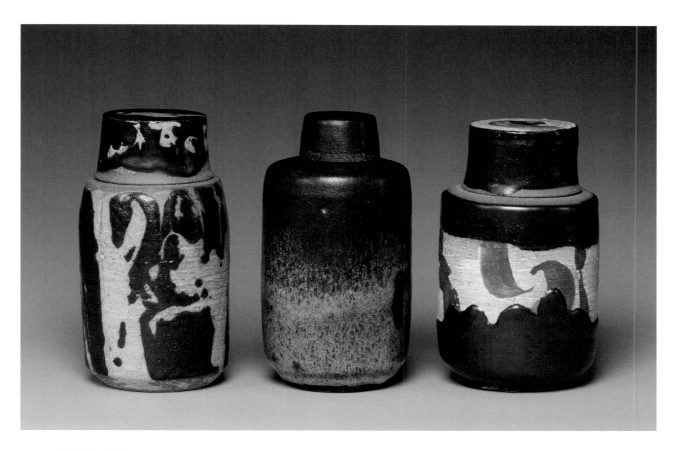

LEFT: **STONEWARE**
6.75 x 3.5 inches, reduction fired

CENTER: **STONEWARE**
6.5 x 3.5 inches, reduction fired

RIGHT: **STONEWARE**
6.75 x 4 inches, reduction fired

sculptural works—but it is their brand of neo-primitivism that endured from late 1940s until the end. Working with a formal language that drew from a number of older traditions, including folk pottery, central and south American, aboriginal, and even late-medieval Anglo-American decoration, the Scheiers produced a body of work that was both historicizing and original; primitive in feel, but modern in outlook. As the couple noted in 1953:

> Vitality cannot be acquired second hand, or by reading books. Clay requires of the artist-craftsman more than the ability to translate into something permanent the rational forms which he knows clay can assume; it demands a feeling for its primitive qualities based on a slow growth of understanding. (Scheier and Scheier, 1953, p. 5)

Eschewing the perfection of the machine through decorative elements and glazing techniques that often left a blistered, earthy surface to their wares, the Scheiers' pottery reconnected the viewer directly to a simpler past. The couple were perhaps the most prominent of potters engaged in this practice, but many contemporaries were pursuing similar investigations. Beatrice Wood, Clyde Burt, and even Antonio Prieto explored primitive decoration on their vessels throughout the 1950s.

NEW DIRECTIONS IN FORM

The mystery of an ever-changing silhouette is more engrossing than the predictable contour of a thrown piece. ("Profile: Leza McVey," 1952, p. 22)

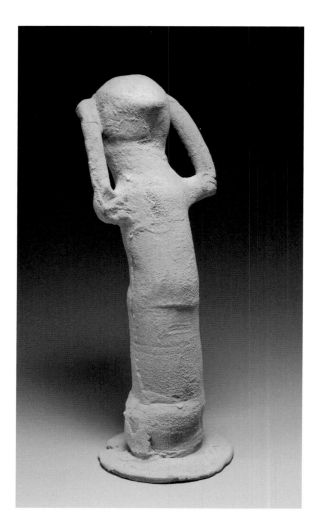

EARTHENWARE
22.25 x 8.25 inches, reduction fired

Among the most significant aesthetic developments of the post-war period for potters was a new exploration of form, a clear break from the quiet, sedate aesthetic that had dominated much of the preceding period. American ceramists in this period shifted the debate from one about decoration to the structural possibilities of clay as an expressive, sculptural force. By retaining their identities as potters rather than sculptors, they raised larger issues about the medium: Do pots need to be functional to still be considered part of the ceramic world?[5] Perhaps more importantly, was there room within the emerging movement to allow for unbridled expression of form, or was decoration the limit of a potter's experimental license?

Among the leaders of this trend, Leza McVey left a body of work and text that is essential to understanding the basis from which these impulses emerged. In rejecting both the historicism of Leach, as well as the decorative impulses—whether modern or primitive—of her contemporaries, McVey's ceramics became a formal exploration of clay's potential. As a 1952 feature on her in *Ceramics Monthly* noted: "In making each piece it is the form that receives her most solicitous attention. A glaze—or any decoration for that matter—is important only in its usefulness in revealing the basic form, is Mrs. McVey's credo." While some of her contemporaries attempted to find refuge in the past, or by assimilating the impulses of contemporary painters and artists, McVey rejected these outright:

> The form expression of our time is strong, vital, telegraphic. For artists of a period to be content to accept unassimilated the art forms of another is an indication of intellectual hibernation. To me it is more gratifying to fail miserably in trying to live [in] today's world than to succeed knowingly imitating products of the culture of some distant unfamiliar place or people. ("Profile: Leza McVey," 1952, p. 22)

Rejecting the wheel for the freedom afforded by hand-built vessels, McVey, as Martin Eidelberg (2002, p. 52) has noted, embraced a type of primitive process. Consonant with "primitive gaucheness" that the Scheiers and others pursued, McVey's method differed by transforming the structure of the vessel rather than simply applying decoration.

While McVey's work represents the most consistent exploration of form during this period, similar impulses were evident in other potters as well. During the early 1950s, Hawaiian-born Toshiko Takaezu, also a student of (and later apprentice to) Maija Grotell at Cranbrook, began crafting multi-spouted vessels that also embraced asymmetry and spoke to notions of craft as a rejection of the mechanized world. At the first Annual Meeting of the American Craftsmen's Council, held in Asilomar, California, in June 1957, she made her position clear:

> In a mechanized age where basic human warmth and the human element is non-existent, there is a vital need for the handcrafted object. Craft work is a necessity for it is a means by which men can search for an expression of individual ideas. Craftsmen are

in a position to create and experiment and not feel bound by mass production. (Ball, 1957, p.11)

Unlike McVey, Takaezu continued to use the wheel as the basis of her productions, preferring to assemble wheel-thrown forms into multipart constructions, rather than building by hand. In contrast to sculptors working with the medium—for whom functionality and self-expression were settled issues—ceramists in this period challenged traditional ideas of form and production and thus questioned what direction the movement should follow. The formal language that McVey and Takaezu helped bring about remained evident in the works of potters like Thomas Ferreira, Henry Takemoto, Robert Sperry, Clyde Burt, and the early work of Hui Ka Kwong, throughout the 1950s.

Although the crux of the argument Leach raised—what pottery should look like and from where it may draw inspiration—was important to American potters in the post-war period, it was a small piece of a broader discourse about the relation of the crafts to the traditional fine arts. By insisting that self-expression was an inherent right of form and design, artists like the Scheiers, Leza McVey, and others dissolved the traditional boundaries and sought to elevate craft to the same intellectual and aesthetic level as the fine arts. Many opposed this, favoring the traditionalist position of Leach, who viewed craft primarily as a process of production, rather than as a vehicle for self-expression. As he described in *Everyday Art Quarterly*, "the unfettered imagination of the artist, or even craftsman, is let loose in a world of phantasmagoria; resulting in a narcissism referred to as 'the ivory tower'" (Leach, 1953, p. 11). Even more damning was Herwin Schaefer's assessment of crafts that *College Art Journal* published in the spring of 1958. Like Leach, he saw the issue in terms of production: whereas fine art was a field immune to the forces of the markets and machines, the crafts—in Schaefer's argument—needed to compete directly with these. "The artist-craftsmen of today," he claimed, "realize they cannot compete with industry in producing the really necessary and useful objects of daily life, and so they concentrate on 'creativeness' and 'originality' This activity leads into a sort of no man's land between that of the real artist who has something to say, and the designers and workers in industry who have the job of producing the really useful objects of daily life" (Schaefer, 1958, p. 270). Schaefer's dislike of the intellectual and aesthetic developments potters were exploring during the 1950s boiled over by the article's end. "The craftsmen of today," he opined, "may delude themselves that their objects will be the 'heirlooms of tomorrow,' but in reality most of them are producing the knick-knacks of today which will be the rubbish of tomorrow" (p. 270). For many, craft was a skill-oriented pursuit that had no business entering into the conceptual or expressive realms reserved for fine art.

As this period took shape, ceramists were divided between those who favored functional objects, and those who viewed the medium as a vehicle of self-expression. Curiously, while clay found acceptance as a medium for

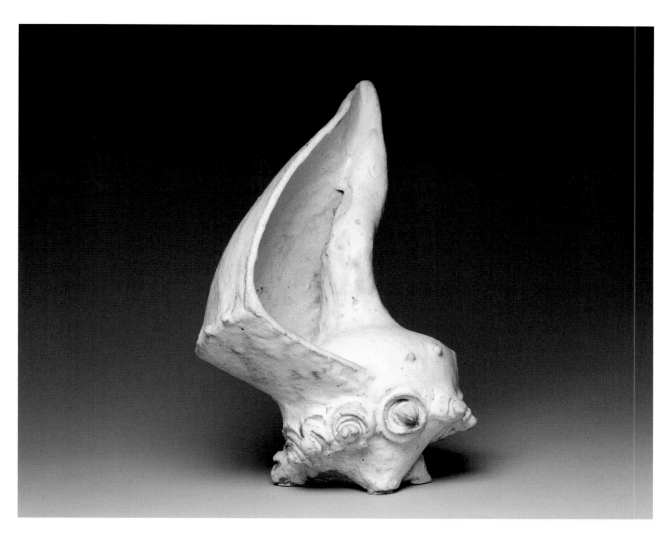

STONEWARE
13.5 x 9.5 x 5.75 inches, reduction fired

sculpture, as in Isamu Noguchi's *Nurse* (1936) or Louise Nevelson's *Moving—Static—Moving Figures* (1945), ceramics had a more difficult time gaining traction as art objects. Writing for *Ceramics Monthly* in 1954, Ohio State Professor of Ceramics Carlton Atherton lashed out against what he saw as "an indication of the self-assertiveness of potters." Atherton asked readers: "Are we losing our integrity, or is it that we are simply losing sight of what pottery is and just playing at pot making? Such directions can hardly produce anything more than superficial dilettantism and defile the dignity of one of the oldest professions" (Atherton, 1954, p. 8). Similar objections were raised later in the year by Paul Bogatay, a juror for the 18th Ceramic National Exhibition in Syracuse: "Pottery forms from pints to gallons, characterized by necks, some too small to accommodate a pencil, were present by the dozen—many of them difficult to defend as either pure form or as 'useful pots to put things in'" (Bogatay, 1954, p. 12).

The building tension between potters who considered themselves potters and those who considered themselves artists was a driving force in the transformation of aesthetics in the post-war period. If glimmers of a resolution appeared in the forms of McVey, Takaezu, and others, it was a subsequent group of potters, Peter Voulkos and the Otis Group, who obliterated the rifts once and for all. Their contributions, which are so overwhelming and sudden, all but obscure the gradual shift that was taking place, and erase some of the lesser-known contributors. Among the

figures often neglected are artists like William Daley, whom *Ceramics Monthly* described as "one of those potters who regard themselves artists, and insist that their pots deserve the serious attention we accord without question to paintings or sculptures" (Olitsky, 1956, p.17). Daley's position, which was emerging simultaneously with that of the Otis group, allows us to consider the contributions of Voulkos not in artistic isolation but as part of a broader dialogue that was permeating American ceramics at the time.[6]

VOULKOS AND THE OTIS GROUP: FURTHER EXPLORATIONS OF FORM AND EXPRESSION

When people talk about a set of values or a list of principles to govern design in pottery, I feel like perhaps I need to apply for a license before I can make any pottery. I don't like to stick to rules for working. How can I say what I am trying to do?.... We just make what we like. It's part of our lives We just want to be left alone to work. Function? What does it mean? It depends entirely upon who is looking at a pot to decide the function of a pot. (Peter Voulkos, in Ball, 1957, p. 12)

Peter Voulkos (1924–2002) looms large as a figure in 20th-century ceramics. By effortlessly knitting together the various trends available to potters in this period—from Japonisme to contemporary design to innovative explorations of form—Voulkos infused ceramics with the energy of the abstract expressionists and fundamentally altered the field. With Voulkos, it was as though the

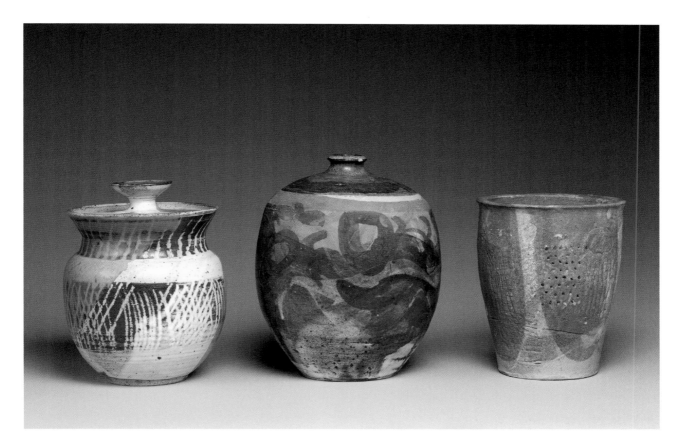

LEFT: **EARTHENWARE**
8.25 x 6.25 inches, reduction fired

CENTER: **EARTHENWARE**
9 x 6.25 inches, reduction fired

RIGHT: **EARTHENWARE**
7.75 x 5.25 inches, reduction fired

culmination of the disparate parts of the emerging movement finally came together into a singular, energetic conclusion. Form, color, scale, and design were no longer separate issues to be explored, but rather tools to be used in concert as a means toward a deeper exploration in a quest for self-expression. Evident by 1956 in his *Rocking Pot* (Renwick Gallery), Voulkos obliterated the line between artist and potter, between high art and craft, and between form and function that previously had caused so much consternation in the field. As an iconic piece of ceramics, *Rocking Pot* is an amazing achievement. It is made more so by the speed with which Voulkos entered and transformed the ceramics world.

Born in Bozeman, Montana, to immigrant parents in 1924, Voulkos never set out to work in clay. Like many soldiers who had served in World War II, it was the GI Bill that enabled him to afford college. The Army's vocational tests suggested he should try a manual skill, so Voulkos studied commercial art at Montana State College. In order to graduate, the school required him to take a two-credit course in ceramics; after three years of avoiding the class, he took it in 1949. The results were startling and immediate: Voulkos took to the medium instantly. In the following year's Fifteenth National Ceramic Exhibition at the Syracuse Museum of Fine Arts, he was awarded a first prize; he had been potting for one year.

Voulkos's early work demonstrated a mastery of the medium and exhibited a number of the trends already being explored by his contemporaries, notably an affinity for Asian designs and the modern and primitive decorative work of Prieto, the Scheiers, and others. By all accounts he voraciously absorbed information, seeking out galleries, periodicals, and virtually anything else that he could look to for inspiration. His transition—from a talented traditional potter working in a modern style to an avant-garde ceramist—was as sudden and thorough as the speed with which he mastered the medium. The turning point appears to have been his invitation to give a three-week workshop at Black Mountain College in the summer of 1953. There, surrounded by the likes of John Cage, Merce Cunningham, and Robert Motherwell, Voulkos was immersed in an environment of self-expression, experimentation, and abstraction. Before returning to Helena, he visited New York, where he met and saw the works of Franz Kline. As Rudy Autio, who was then working with Voulkos at the Archie Bray Foundation, later recalled: "He came back ... but he was never the same again" (Slivka, 1978, p. 16). Within the next few years he would almost singlehandedly transform the creative potential of American ceramics. His work was gestural, vigorous, and bold, concerned as much with the process of construction as with its results.

In addition to the formal language that Voulkos introduced to ceramics, his role as a teacher influenced a number of important ceramists who trained with him.[7] Voulkos had been giving workshops and teaching in the early 1950s, but this was not his primary vocation until 1954,

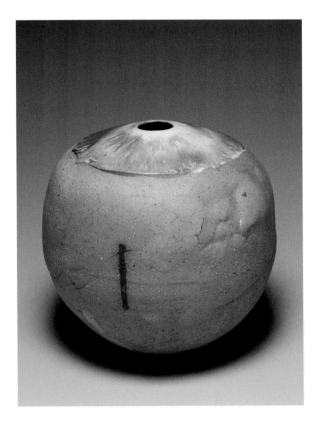

STONEWARE
14.5 x 13.25 inches, reduction fired

when he was hired by Otis to build a ceramics program for the school. At Otis, he led a legendary program that relied on inspiration, experimentation, and camaraderie more than a rote plan of teaching skills to his students. His students' works—Paul Soldner's for example—tended to expand upon the formal language of his own. They often were large constructions that defied easy classification, hovering somewhere between the pot and sculpted form, with a masculine expressive strength. The group's work often was crude and raw, deliberately so, and spoke to the expressive power of the handmade in a world in which mechanization and serial production were dominant forces.

Voulkos's and his students' works created a clean break with the traditional notions of ceramics that allowed for further experiments pushing the envelope. As throughout much of the second half of the 20th century, California remained the center of ceramic innovation and production. With the Voulkos group essentially ending any debate about the possibilities of form, the next movement that emerged explored taboo subjects and challenged distinctions between high art and low. If the Voulkos group succeeded in demanding for ceramics the credibility usually reserved only for fine art, the next wave would seek to reverse this entirely.

FUNK, POP, AND CERAMIC SUBVERSION

Arneson is where the movement starts, with credit to the slightly older Voulkos for establishing a new form. In 1958, Arneson showed his urinals and toilets at the Stone Gallery,

New York. Today, they're no less shocking and no less beautiful [His] sculpture is so preposterously ugly it escapes ugliness utterly. (David Zack, 1969, p. 28)

There are crudities that utilize no wit, a very few of which may be effectively jarring, ugly. In fact, most of this show isn't anti-art, it's just bad art. It's too murky to be good anti-art. (Gregory McDonald, 1967, p. A16)

In contrast to the Otis school of Voulkos, which explored ceramics as an abstract expressionist idiom—subversive in the context of the medium, but acceptable as a means of artistic expression—the ceramics that emerged as a result of Robert Arneson's influence at the University of California, Davis were socially subversive, challenging the boundaries of taste and propriety. Although some critics reveled in the seemingly boundless energy this new movement embodied and rightly sensed a new direction emerging in ceramics, others found it abhorrent.

Arneson's early career was steeped in traditionalist ideas about ceramics, shaped largely by his studies with Antonio Prieto, and gave no indication of the profound shift his work would undergo in the 1960s. In fact, during the early debates surrounding the developments of Voulkos and the Otis group's work, Arneson wrote to *Ceramics Monthly* suggesting that the magazine "print an article on 'What Constitutes Good Pottery,' and have a group of artist-potters contribute their beliefs" (Arneson, 1957, p. 4). Within a few years, however, he converted and worked

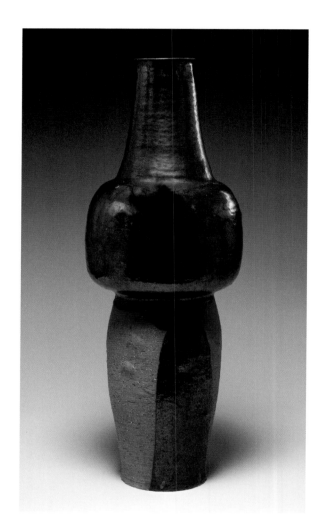

EARTHENWARE
28.25 x 10 x 4 inches, reduction fired

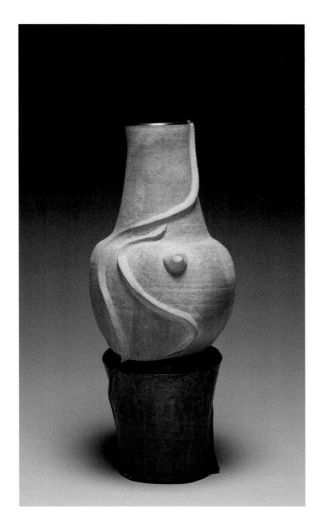

EARTHENWARE
22 x 9 inches, oxidation fired

essentially in the Voulkos style. Despite a deepening rift with Prieto over this transformation, Arneson began to have increasing success. By 1962, he had joined the faculty of UC Davis and was charged with developing a ceramics program, located in a temporary building on campus known only as TB9.

At Davis, Arneson cultivated a cadre of students who worked in a figurative style that has come to be known as Funk. Drawing inspiration from pop art, surrealism, and dada, Arneson and his students—David Gilhooly, Margaret Dodd, and others—crafted works that transformed everyday, often banal objects into objects of humor and cultural critique. Arneson's first efforts—perhaps influenced on some level by his friendship with Wayne Thiebaud—were food-related. During the summer of 1961, while working at the California State Fair with Prieto, he and a friend, frustrated by the attention and free dinners Prieto received, began making their own dinners out of clay. Although most of the work was broken the next day, largely in deference to Prieto's anger upon seeing it, Arneson later recalled saving some of the work, including *No Return*, a quart-sized beer bottle.[8] The title's purpose was twofold: referencing the text found on bottles (though missing from Arneson's) and signaling Arneson's desire to escape the language of abstract-expressionism and forge his own path.

Although *No Return* became a symbol of Arneson's commitment to push the boundaries of the movement forward, he later admitted that it was not until he created his

first *John* that this transformation was complete. Recalling his struggle to escape the shadow of Voulkos's work and establish a distinct and individual artistic presence, Arneson told Madie Jones in 1981:

> I really thought seriously about what were the ultimate ceramics in Western culture. I was thinking about this one day while I was taking a crap in "TB9" and my old knuckles knocked on the pot and I said, "Hey man, you're on it. This is it. This little pot has no heritage. You can't reflect on art in any way on this thing. And it is 100% ceramic, man. This is it, and you're just going to have to cut loose and let yourself go." So I actually pursued that and I made a toilet. I cut myself loose and let every scatological notation from my mind flow freely across the surface of that toilet I was making. This was 1963. And God, it came out fantastic. (Arneson, 1981)

Whereas earlier potters, like Prieto, had incorporated the Surrealistic motifs of Joan Miró and others into the decorative scheme of their vessels, the Funk potters embraced Surrealism from a structural vantage point, using clay to craft sculptural objects that brought a tangible presence to the musings of their unconscious. At times, their works were highly personal, almost inscrutable, like one-liners that exist outside of any recognizable context or referents. Part of Funk's mission was undoubtedly humor and shock, but the visual qualities of the work, the overlapping layers of biography (both imagined and actual), the punning,

and the violence one finds in these works seems to indicate a deeper basis than even Arneson was willing to explore.

> I always felt my work should bring laughter and joy and [be] high-spirited—that's what my art's about. You don't have to be a student of art history to get through my stuff at all. It's all out front, it's all up front as well. I want to leave you with a belly laugh. It's got to be serious, too. You kind of straddle the line there. (Arneson, 1981)

A close visual analogy for Arneson's *John with Art* (1964) that suggests the possibility of a deeper reading of his works might be found in Rauschenberg's *Bed* (1955, MoMA), which also transformed an everyday object through paint and process.[9] Similarly, the study of Dada's use of humor and subversion as a cultural construction may be a useful starting point for a deeper understanding of the strategies employed by these artists.

As abstract expressionist and Funk pottery expanded the boundaries of both form and message, some artists found new and novel ways to again transform the medium and push it further. Following the lead of the emerging Pop movement, and in contrast to the Otis and UC Davis groups, Pop ceramists embraced a cleaner craft aesthetic, while infusing their works with commercial reference, cartoon figures, narrative elements, and bright color.

Michael Frimkess, a sculptor turned cartoonist turned potter, studied with Voulkos at Otis but resisted the abstract expressionist elements of the movement in favor

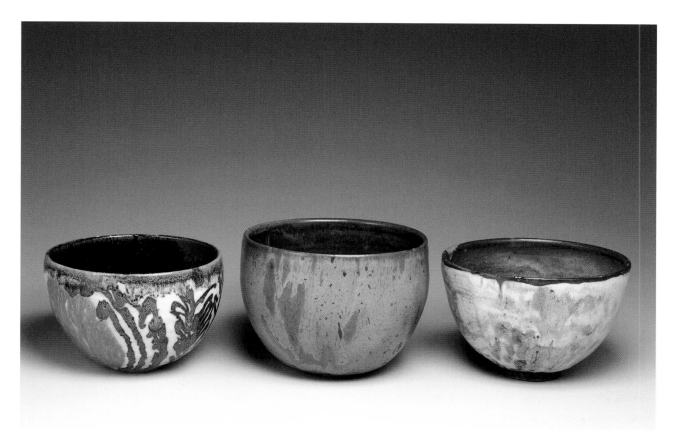

LEFT: **STONEWARE**
7 x 8.5 inches, reduction fired

CENTER: **EARTHENWARE**
8 x 8.75 inches, reduction fired

RIGHT: **EARTHENWARE**
7 x 8.5 inches, reduction fired

of caustic, narrative works on smaller-scale, exquisitely thrown pots. *Jumpin at the Moon Lodge* (1968, Scripps College) is indicative of the Pop sensibility that emerged in ceramics. Employing his cartoon-like style (he previously had drawn for the TV series "Mr. Magoo"), Frimkess created raucous scenes, finely crafted with images of sexual promiscuity, political satire, and enigmatic political/social commentary. In *Jumpin*, the characters range from Adolf Hitler dressed as Santa Claus, to an Uncle Sam-like figure chasing down naked women, to monkeys reading Russian newspapers. Although the imagery creates complicated meanings in terms of social, biographical, and political layering, Frimkess's work marked the return of narrative elements to the vessel. He also depicted life in America as multi-racial, something noticeably absent in the work of his contemporaries.

In contrast to Funk ceramics, which tended simultaneously toward an enigmatic inner narrative and an outer, immediate humor, Pop ceramics often are more easily legible, using strategies of humor to create social narratives and commentary on contemporary society. Howard Kottler's *Look Alikes* (1972), for instance, seems charged with competing notions of American traditionalism and homosexuality. Originally offered in a black leather pouch through which only the central figures in his reinterpretation of Grant Wood's *American Gothic* were

visible, the juxtaposition of leather, transferware, commercial dinnerware, and high art creates a complex meditation on sexual politics and traditional notions of family and ritual in American culture.

TOWARD CONTEMPORARY CERAMICS: IDENTITY AND PLURALITY IN THE LATE 20TH CENTURY

With an art education that is thus neither sufficiently basic, nor competent in its techniques, we have fostered a generation of "rock and roll" craftsmen who float in a sea of violent and misunderstood "self-expressionism," disregarding all essential laws of human and artistic integrity. It is no wonder that, in this confusion of issues and responsibilities, the motto, "Anything that's new goes" has become the main theme of our young craftsmen, the rigid conformity of our time. (Marguerite Wildenhain, 1973)

Despite her traditionalist biases, Marguerite Wildenhain's assessment of late-20th-century ceramics is remarkably prescient. By embracing an aesthetic that favored, in many cases, self-expression and individualism over traditional notions of craft, the ceramic movements that emerged in the post-war period have, like their counterparts in fine arts, tended to value contributions of originality and creativity over strict concerns of technique and functionality. Without the benefit of hindsight, and in the presence of many

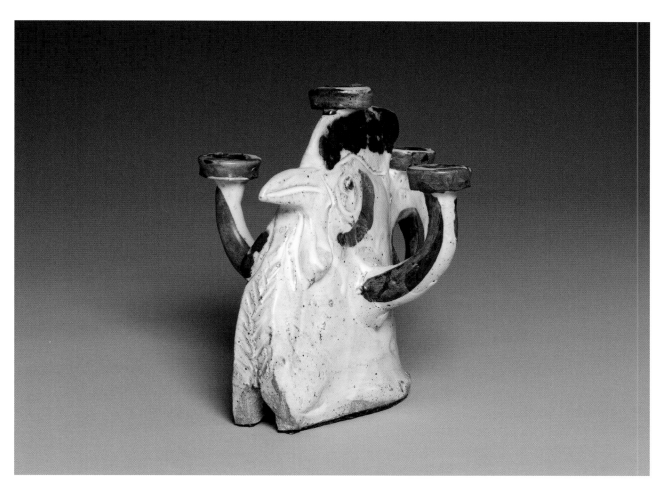

EARTHENWARE
7.25 x 7.25 x 6.75 inches, reduction fired

diverse forms and makers, it remains difficult to summarize the developments in ceramics from the late 1970s to present with the same clarity of the earlier movements. In general, however, ceramic artists have responded to the same impulses as have those in fine art, exploring notions of identity and often pushing the medium from individual concerns toward broader statements of a social and political nature.

Judy Chicago's *The Dinner Party* (1974–79, Brooklyn Museum of Art) is indicative of this trend and remains perhaps the strongest refutation of Wildenhain's concerns regarding the direction in which ceramics were headed. Rather than continuing in the manner of the Voulkos School or of Funk ceramics—aesthetic provocations that took the rejection of traditional signifiers of craft, like finish and form, as their departure for self-expression—Chicago's installation demonstrated that the binary structure of Wildenhain's beliefs (craftsmanship/"anything goes") was unable to convincingly circumscribe the potential options available to artists in the medium. Among the many things Chicago's installation demonstrates then, is the problematic nature of any criticism of modern art that conflates the desire for self-expression with a reckless abandonment of formal discipline. Finely crafted and meticulously finished, Chicago did not

need to pick a side in the argument of craft or expression, but discovered a way to coherently unify these seemingly opposite poles within a single work.

If Chicago's *The Dinner Party* is historically grounded by her continuation of the search for self-expression that concerned many ceramists from the post-war period into contemporary times, it also signals notable departures from prior strategies and remains indicative of important concerns in ceramics in the post-modern period. Unlike her predecessors who eschewed the notion of legibility and created forms that reveled in a personal (and often opaque) sense of self-expression, Chicago's installation embraced, and in a sense reintroduced, a deliberately narrative element into the medium. Whereas, philosophically, Voulkos's work and the work of Arneson might be framed as a meditation of the boundary between art and craft and the formal potential of the medium, Chicago's installation uses the medium to make demands upon the viewer. It is in this sense—her use of a narrative structure to raise issues that are motivated by concerns that lay beyond the boundaries of craft—that her work signals a departure from previous periods and denies the validity of Wildenhain's concerns. *The Dinner Party* requires the viewer not to consider form and meaning as abstract things, and initiated a rejection of

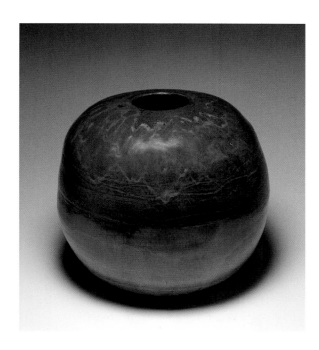

STONEWARE
18.25 x 21 inches, reduction fired

the internalized, non-objective creative process that Voulkos and his followers practiced. Most significantly, it reasserted the importance of narrative elements as a didactic tool and reframed the idea of self-expression in ceramics from formal and philosophical concerns to overtly political ones.

If *The Dinner Party*, as I suggest, liberated craft from only debating the medium of craft, its legacy is not without complexity or contradiction. By using a physical setting and processes that spoke to the often-limited roles of women in the world, Chicago created a statement full of contradictions, irony, and wit. Juxtaposing the specificity of the event (a dinner party) with a trans-historical roster of guests, Chicago employed ceramics centrally in a work that simultaneously referenced the marginalized position of women by elevating it to the forefront; she created a piece both historical and contemporary, timeless yet rooted in concerns specific to her time. And yet, even while bringing awareness to the marginalization of women, the very creation of this installation and the clear assignment of it to Chicago's authorship alone appears to create a marginalized place for the craftswomen whose execution made the piece possible. If Voulkos's work demanded a respect for the medium that placed the craftsman on equal footing with the artist in terms of self-expressive design and creative

potential, does the limited recognition of the craftswomen in Chicago's installation represent an evolution of the medium, or a turn back to craft as a manual skill, less valuable than (and seemingly in service of) the goals of art?

Without the perspective of hindsight, these questions are posed not to be answered definitively, but to signal the ongoing debates that continue to shape the field. Chicago's work, and that of those similarly concerned, represents a slice of contemporary ceramics rather than the discipline's entirety, for many ceramists who shaped the developments in the field from the 1950s onward have continued to teach and produce work. Their continued presence brings to this period a broad sense of diversity and plurality, as their reputations and visibility have not waned. Peter Voulkos, for instance, who worked until his death in 2002, and Robert Arneson, who died in 1992, remain potent role models by virtue of the many students whom they trained and others they inspired. Today, as it was in the post-war period when Frans Wildenhain arrived, contemporary ceramics is a diverse field with numerous practitioners working in a range of styles. If the options appear limitless and without a clear, objective narrative, we might find the common link in the prescient words of Edwin and Mary Scheier that began this essay. For regardless of their differing philosophical and design strategies, clay remains "no medium for the craftsman unsure of himself."

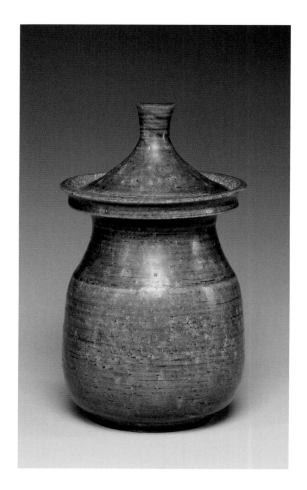

STONEWARE
9 x 5 inches, reduction fired

NOTES

[1] A slightly different chronology was reported later in their career. See "Two Austrians," (1950), *The Christian Science Monitor*, which sets their departure year as 1939.

[2] See Martin Eidelberg (2002, pp. 60, 85) for convincing evidence that the author of this article was William McVey.

[3] Although previous scholarship has attempted to credit Leach with nearly all the developments in ceramics that emerged in the mid 1950s, the aesthetics of his work and his written statements warning about the dangers of an "unfettered imagination" point to precisely the type of conservatism that ceramists such as Voulkos, Soldner, and others were challenging with their forms. See, for instance, Levin (1988, esp. pp. 200–201).

[4] Edwin Scheier seems to have absorbed the influence directly, likely as a result of a drawing class he took with Hans Hofman in the summer of 1944. See Komanecky (1993, p. 62). The text remains among the most thorough surveys of the couple's life and works.

[5] It is worth noting that despite the clean lines and functional appearance of some modernist ceramics, their creators did not necessarily intend them for use. Otto Natzler, for instance, described the use of his and Gertrud's ceramics succinctly: "Their possible function as containers is unimportant to us. We are concerned with the ceramic medium as such in an aesthetic sense, with what it has to offer, what it yields voluntarily, what must be extracted" (Natzler, 1966, unpaginated).

[6] Daley (b. 1925) went on to teach at the Philadelphia College of Art for 30 years, and although he no longer teaches, he continues to work and exhibit.

[7] Although the term "Abstract Expressionist" has been generally accepted in the narrative of modern ceramics, recently there has been some dissent, or at least reticence, to use the term without qualification. See, for instance, Adamson (2007, pp. 44 and 176) for sources and discussion.

[8] Arneson later recalled: "We made all these dinner wares, God, chickens and steak dinners. Then we would make drinks, beer bottles. We were just having a good time. The next day Tony saw that stuff and said, "What's this shit?" He was really upset. I think we ended up probably feeling bad enough. We probably broke a lot of it because it was just free-spirited playing around. But I saved some of them, and the quart beer bottle" (Arneson, 1981).

[9] In a review for *Arts Magazine*, Minimalist Donald Judd (1965, p. 69) noted the affinity between Arneson's work and that of Claes Oldenburg, but ultimately dismissed Arneson's because his "scatology isn't complex enough." See, also, Adamson (2007, p. 148).

REFERENCES

"18th Ceramic National: The Syracuse Show" (1954). *Ceramics Monthly* (December), pp. 11–13.

Adamson, Glenn (2007). *Thinking Through Craft*. Oxford and New York: Berg, 2007.

Adlow, Dorothy (1947, July 5). "American Pottery Benefits by Migrations From Europe." *The Christian Science Monitor*, p. 6.

Arneson, Robert (1957). "Letters." *Ceramics Monthly* (July), p. 4.

Arneson, Robert (1981). *Oral history interview with Robert Arneson, Aug. 14–15*. Archives of American Art, Smithsonian Institution.

"Artist Potters Busy Here After Flight from Austria" (1939, March 10). *Los Angeles Times*, p. A1.

Atherton, Carlton (1954). "Pottery Today—for Show or Use?" *Ceramics Monthly* (July), pp. 8–11.

Ball, F. Carlton (1957). "Craftsmen Talk it Over." *Modern Ceramics* (August), pp. 10–14.

Eidelberg, Martin (1983). "Ceramics," in Robert Judson Clark (ed.), *Design In America: The Cranbrook Vision, 1925–50*. New York: Harry Abrams.

Eidelberg, Martin (2002). *The Ceramic Forms of Leza McVey*. Hudson, NY: Philmark.

Judd, Donald (1965). *Arts Magazine* 39 (Jan.), p. 69.

Komanecky, Michael K. (1993). *American Potters: Mary and Edwin Scheier*. Manchester, New Hampshire: Currier Gallery of Art.

Koplos, Janet and Metcalf, Bruce (2010). *Makers: A History of American Studio Craft*. Chapel Hill, NC: University of North Carolina Press.

"The Larger Picture" (1953). *Ceramics Monthly* (July), p. 9.

Leach, Bernard (1950). "American Impressions." *Craft Horizons* 10 (4), pp. 18–20.

Leach, Bernard (1953). [untitled Statement]. *Everyday Art Quarterly* 27, pp. 10–11.

Levin, Elaine (1988). *The History of American Ceramics, 1607 to the Present*. New York: Harry N. Abrams, 1988.

MacKenzie, Warren and MacKenzie, Alixandra (1953). [untitled Statement]. *Everyday Art Quarterly* 27, pp. 12–15.

McDonald, Gregory (1967, July 23). "ICA Show: Funk or Junk?" *Boston Globe*, p. A16.

McVey, Leza (1953). [untitled Statement]. *Everyday Art Quarterly* 27, pp. 20–25.

Miller, Arthur (1945, March 25). "Ceramic Art of California Attains New High in Display." *Los Angeles Times*, pp. C1, C4.

Natzler, Otto (1966). "Preface" in *The Ceramic Work of Gertrud and Otto Natzler: A Retrospective Exhibition*, exhibition catalog June 15–August 14, 1966, Los Angeles County Museum of Art. Los Angeles: Los Angeles County Museum of Art.

Olitsky, Jules (1956). "Pots for Show: Young Ceramist Aims at Works of Art and Not Useful Objects." *Ceramics Monthly* (December), pp. 17, 32.

"Profile: Leza McVey" (1952). *Ceramics Monthly* (June), pp. 22–23.

Schaefer, Herwin (1958). "The Metamorphosis of Craft." *College Art Journal* 17 (3), pp. 266–76.

Scheier, Edwin and Scheier, Mary (with Paul Grigaut) (1953). [untitled Statement]. *Everyday Art Quarterly* 27, pp. 4–9.

Slivka, Rose (1978). *Peter Voulkos: A Dialog with Clay.* Boston: New York Graphic Society.

"Two Austrians Build Success on Clay Talent" (1950, May 29). *The Christian Science Monitor*, p. 12.

Webb, Aileen O. (1953). "Changing Concepts of Beauty." *Craft Horizons* 14 (1), p. 9.

Wildenhain, Marguerite. (1973). *The Invisible Core: A Potter's Life and Thoughts*. Palo Alto, California: Pacific Books.

Zack, David (1969). "California Myth Making." *Art and Artists* 4 (July), pp. 26–31.

JONATHAN CLANCY is Director of the American Fine and Decorative Arts Program at Sotheby's Institute of Art, New York. He has curated, lectured, and written extensively on the Arts and Crafts movement and American painting. His publications include *Beauty in Common Things: American Arts & Crafts Pottery from the Two Red Roses Foundation* (with Martin Eidelberg, 2008) as well as articles for *Modern Craft, The Journal of Design History, Style 1900*, and the Smithsonian's *American Art* journal. He is presently editing a catalog of the painting collection at the Redwood Library and Athenaeum in Newport, Rhode Island.

This essay is indebted to a number of earlier scholars' works. Among the most useful for this project were: Ulysses Grant Dietz, "American Ceramics and the Divergence of Art and Craft," in *Crafting Modernism*, ed. Jeannine Falino (New York: Abrams and the Museum of Arts and Design, 2011), 164–83; Janet Koplos and Bruce Metcalf, *Makers: A History of American Studio Craft* (Chapel Hill, NC: University of North Carolina Press, 2010); Jo Lauria, *Color and Fire: Defining Moments in Studio Ceramics 1950–2000* (New York: Rizzoli, 2000); Martin Eidelberg, ed. *Design 1935–65: What Modern Was, Selections from the Liliane and David M. Stewart Collection* (New York: Harry Abrams and Le Musée des Arts Decoratifs de Montreal, 1991); and Garth Clark, *American Ceramics, 1876 to the Present* (New York: Abbeville Press, 1987).

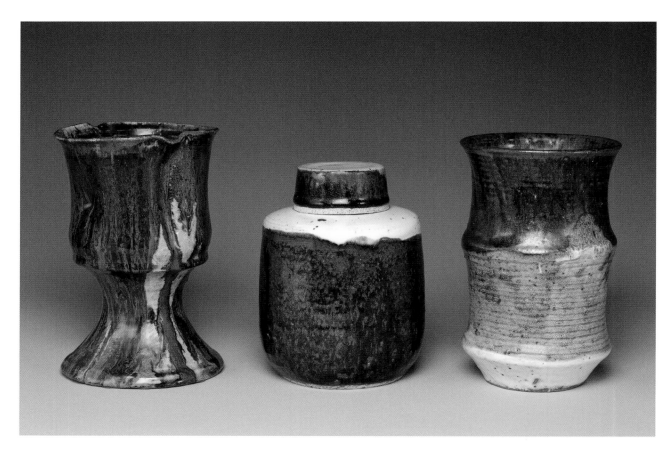

LEFT: **EARTHENWARE**
8.5 x 5.5 inches, oxidation fired

CENTER: **EARTHENWARE**
7.25 x 5.25 inches, reduction fired

RIGHT: **EARTHENWARE**
8.25 x 5 inches, reduction fired

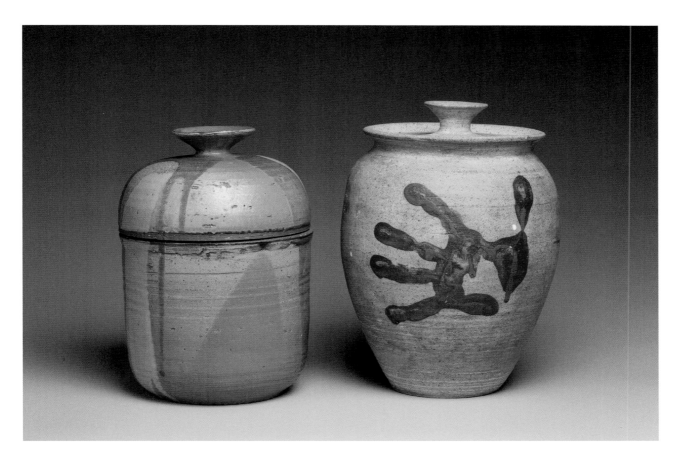

LEFT: **EARTHENWARE**
11.25 x 7.75 inches, reduction fired

RIGHT: **EARTHENWARE**
12.25 x 8.75 inches, reduction fired

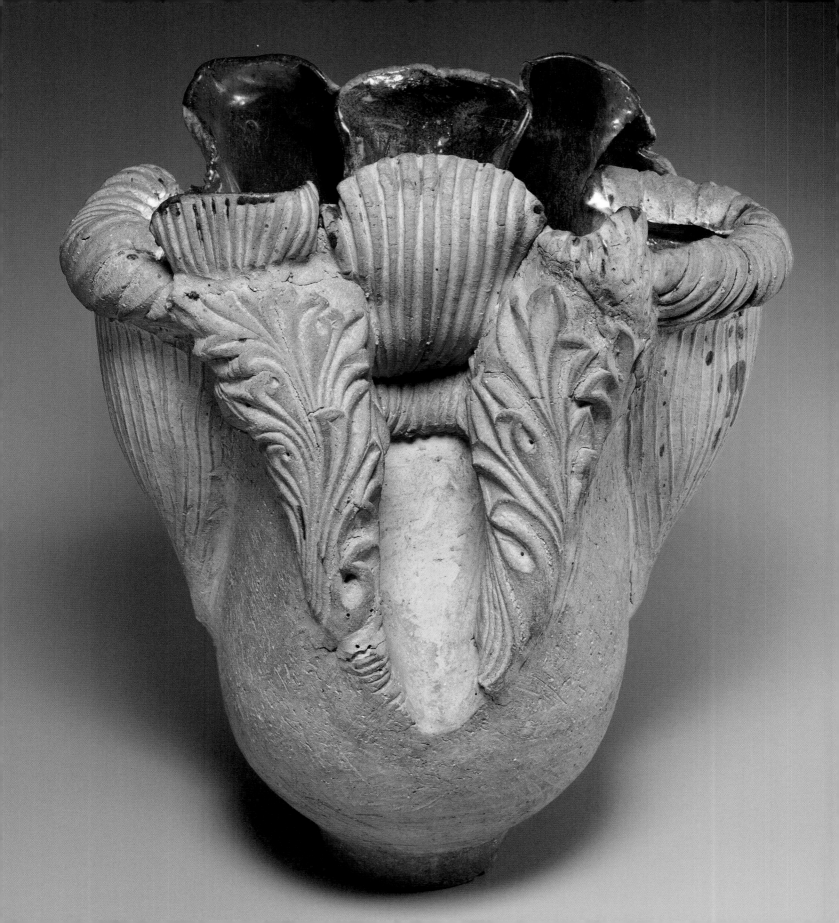

5

SELLING CRAFTS AT MID-CENTURY: MOVING THE MERCH AT SHOP ONE

BRUCE A. AUSTIN

"We would love to pour you a cup of tea any afternoon you can find time to drop by." (McIlroy, 1953)

Thus concludes a letter to the Rochester *Times-Union* newspaper's art critic signed by "Marjorie McIlroy, Secretary, Shop One." It is quaint by contemporary standards. Typewritten, the yellow carbon copy was tucked inside a stiff manila paper file folder and stored in a metal file cabinet. Written when Patti Page enjoyed a hit song with her version of "(How Much is That) Doggie in the Window?" the letter is very much a product of its time. Read today, it is an old-fashioned artifact distinctly out of place in a digital world where evanescent, often disposable messages composed in cryptic prose and abrupt syntax whip through the ether at blinding speed.

In the early 1950s, those interested in acquiring handcrafted goods could find a retail establishment selling *only* handcrafted objects at two places in America: 52nd Street near Madison Avenue in New York City or Troup

EARTHENWARE
21 x 17.5 x 11.25 inches, reduction fired

Street in Rochester, NY. In Manhattan, there was America House; in Rochester, Shop One.

Even today, McIlroy's message could not be clearer. It is an invitation, with no attempt to disguise the writer's motivation: Have tea with us, at our store, where you will be surrounded by the beautiful things we created and would like to sell to the readers of your newspaper column.

The delicately polite letter is composed in an endearingly semi-familiar way, akin to what social scientists would soon call "para-social interaction" (Horton and Wohl, 1956): one-sided relationships, often involving media celebrities, where audience members feel knowledgeable about and personally known to the celebrity who is unfamiliar with them. Too, the letter plays to tenets of a then relatively new theory of media effects. Named Two-Step Flow, the theory predicted that the effects of media messages on media audiences were mitigated by the influence of especially knowledgeable individuals—opinion leaders—including professional critics. One doubts McIlroy had such theoretical knowledge, just as one suspects she did have the common sense to curry the newspaper critic's favor.

With little money for advertising, never mind a sophisticated, agency-driven marketing and public relations campaign, reaching out in a personal way—a stamped letter delivered by uniformed Post Office carriers—was then, and probably now, among the most effective ways of presenting to influential recipients one's brand and identifying for them the unique products offered. Indeed, short of a

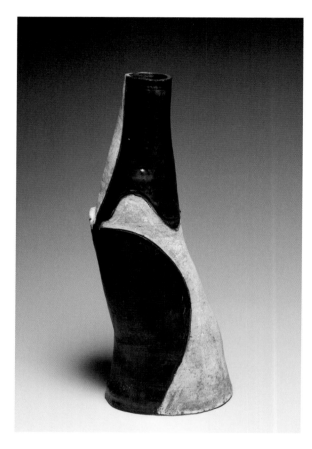

EARTHENWARE
27.25 x 10 inches, oxidation fired

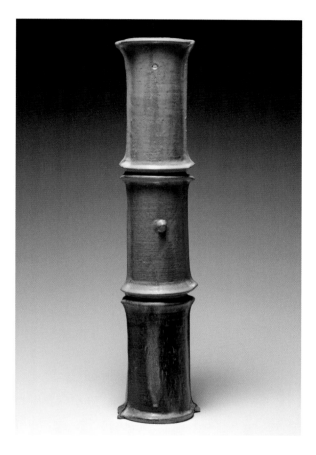

EARTHENWARE
29 x 7 inches, reduction fired

face-to-face meeting, how better to attract the interest and attention of an opinion leader whose published texts might drive customers to the door? McIlroy wrote Virginia Jeffrey Smith—the Dean of Rochester's art critics—that she "would very much like to show you our new shop," noting, as incentive, the addition to their inventory of textiles by Karl Laurell (McIlroy, 1953).

If Page, Doris Day, and Dean Martin typified the letter's present, then Lenny Bruce, Elvis Presley, and Marlon Brando populated its future. In *The Wild One* (1953) Brando's character, Johnny Strabler, responds to, "What are you rebelling against?" with, "Whadda you got?" From order to anarchy. In fact, thematic changes in movies and music, pop culture's two most prominent artifacts, frame the chronology of Shop One, "the Camelot of craft shops" (Krakowski and Cowles, p. 1).[1] Not because they influenced Frans Wildenhain and his Shop One colleagues or their customers, as there is no evidence of that, but because music and movies reflect and project values, shaping the consciousness of the (buying) public and are essential, formative parts of their milieu. At mid-century, each medium's content evolved dramatically into something very different from its broadly inoffensive, lowest common denominator formulae of the early 20th century.

In the 1950s, rock 'n' roll emerged as the most popular form of recorded music; its overt, sexually charged name was revolutionary, never mind the lyrics. Popular among former GIs previously attuned to related fringe genres

including jazz, blues, and swing, rock 'n' roll became a market driven by the babies boomed by those GIs. After a half century's monopoly on the moving image entertainment medium, movies unsuccessfully combated the threat television posed to drawing away their audiences by turning to color and widescreen and to gimmicks such as 3-D and Smell-O-Vision: technology harnessed to fight another technology. What Hollywood discovered, however, was that the more effective strategy to retain their audiences was to address mature subject matter the living room medium would not. *Blackboard Jungle* (1955) is an instructive, integrated metaphor for 1950s cultural upheaval: from its crashing "Rock Around the Clock" soundtrack over the film's opening credits to the high school misfits smashing of the jazz records of their clueless teacher.

Likewise, crafts took (r)evolutionary steps. Emerging from the worlds of industrial product, physical rehabilitation, and basement hobby, ceramics transformed themselves beyond conventionally shaped and decorated vessels well-suited to florists' shops, to sculptural art forms, no longer looking like the flower holders people were accustomed to seeing. Fitting within that schema was Shop One. As will be shown, a retail store in a medium-sized market specializing in only crafts was as revolutionary as Strabler's long sideburns and rock 'n' roll's beat-driven, frequently sexualized lyrics: an outrageously different place and path to furnishing, decorating, and appreciating art.

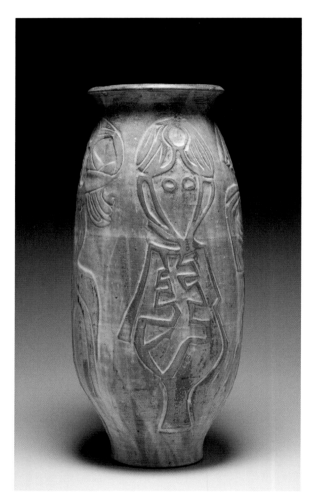

EARTHENWARE
23 x 8 inches, reduction fired

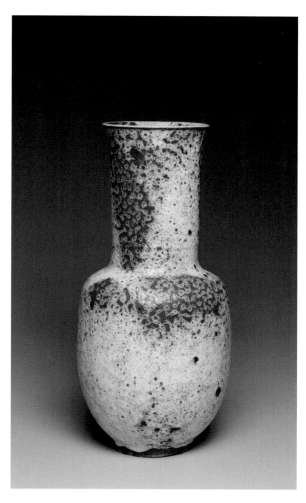

EARTHENWARE
17.25 x 7.75 inches, reduction fired

Described in 1956 as a "pioneering effort" and "one of the most unique craft shops in the country" (Winebrenner, 1956, pp. 31, 29), the trail Shop One chose was not an easy one to follow. Certainly, the destination of financial success was not assured. For instance: a Shop One appeal to consumers for handcrafted work was often a sales pitch by negation: here is what we do not have; we offer something that is not mass manufactured or one of a million. The claim of exclusivity as a virtue for one-off objects is persuasive only to those who both can afford such pieces and are inclined to part with their money for them. Shop One's long-term persistence despite such odds makes its story all the more remarkable.

Merchandising handcrafted objects faced a welter of challenges in the 1950s. If required then to draw up a business plan as one does today, no responsible banker would loan a cent to a venture such as Shop One. The obstacles were too many and too high. Yet by pooling their resources and their talents, four craftsmen created a success with their unique artists' cooperative venture at the dawn of the modern age. Their craft store became a business model for others, lasting nearly a quarter century, achieving an international reputation for itself and the artists whose work it represented while simultaneously elevating craft and the craftsman's status from that of garage hobbyist to gallery artist. Likewise, for Shop One's retail buyers, their station rose from consumer to connoisseur.

Aerni's (1987) evidence shows that the rise of crafts as a vocation and form of commerce did not begin until at least the 1960s and, more likely, the 1970s. The present chapter is a snapshot of the business, commercialization, and monetizing of craft at the first point in its modern development. It is a case study of the early history of the modern marketplace for crafts. The creation of an organized and ongoing retailing establishment for crafts was Shop One's innovation, with its implementation complicated by the public's understandable unfamiliarity. At the very center of the innovation was Frans Wildenhain of the School for American Craftsmen at Rochester Institute of Technology.

BEGINNINGS: 1952–1959

Looking back 20 years after the launch of Shop One, journalist Eleanor Dienstag (1972, p. 18) neatly explained the 1952 founding of "the granddaddy of all crafts stores" in the Rochester daily newspaper's Sunday magazine. Four craftsmen had discussed without solving the problem of retailing the work they produced. "Finally," she wrote, "after many into-the-night sessions, the obvious solution presented itself—a place of their own. Each partner kicked $50 into the kitty, and dedicated after-work hours to refurbishing first the lot on Ford Street, and then, within a year, the carriage house on Troup Street that remained the shop's home for 18 years" (Dienstag, 1972, p. 20). The prosaic report of the "Eureka!" moment, practically right

out of a Mickey Rooney-Judy Garland movie where the kids decide to enact a play "in Dad's barn," is a bit too tidy to be comprehensive. The four principals were three School for American Craftsmen faculty: John (Jack) Prip, Tage Frid, and Frans Wildenhain; and a former SAC student, Ronald Pearson. However the four craftsmen's conversation exactly evolved, their decision was gutsy and bold—maybe even foolhardy.

Prip (1922–2009), the son and grandson of silversmiths, was a Danish-trained silversmith. Born in Yonkers, NY, but raised in Denmark, he apprenticed with master silversmith Evald Nielsen, returning to the U.S. in 1948 (see Pearson, 1973 and Falino, 2010). On the same boat to New York as Prip was woodworker Tage Frid (1915–2004). Frid had worked for nearly a decade at Royal Danish Cabinetmakers. Both men had been recruited by the American Crafts Council to teach at SAC, then in Alfred and later Rochester, NY. Eventually, each left RIT and taught at the Rhode Island School of Design. Silversmith and jewelrymaker Ronald Hayes Pearson (1924–1996) came from an Arts and Crafts family with roots in the Elverhoj crafts colony near Poughkeepsie (see Braznell, 1999, p.185 and Ludwig, 1983, pp. 24, 47). After five years in the Merchant Marine Corps during World War II, he briefly attended SAC at Alfred from September 1947 to May 1948. By December 1947, he had established his own workshop.

From the very beginning, Shop One sought to distinguish itself from other retail stores selling decorative arts or gifts. It would not offer customers mass-marketed goods, only the

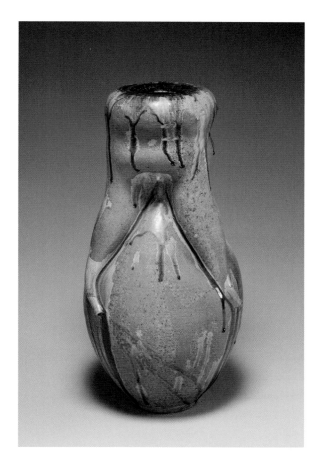

EARTHENWARE
27 x 14.75 inches, reduction fired

work produced by the principals: well-designed handcrafted products and "no filler items of the usual gift store variety" (Winebrenner, 1956, p. 29). To maintain the distinction, the business of business had to be attended to in order to sustain Shop One's fiscal viability.

Braznell (1999, p. 200) reports Prip as saying the SAC teachers lacked the time and interest to manage a retail shop and quotes Pearson: "There were no feasibility studies." They probably also lacked retail business experience. Instead, the four-way partnership seemed to offer mutual advantages for the breadth of crafts they could offer the public and their "enthusiasm and energy were contagious." Prip knew Pearson from Alfred and was aware of Pearson's success at selling his own spun bronze bowls. Prip suggested to Wildenhain and Frid that Pearson function as manager for Shop One. Pearson, who in addition to his own business experience was without SAC teaching obligations, agreed to assume the role.

Creativity at Shop One was not restricted to the inventory offered for sale to the public. The store's very name was a puckish, clever play on words. As with the word "craft" (see Jefferies, 2011, pp. 231), "Shop" could be understood as both a noun and a verb: as a description of a place and an action to be taken. "One" and the number "1"— both of which were used on the store's signage, stationery, postcards and fliers, and print advertisements—suggests a measure of exclusivity, uniqueness, and specialness for the

customer's status and discriminating taste as much as it did the store and its goods. And none of this was accidental, as printed advertisements actively and repeatedly exploited the word play strategy by, for instance, encouraging readers to "Stop at Shop 1 ... and see what's in store for you."

The challenges associated with selling crafts were neither new nor had they gone unnoticed. When Shop One opened in January 1953, the number of U.S. galleries selling crafts was no more than five, though they did not exclusively sell crafts (Aerni, 1987, p. 25). Farther back, in a not entirely consistent 1917 speech to the annual convention of the American Federation of Arts, Henry Percy Macomber, then secretary of Boston's Society of Arts and Crafts, referenced the "surprising apathy and disregard" for crafts in America, yet warned of the forthcoming "intense competition" from non-American craftsmen following the close of the war while commenting on the proliferation of gift shops offering crafts ("The 1917 Convention," 1917, p. 361).[2] Following World War II, the nation's still recovering traditional trading partners and design influencers, including Great Britain, Italy, Germany, and France, were not positioned to take advantage of the strong U.S. consumer market, as was true when Macomber spoke. Their focus was on infrastructure rebuilding rather than the material culture of couture, furnishings and decorative arts. The 1950s U.S. postwar consumer market was both "hot" and a domestic manufacturers' monopoly. Aerni reported (1987, p. 18) the results of other studies

indicating "impressive growth" for the crafts industry "in almost every respect"—however, the growth only occurred beginning in 1960.

Beyond these broad strokes, the business acumen of the Shop One founders was slight at best. For two—Prip and Frid—their commercial retail experience is not revealed by the received history, though any such experience would not have been in the U.S. and would have all been pre-war. Pearson, however, had demonstrated a significant and successful entrepreneurial flair by marketing and selling his spun bronzeware nationally. For instance, the $800 in sales he achieved in less than one year during 1948 jumped by 50 percent the next, and nearly doubled to $1500 by 1950 (Braznell, 1999, p. 195). Still, Pearson's experience was singular, restricted to the medium of metal, and brief.

Wildenhain, the eldest of the four, was not unaccustomed to the business worlds of creation, production, and distribution and the wholesale and retail trade. Though Gordon Herr's assessment of his business skills while in Europe was hardly positive (see the Biography essay), Wildenhain doubtless had an acquaintance with business practices. In the 1930s, after moving to Holland to join his wife, Marguerite, their "Het Kruikje" pottery workshop took to heart the Bauhaus focus on "creating forms suitable for mass production." Working without students or assistants, they achieved "financial and artistic success" and "established a strong international reputation

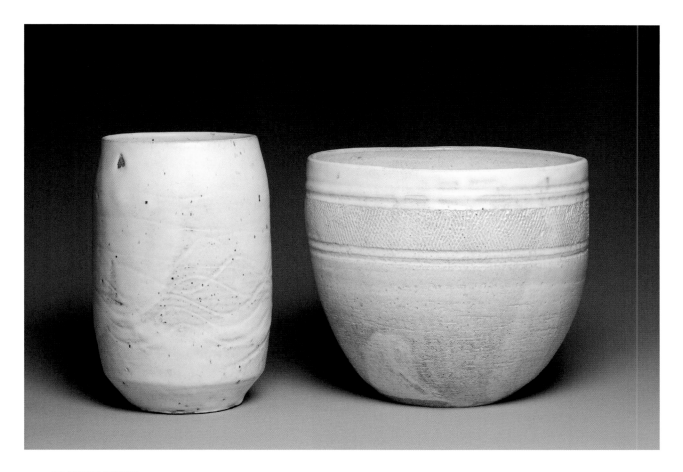

LEFT: **EARTHENWARE**
10 x 6.5 inches, reduction fired

RIGHT: **EARTHENWARE**
9 x 9.75 inches, oxidation fired

for their well-designed tableware, exporting substantial quantities to France, England, and the United States" (*American Studio Ceramics 1920–1950*, 1988, p. 97). Mindful of Herr's assessment of Wildenhain, the extant evidence does not reveal which one of the couple accounted for their financial success. We do know, though, that Marguerite was from a prosperous mercantile family (*American Studio Ceramics 1920–1950*, 1988, p. 91) and with her own manufacturing experience she probably contributed disproportionately to any profitability enjoyed by Het Kruikje.

A few signs pointed in a positive direction. The first was the earlier model for Shop One presented by the nearly single-minded Aileen Osborn Vanderbilt Webb. Known to the Shop One principals for underwriting their School for American Craftsmen, Webb had long championed the cause of crafts. Braznell (1999, p. 212) tightly summarized her dedication to crafts: Webb "founded an organization, a magazine, a school, and a museum for them." In October 1940, Webb opened America House in midtown Manhattan, affording craftspeople an urban retail outlet for their work. America House was the big-city version of Webb's earlier, more countrified Putnam County initiative, a retail venue for those dispossessed by the Great Depression. Pearson, however, was dismissive: "Of course there was America House, but it was doing a very small job at that time" (Braznell, 1999, p. 195). A key difference between America

House and Shop One was the size of the market in which each was located. And a second difference between Webb and Wildenhain et al., of course, was money: she had it, they had little of it.

The Shop One proprietors were aware of the financial distinction. They may have even been consumed by hubris regarding their relative poverty. A 1956 article about them reports: "They take pride in the fact that they have built up Shop One with their own time and money and without subsidizing [*sic*]" (Brown, 1956, p. 22). And, maybe referencing Webb's well-known philanthropy, Prip stated: "Every time there was a craft venture, you'd scratch beneath the surface and find some wealthy person supporting it. We were determined to establish something that would stand on its own feet" (Brown, 1956, p. 22).

A second factor favoring the Shop One enterprise was the globalization of taste that occurred following the close of World War II, though it seems unlikely Wildenhain et al. would have been fully attuned and responsive to the emerging sentiment. Significantly, many former GIs began attending college, including art schools, thanks to the GI Bill of Rights. And just as the GIs' exposure to a war-torn Europe helped to further democratize and internationalize the motion picture industry by making foreign film subject matter appealing (see Jowett, 1976, pp. 377–379), so, too, was the American public's appreciation for nondomestic art broadened. One prominent Rochester art dealer, Clara Wolfard, asserted that after the war

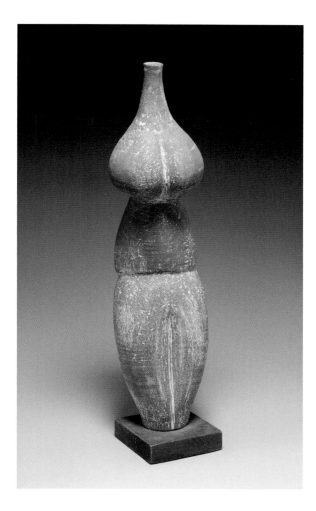

EARTHENWARE
31 x 7.75 inches, reduction fired

had ended, "The Rochester art scene was becoming more open to various genres of artistic expression" (Wolfard, 2003, p. 18). Craft, too, was a dimension of expression that began to emerge with a heightened status.

The 1953 opening for Shop One occurred almost silently: "No ads, no big fanfare" (Cowles, 2010, slide 27). So subtle was its presence that neighbors assumed the location was an auto mechanic's garage (Cowles, 2010a). Public notice of Shop One's existence, complete with significant omission and error, occurred in the January 23, 1953, edition of Rochester's afternoon paper. Though failing to mention it by name and also publishing an incorrect address, the *Times-Union* reported without a journalist's byline, "An experiment, which we trust will be permanent, has been started in Rochester, with the opening at 49 [*sic*; the correct street number was 24] Ford St. of a studio by four skilled young craftsmen who have won their laurels many times over in exhibition in America and abroad They have transformed an old loft with the labor of their hands and have rearranged an attractive showroom and studio with work benches" ("Craftsmen Open Studio," 1953).[3] Later that same year the *Times-Union* reported on an open house at Shop One, this time providing its name and correct address, and advised readers it "is well worth a visit" ("Craftsmen Exhibit Work," 1953). The craftsmen's own undated announcement was plain and straightforward: a typewritten, 8.5 x 11 inch document printed on Shop One letterhead identifying it

as "a retail outlet originated, owned, and operated by four nationally-known designer-craftsmen." Each name was listed in uppercase letters, followed by their craft; the letterhead did so at upper right and the typescript repeated the credentials below. Frid and Wildenhain, respectively, were identified with furniture and ceramics on the letterhead, and as "cabinet maker, furniture designer" and "potter, sculptor, painter" in the typescript. Prip and Pearson were identically identified in each place: "jewelry, silver/smith." The sparse text continued: "Individually, their work has been widely shown both in this country and abroad. However, this is the first of a series of planned group exhibits" (Cowles, 2010, slide 27). Also included in the debut exhibit was work by Robert Donovan (cabinet maker, furniture designer) and Karl Laurell (weaver, textile designer), "both of Rochester, N.Y."

The original Ford Street location (now demolished) quickly proved too small. The already tiny display area was further cramped by the intrusion of Prip's and Pearson's shared workspace (first at Ford and later Troup Street). They maintained a workshop in order to telegraph the intimate connection between craftsmen and customers as well as to enhance the likelihood of custom work. The need for larger quarters was almost immediately apparent.

By the time McIlroy wrote the letter quoted at the beginning of this essay, Shop One had moved, after a hiatus, to what would be its location for the next 18 years:

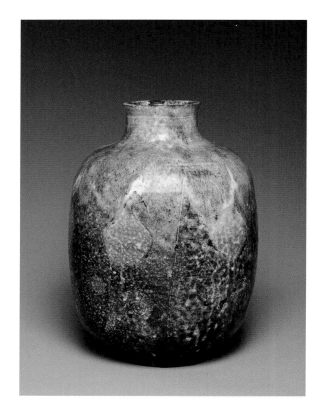

EARTHENWARE
13.5 x 9.75 inches, reduction fired

THE SHOP ONE 77 TROUP STREET LOCATION
As photographed in Fall 2011

77 Troup Street. In her letter, McIlroy acknowledges critic Smith's *Times-Union* mention of Shop One in a Thursday, September 24, 1953, column. At the end of the year, Marilyn Rouse, a reporter for the University of Rochester's women's college newspaper, alerted her readers to the affordability of Shop One merchandise, also noting that the store solved their Christmas shopping problem. SAC "student work is marketed through America House, Ltd., in New York City, a wholesaling and retailing outlet for American craftsmen, and this [American craft objects] is not, in general, available for purchase here in Rochester. Shop I, however ... provides the opportunity to purchase crafts of this type The shop displays a variety of crafts, many pieces within the price range of the college student" (Rouse, 1953). At that time, the College for Women was located just outside downtown, on Prince Street, a short drive to Troup.[4]

To alert customers of the change in location, an oversized, horizontally oriented postcard was printed, using a pink-lavender background color depicting cubist-styled buildings and with a map showing Main Street, Plymouth Avenue South, and Troup Street. The Shop's logo number "1" was set inside a large green-colored trapezoidal block and "77" inside a green circle. The uppercase text at the bottom read: "It is with a feeling of achievement we announce the move, on July 1st, of 'Shop One' from its present Ford Street location to larger and better quarters. We have been greatly encouraged by the reception Rochester has given our new

kind of shop and are looking forward to seeing you after July 15th at our new address, 77 Troup Street just off Plymouth Avenue" (Cowles, 2010, slide 33).

The new location for Shop One was on the second floor, up a long and relatively narrow stairway, in a Tudor-style carriage house behind a Plymouth Avenue Victorian mansion: "where the rent is lower, parking easier, and surroundings pleasant" (Winebrenner, pp. 29, 31). A "house of many delights," as one journalist later described it (Walrath, 1963), aside from three of the proprietors' employment, RIT and Shop One were unrelated. As if to italicize this, no advertising for Shop One appears in any issue of RIT's student yearbook, *Techmila*. The store's Troup Street location, however, was a convenient one for members of the RIT, as well as the broader Rochester, community. And standing in RIT's reputational shadow, especially when the School for American Craftsmen was still a novelty, was neither accidental nor a matter of geographical convenience. Shop One was just a couple blocks from the SAC studios and the Institute's fine and applied art Bevier Building. The red door on the Spring Street SAC building matched the red door for Shop One's entrance and red was the background color for the white "1" on their sign. The RIT Student Union was located opposite and just a few doors down from Shop One at 90 Troup Street (now demolished).

Once Rochester's "choice residential district," Troup Street was "a pleasant stint" to and from town (McKelvey,

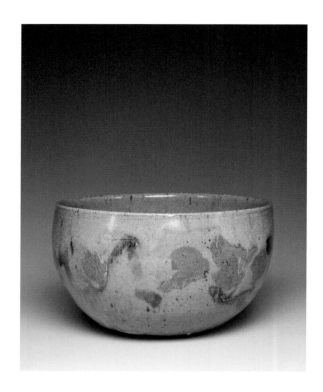

STONEWARE
5.75 x 9 inches, reduction fired

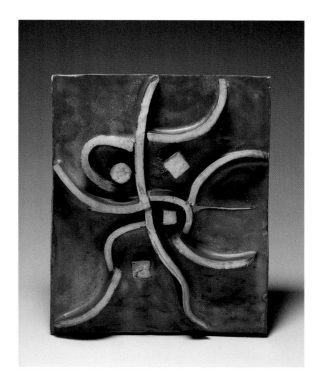

STONEWARE

16.25 x 20 x 3.75 inches, reduction fired

1965, p. 16). Within a mile of center city Rochester and two miles from Eastman Kodak's State Street offices, downtown visitors would not have found Shop One far out of their way. A national magazine article published one year after the store's opening observed, "Shop One is becoming a part of the cultural life of the Rochester community and is sponsoring and encouraging local artists and craftsmen by arranging monthly exhibitions of their work" ("Shop One: A Unique," 1954, p. 46). Indeed, Shop One joined what had once been the center of Rochester's art culture: in 1929, the Rochester Art Club, under the guidance of its president and Mechanics Institute faculty member Clifford Ulp, opened its arts center in the Third Ward on South Washington Street, moving in 1937 only when Mechanics Institute acquired its building (McKelvey, 1970, pp. 3, 7). Another national publication's article on Shop One, two years after the first, was accompanied by nine photographs of inventory objects. It, too, commented: "Shop One is becoming an important center of cultural activity in the community" (Winebrenner, 1956, p. 31).

But even as Shop One opened, the neighborhood was changing, and not for the better. One local reporter portrayed the evolution favorably in his lede: "A chunk of the old Third Ward, hallowed for the ruffled shirt crowd that once lived and died along its elm-shaded lanes, is becoming Rochester's Greenwich Village" (Korde, 1955). Describing the area surrounding Shop One, he wrote: "The heart of this

sprouting niche of culture is Troup Street and Washington Street South—It is no longer a pretentious quarter. It is the absence of the artificial, in fact, that seems to be attracting these newcomers." Photographs of Shop One's Pearson and local artist Ralph Avery accompanied this *Democrat and Chronicle* story. Barbara Cowles, then an RIT librarian and married to SAC faculty member Hobart Cowles, is more direct: the Third Ward had become an impoverished ghetto (Cowles, 2010a). Gordon, in his history of RIT, describes the 1954 Third Ward as "an area of dilapidated tenement houses" (1982, p. 234).

Impressionistic, romantic notions of beret-topped beatniks replacing the formally attired old money crowd notwithstanding, the difference between the newer residents and the older ones is identical to that between Aileen Webb and the Shop One partners—disposable income—a harbinger, perhaps, of the economic challenge faced by Shop One.

Virginia Smith, prominent art critic for the *Times-Union* and herself an accomplished and exhibited painter, functioned frequently as a Shop One booster. In bylined columns and unsigned news notes, she drew attention to the venture. A January 23, 1953, story, probably written by her, details the personalized nature of Shop One's products while suggesting an international endorsement: "One of the things which impresses a tourist in the Scandinavian countries is the honor given to the designer. Individual craftwork is always signed and even when a design is made for mass production, the artist is given credit" ("Craftsmen Open Studio," 1953). Late in 1953, in time for the holidays, an unsigned article reported on the four SAC faculty members who bonded together to exhibit their craftsmanship at Shop One and their open house ("Craftsmen Exhibit Work," 1953). And then in 1955 is this endorsement in a bylined article discussing an exhibit of 14 American sculptors' work: "Shop One has gone far since it opened a number of years ago on Ford Street. Rochesterians have learned that here one can find the finest type of art handicraft work with no compromise to commercialism. Its atelier at 77 Troup Street is so full of objects of beauty that it is always a privilege to examine them" (Smith, 1955).

From the beginning, Marjorie McIlroy functioned as Shop One's publicist, cultivating the local art critics during the hours after working at Eastman Kodak and between practicing her craft as a metalsmith. Cowles recalls, "There were few gallery shows and fewer openings at that time, so a Shop One opening was a local gala occasion" (Cowles, 2010, slide 44). The two daily newspapers were less receptive to McIlroy's overtures than the weekly *Brighton-Pittsford Post*. Purchasing modest-sized display advertising in the weekly—far less expensive than the dailies—seemed to enhance the likelihood of news coverage (Cowles, 2010a). "There were difficulties in

**STERLING AND ENAMEL JEWELRY CREATED
BY MARJORIE MCILROY**
Circa 1950
Photograph courtesy of Andrea Hamilton

attracting the press—but when an article about a show did run, the readers were delighted, as was the store" (Cowles, 2010, slide 44).

In addition to modest investments in paid weekly newspaper advertising, ads also were purchased on the Rochester classical music radio station, WBFB-FM. The radio advertising was targeted to a focused, small-sized, albeit homogenous and presumably upscale audience due to both the station's content and its location on the FM rather than the more popular and accessible AM broadcast band. Still a novelty in the 1950s, there were far fewer FM than AM radio broadcasters and, significantly, receivers. For the most part, however, the early marketing plan for Shop One relied heavily on the printed postcards designed by the partners and the kindness of strangers: word-of-mouth by the disproportionately female customer base (Cowles, 2010a), including members of RIT's Women's Council, Memorial Art Gallery, and SAC (Cowles, 2010, slide 39). Postcard distribution was initially limited by the absence of a mailing list (though this would develop) and later by the fact that their distribution to other artists and craftspeople was more "ego advertising" (Baker, 2010) than advertising to retail buyers. Occasionally, Shop One inventory was displayed at a downtown Security Trust Bank building and even at a nearby typewriter repair shop. The principals' exposure at the annual Finger Lakes Exhibition, coupled with the awards

they regularly won, including Prip's 1956 Fairchild Award and Wildenhain's 1958 Guggenheim Fellowship, helped Shop One maintain visibility beyond Troup Street.

In 1954, Barbara Newton, a Skidmore College fine arts major and a former SAC metal student of Prip's, became Shop One's first paid manager. She was described in a promotionally significant *Craft Horizons* article as "charming and efficient, she believes in her job and Shop One is her cause." The article reports that Newton's love of crafts is infectious: "A conviction which is so strong that she communicates it to even the casual browser." Describing the ambience, the article reports the four founders "planned a store where the customer could feel the connection between his purchase and the person who made it" (Brown, 1956, p. 20). Prip and Pearson continued to maintain their workspaces at the rear of the Troup Street store. "This close contact between customer and craftsman is reflected in Shop One décor. Strikingly non-commercial in appearance, it presents the crafts in an environment that combines the best features of a gallery and an elegant apartment The total effect is uncluttered and casual. Each craft seems to enhance the others. The customer gets the clear idea of what a particular object will look like in a tastefully decorated room" (Brown, 1956, pp. 20–21). By 1956, Prip left for Tauton, Massachusetts, to work at Reed and Barton, and Pearson moved his workshop to his home; what was formerly their workspace became welcome additional exhibition space for Shop One.

Shop One began 1955 by completing an exhibit, begun in December 1954, of photographs by recently arrived RIT photography professor Minor White. During the same year, informal partnership interest was extended to Hans Christensen, Laurence Copeland, and Max Nixon (three SAC silversmiths), weaver and print designer Karl Laurell, ceramist Hobart Cowles, and two SAC alumni—cabinetmaker Robert Donovan and woodworker Richard Wakamoto (Braznell, 1999, p. 202). The extant evidence suggests critical success and positive public response to Shop One. Financial success was yet to be captured; the promotionally significant 1956 *Craft Horizons* profile stated Shop One had not yet broken even: "Its directors are not the least bit discouraged by this. They are sure the shop will turn the corner into the black" (Brown, 1956, p. 22). With only a few years in operation, it was premature to expect profitability.

Aerni (1987, p. 8) reports on financial guidance that, were it to be followed, only predicts difficulties: "Labor, and implicitly, artistic ability comprise almost all of the costs of a crafts firm and determine the prices that can be charged." An important article announcing broadly Shop One's presence was published in the March/April 1956 issue of *Craft Horizons*, accompanied by several photographs. Written by the magazine's editor, Conrad Brown, the article instructs would-be craft creator-proprietors to compute their cost of creation (materials and processing plus one's time) to determine the sale price (Brown, 1956, p. 22).

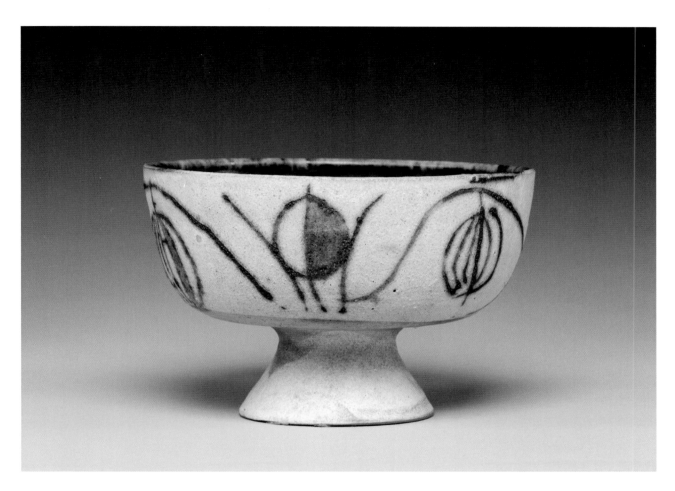

EARTHENWARE
4.25 x 6.5 inches, oxidation fired

Following this advice virtually ensures an absence of a profit for the craftsman, since it assumes one's labor is one's profit; ordinarily, one is compensated for one's labor and then profit is added. Moreover, omitted from the financial equation are such overhead costs as the rent for the place where the crafts are created, utility costs for lighting and heat, equipment costs, taxes, furnishings and display cases, and employee wages. In Shop One's case, its employees, at least at the beginning, were the wives of the store's principals. Their duties included food preparation for openings.

At the selling (pricing, more precisely) end, Aerni explained, "A firm prices mostly by trial and error and by imitating other craft firms' prices" (1987, p. 76). Since there were few comparables at the time, one suspects plenty of trials with nearly as many errors. Indeed, three years after beginning operation, in 1956, Shop One still was not profitable. Braznell (1999, p. 202) explains: "High standards governed what was offered for sale in the shop, and the proprietors sacrificed the profits that could have been available from more saleable, lower-quality work." The shop's 30 percent mark up was well below what most retail consignment stores and art galleries add to the wholesale cost (Brown, 1956, p. 22).

Shop One's establishment signified the seriousness of the craft business versus the playfulness of the hobbyist. Too, for Shop One there was an implied comparison to

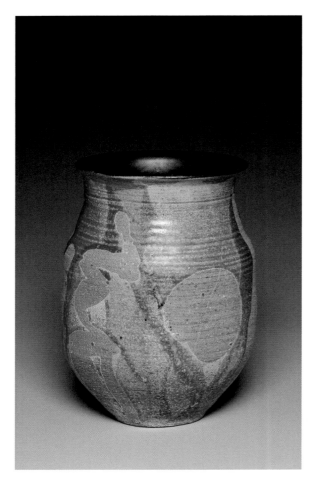

EARTHENWARE
8.25 x 6 inches, reduction fired

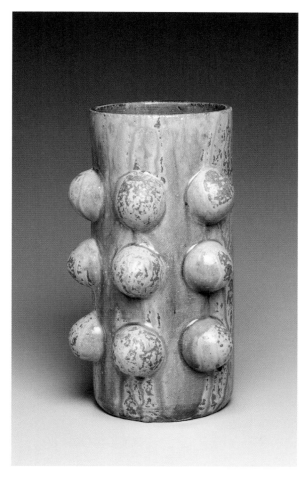

EARTHENWARE
12 x 5.5 inches, reduction fired

high-minded but noncommercial art. Shop One's innovation was an artists' cooperative long before such things became fashionable and, perhaps, even sensible. However, within a half dozen years, at least a few cooperative galleries had been established around the country (see Braznell, 1999, p. 202). For example, in March 1957, the Ferus Gallery opened on La Cienega Boulevard in Los Angeles. At this artists' cooperative, founded by artist Ed Keinholz and curator Walter Hopps, the contributors shared the profits. Ferus closed nine years later in 1966 (see Clark, 2000 and Schwartz, 2010, pp. 26–35). By 1959, the SAC consignments to America House had ended, at least by woodshop students (Keyser, 2011). The American Craftsmen's Educational Council (now American Craft Council) divested itself of America House in 1959 and the shop moved from its East 52nd Street location. And, in Rochester, at virtually the same time as Shop One was opening, Clara Wolfard and her husband Teddy, who operated the well-regarded Wolfard Gallery in the Shop One neighborhood, began looking for new quarters, "although the wrecking ball was still nowhere in sight. We did not regret having to leave Spring Street— the run-down neighborhood" (Wolfard, 2003, p. 20). They moved to 9 South Goodman Street, well outside the center city district.

By the end of the 1950s, Shop One added some commercial products to its inventory, bowing to "the realities

of the marketplace" (Dienstag, 1972, p. 26). An unidentified newspaper clipping dated November 12, 1959, and reporting on a satellite exhibition by Shop One craftsmen, called Shop One's founding "something of an experiment" and suggested "the present retrospective exhibition at the gallery of Rush Rhees Library proves it was successful" (unidentified source, clipping, 1959). Pearson attributed the success of Shop One to the volunteer work of McIlroy (Braznell, 1999, p. 200). Managers, though, were difficult to retain: Newton left in 1956 or '57 to raise a family, Jocelyn Todd managed the store from 1956/7 to 1958, followed by Marina Ujlaki until 1960.

Though perhaps off and running, Shop One's track was one that had not previously been raced and it continued to face considerable challenges. By any analysis, contemporaneous or hindsight, there was at best mixed success forecast for a crafts shop.

THE DIFFICULTY MERCHANDISING CRAFTS

Selling handcrafted goods is not a novel idea. They are, after all, what people owned before there were machines to produce them since there was no alternative: make it by hand or not at all. And those goods were treated as commodities in exchange for other things, including money. The two elements—machines and money—were sometimes points of contention or confusion in the sales process for creators, retailers, or consumers. Toffler remarked in *The Culture Consumers*, originally published in 1964: "Throughout American history the only thing lower than the businessman's reputation among artists has been the artist's reputation among businessmen" (Toffler, 1973, p. 92).

The Shakers—"your hands to work, your heart to God"—despite their otherwise simple ways, were not averse to using the machine or seeking profit. They rejected the immoralities of the outside world, while depending upon and successfully selling their often machine-made goods to precisely that market. And, at the turn of the 20th century, a number of otherwise ostensibly machine-opposed and noncommercial Arts and Crafts societies and organizations across the United States did likewise. The Handicraft Guild of Minneapolis, Saturday Evening Girls (Boston), and Arequipa Pottery (Fairfax, California) are coast-to-coast examples of organizations that sought to profit from the handcrafted products created by their members. Even before founding their Byrdcliffe colony in Woodstock, New York, the Whiteheads envisioned an "art convent" driven by principles of the simple life movement, and that included retail sales (see Nasstrom, 2008; Green, et al., 2004; Edwards, 2004). The Southern Highlands Handicraft Guild was founded in 1929 with an agenda that included "selling or providing a place for craftspeople to sell crafts." It held its first fair in 1948 (Aerni, 1987, pp. 4, 22 citing Bullard, 1976). The craft shop with perhaps the longest tenure was Albert Berry's. The one-man gift shop featured only his hammered

HAMMERED COPPER WITH ANTLER CANDLESTICKS
Albert Berry, stamped Berrys' Craft Shop, Seattle
Circa 1920, 9.75 x 4.75 inches
Private collection

copper goods, frequently embellished with antlers or fossilized ivory. First opening in Juneau in 1913, it moved to Seattle in 1918 and remained open until 1971 or 1972 (see Farmarco, 1998; Fish, 2006; Hill, 1989). None of these examples, though, suggests that sales of handcrafted goods were effortless or profitable.

Another sticking point occurs once crafts are conflated in the marketplace with art. "Art" implies non-functional objects. Art is absent "practical" utility or purpose even though there may be commercial motivation. "Craft" suggests a purposeful, practical utility and, among those with generous minds, blends aesthetic, artistic, and workmanlike elements. And while it may be true that craftspeople are "not plagued by an insistence on the virtues of hand-crafted versus machine production or the policing of the semantic boundaries of craft and art" (Braznell, 1999, p. 201), craft buyers may not share those sentiments. Barry Targen identified "the irony that even when craft objects are ostensibly utilitarian, they are often not bought to be used." More often than not, he states, those who buy crafts "buy them not for themselves, but rather for ceremonial purposes of presentation to others as gifts" (cited by Mainzer, 1988, pp. 259–260). The presentation, then, is the practicality of the craft purchased.

Whatever the fine discriminations drawn among antiques, fine art, and crafts, all three share at least one attribute: they are luxury products, personal indulgences,

and are not necessities. Because of this, there is no predictable, purchase-ready cohort of buyers for them as there is for, say, that offered by the grocery store. Their consumer markets are narrow and shallow. Aerni observes the similarities in demand for art and for crafts, acknowledging product differentiation and "competition based primarily on quality and design rather than price" (Aerni, 1987, pp. 2–3). Moreover, for buyers, creativity is costly. Irrespective of the mythology engagingly recorded by Tom Wolfe (1972, pp. 62–89), kandy-kolored tangerine-flake streamline customized cars were for the few, not the many: most likely Hollywood stars and only rarely were the buyers the shade tree mechanics. An old chestnut in the antiques trade explains the problem confronting novice antiques dealers who busy themselves with inventory acquisition: if inventory is what defines an antiques dealer, then anyone can be one since the only thing required is money. Buying, in other words, is easy; selling is hard. Aspiring antiques dealers who purchase without regard to resale quickly find themselves both out of money and business. Likewise, artists motivated by their muse who produce art but are absent patrons or paying customers find no economic support for their art. There can be little consolation in Aerni's (1987, p. 3) observation: "In economic terms, craftspeople and artists receive psychic or nonpecuniary rewards for their occupation." Though the difference between creating

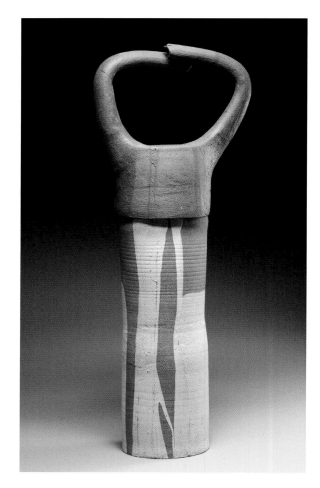

EARTHENWARE
42.75 x 16 x 7.5 inches, reduction fired

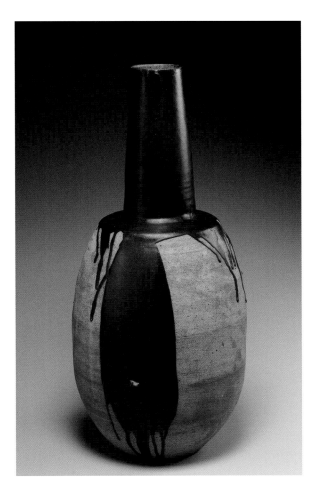

STONEWARE
29.25 x 13 inches, reduction fired

art or crafts and the ease of buying antiques is arguable, the business corollary is identical: the difficult part of the equation is the selling. While Aerni (1987, pp. 2–3) may be correct when she states that art and craft firms do not have "profit maximization" as their "major goal," no one goes into business to lose money.

Individually designed, hand-built crafts also smacked of an amateurism running against the grain of that which was fashionable in the 1950s. The tension—between man and machine—was hardly new. Luddites had previously, if quixotically, italicized that point. When modernity is defined by its industrial-ness, handwork is seen as old-fashioned, out-of-date, inefficient, and even wasteful. The merits of mass manufacturing were unambiguously italicized by the unconditional surrender that ended the Second World War. The initiation of the atomic age certified science and the methodically linear and left-brain objectivity embodied by the industrial enterprise. The handcrafted component of craft was the very antithesis of a modern, uniform, and reliable product. The post-war Levittowns were apt metaphors for the virtues of uniformity; deviation was possible only from a narrowly drawn menu of choices. Paraphrasing an expression attributed to Henry Ford's better-known products, people could buy a Levittown house in any style they wanted, as long as it was one of the three styles offered in the catalog. "Hand-built Crafts,"

then, would probably not be the 1950s marketers' preferred slogan to favorably position the product in the widest buying public's mind.

Art and antiques have a longer retail shelf life than crafts. Whereas the acquisition of antiques has the cache of a century's persistence (and they only get older the longer they sit unsold), the craft product's lifespan is not even half that. Too, antiques and art achieved credibility as a result of their enshrinement in educational curricula, museum exhibitions, collector associations, and clubs, as well as their sales records at public auction. Crafts in the 1950s, on the other hand, existed in an uneven and outmoded mixed world of utilitarianism, therapy, rehabilitation, and reformation. They were more an activity (and less a product) to be taught to youngsters who were certain to abandon the diversion at adolescence. The crafts produced at summer camps move ignominiously, even if sometimes deservedly, from the prideful parental trophy on a shelf to the long-forgotten amateurism sold at garage sales. Negative connotations are associated with the rehabilitative dimension of crafts and the craft hobbyist prompts an association with the dilettante. At mid-century, crafts had not achieved a status endorsed by museums, were rarely collected by collectors, and were not sold for attention-getting prices at auction.

Most curricula for clay-working and clay-modeling focused on technique and tools, skills and chemistry and, surely some argue, creativity, aesthetics, and personal expression. In 1949, Frances Wright Caroe, director of America House and daughter of Frank Lloyd Wright, argued with little apparent effect in *Craft Horizons* that ceramics students must be prepared to earn a living: the "realities of dollars and cents are as sharp as a cutting tool, as tricky as a glaze" (quoted in Braznell, 1999, p. 191). For the most part, the craft curriculum did not touch upon marketing, advertising, publicizing, and persuading the customers who had not yet arrived at some unspecified retail outlet to part with their money in exchange for the creator's work. And, as noted above, the exchange—money for goods—is one characterized as an indulgence for the sake of the customer's self-satisfaction perhaps without regard to utility. In virtually any other context, such an arrangement only describes a decadent world of the wealthy.

Compounding the marketplace realities that forecast difficulties retailing crafts was the relative dearth of affordable, mediated advertising vehicles in the 1950s. Mass media were comprised of daily and weekly community newspapers, billboards, and AM radio, all of which were geographically bounded; among periodicals with national distribution, advertising was expensive and could not be customized as it is now for more narrow market segments (e.g., by postal zip code, a feature that did not exist until 1963). Television was just beginning its U.S. diffusion and movies were only rarely accompanied by paid advertising except for the trailers promoting other films (see Austin, 1986). Advertising in the

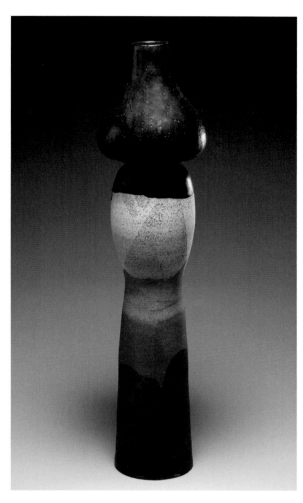

EARTHENWARE
41.5 x 9.5 inches, reduction fired

daily newspaper in a monopoly market such as Rochester, where the morning and the evening paper were both owned by Gannett Company, Inc., was prohibitively expensive. Radio, like billboards, is geographically restricted and is a medium suited for telling, not showing, thereby a less attractive vehicle for the craftsman. And so the 1950s crafts creator or retailer was left with the weekly newspaper, display media such as posters (and less economically likely billboards), and direct mail as their publicity-advertising marketing media.

The would-be craft retailer of the 1950s was in uncharted waters. The first American Crafts Enterprise show occurred in 1966. Featuring 60 crafts exhibitors, its gross was $18,000 in sales (Aerni, 1987, pp. 1–2). There was little cooperation among craftsmen and retailers who sold crafts: "Everybody was pretty close to the vest" (Cowles, 2010a). Professional advice for the craft retailer was largely absent until the 1970s. Jane Wood's *Selling What You Make*, published in 1973, was one such "how-to" book for aspiring craft businesspeople. Printed with a font mimicking handwriting, and a breezy "hippie" style, the somewhat formulaic advice offered there was mirrored by other "cook books." Their authors rely on idiosyncratic personal experience and anecdotes as evidence to support their suggestions and instructions to novice businesspeople. The titles offer counsel on handling money, obtaining insurance coverage, getting to know one's customers, and turning a hobby into a profitable business

(see, e.g., Kadubec, 2000; Robbins and Robbins, 2003; Rosen, 1998), largely reaffirming notions of amateurism already negatively associated with craft. Windschuttle (1986, p. 34) summarized what many already knew: "One of the major difficulties many artists find in running their own enterprises is the marketing of their products and services."

A related problem was the supply side of the equation. Priscilla Merritt, founding co-director of the Haystack Mountain School of Crafts (Deer Isle, Maine), opened a gallery named Centennial House in 1961. Featuring fine crafts, including the work of Haystack faculty, she recalled, "In 1962 there was very little choice of merchandise to put in the shop because there were so few craftspeople then" (quoted in Sager, 1998, p. 32; see too "Priscilla Hardwick Merritt," 2006). Later, Centennial House presented the work of such leading craftspeople as Karen Karnes, Toshiko Takaezu, and Dale Chilhuly (Kestenbaum, 2006).

Partially mitigating all of this doom and gloom were a few factors far outside of Shop One's control. Interest in crafts and modern design was fueled by post-war pent-up consumer demand (from wartime restrictions and shortages) coupled with the growth of population, housing, and family sizes. Too, the end of the war saw a revival for crafts generated by occupational therapy programs coupled with Aileen Webb's increased activism on behalf of crafts (Braznell, 1999, p. 187). The 1948 Southern Highlands Handicraft Guild's first craft fair was "most vital of all" as

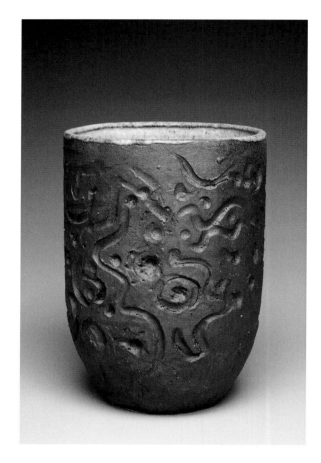

STONEWARE
9.75 x 6.75 inches, reduction fired

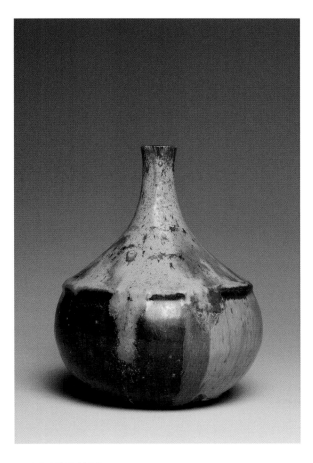

EARTHENWARE
7.5 x 6 inches, oxidation fired

it provided craft firms with a marketplace; previously, no organized method for selling had been established and "craft firms sold what they could, when they could" (Aerni, 1987, p. 22). But according to one observer, in Rochester "the single biggest influence [on art] ... during the last century was Rochester Institute of Technology" (Dawson, 2008).

The School for American Craftsmen's (SAC) move from Alfred, NY, to Rochester in 1950 and its installation on RIT's Spring Street campus yielded the critical mass necessary for the modern commercialization and monetization of crafts. In contrast to prior individual efforts among woodworkers or clay throwers, SAC not only produced students with professional training keyed toward earning a living, it gathered together similarly motivated craft masters who proved to be the necessary ingredients for producing the crafts to be offered for sale in an organized, businesslike way, and on a scale grander than that attempted by mom-and-pop entrepreneurs. In 1951, *Popular Mechanics* described SAC in precisely these terms: "Production training—the making of saleable articles—is not sneered at in this [RIT] school Instructors emphasize the sale of craft articles. Students are lectured on pricing and market trends by experts in the various fields" (Eris, 1951, p. 143). One 1956 SAC graduate reports he enrolled in SAC specifically for this reason and "took up ceramics as a way to make a living while I was painting" (Gernhardt, 2011). Another, a 1961 graduate, noted that Shop One's presence was "instrumental

in getting me to come to RIT to study" (Keyser, 2011). Rochester gallery owner Shirley Dawson wrote that SAC "brought an army of talented faculty and students who stayed in our community [and] exhibited and sold their art." The result, she wrote, was that SAC "created a marriage of art forms that gave a level of sophistication to visual arts here that few cities could match" (Dawson, 2008). Shop One was one beneficiary. "Because of the endless variety of quality goods from SAC, because of the stream of first-rate craftsmen coming and often settling within the vicinity of the school, the shop picked up momentum just as the craft movement itself gathered steam" (Dienstag, 1972, p. 22). It was a propitious time for the Shop One innovators.

MATURITY: 1960-1972

The melodic, wholesome harmonies of the Beach Boys on "Surfin' Safari" (1962) were accessible and appealing to virtually everyone, including those for whom the nearest beach was 1500 miles away and the lyric "walking the nose" made no sense. Shop One was to retailing what Dick Dale was to the Beach Boys: a niche for the adventuresome purist, a real surfer and amp-blowing manic guitarist—not five guys in identical shirts assembled for a photographer's benefit on a yellow pick-up truck with a stick. From the customary and conventional to the unusual and unexpected, Shop One catered to a genuinely diverse clientele: broad in their interests, though homogenous in their support for the craftsmen and their financial wherewithal.

Germinated and nurtured in the 1950s, Shop One was situated outside of the mainstream as a source for quality handcrafted merchandise. It was a novelty at once attractive but foreign, making its marketing a tall hurdle. In a 1966 eight-page spread, *Life* magazine reported on the U.S. crafts revival. There, Wendell Castle, who would become a Shop One partner, explained his iconoclastic approach: "My furniture goes against the grain of 20th century design. I have no special interest in form following function. I want to be inventive and playful, to produce furniture to make life an adventure" ("The Old Crafts," 1966, p. 27). The broad generic categories of merchandise and media—furniture, jewelry and vases; wood, metal, and clay—inventoried at the store were familiar to general retail customers and craft collectors alike. Even among visitors uninformed about crafts, SAC, or contemporary design, they would find merchandise at the shop that was consonant and would resonate with their own experience. At the same time, Shop One's ambience and the objects on display telegraphed a distinctiveness from, say, the department store furnishings and accessories and the cutesy kitsch of gift shops. A Shop One exhibitor and SAC faculty member described the store: "It was quaint, it was very professional, it had all handmade goods and no imported junk. It set an example" for other galleries (Keyser, 2011). After pioneering the idea for a retail crafts shop in the 1950s, during the 1960s Shop One led and shared the crafts industry's growth, cementing its place in the retail market. But, as a novelty in Rochester, Shop One

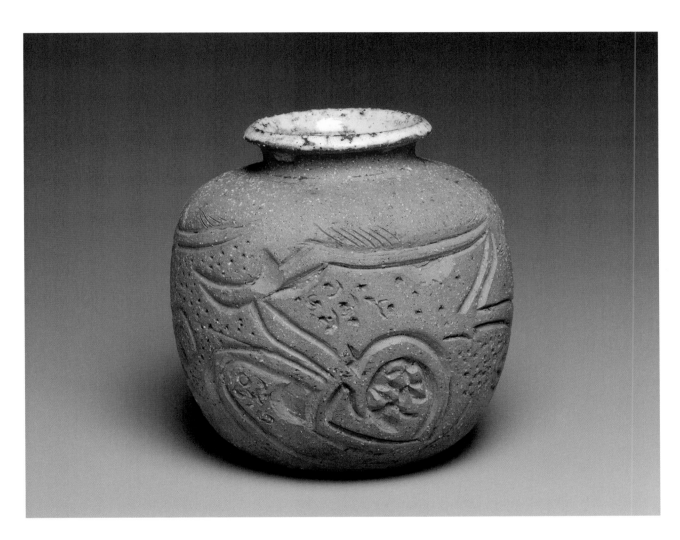

STONEWARE
9 x 8.75 inches, reduction fired

was compelled to find its own way through a retailing maze still being mapped.

Piggybacking on the credentials of others produced a halo effect benefitting Shop One. The Museum of Modern Art's Bauhaus-influenced mid-century exhibitions (1950–55) helped set the stage. Assertively titled, "Good Design," featuring work by Breuer, Eames, Saarinen, and others, MoMA's exhibits did not ask a question. They presented a position and were as much instruction as inspiration for visitors.[5] The 1956 New York opening of the Museum of Contemporary Crafts (later the American Craft Museum and now the Museum of Arts and Design), "the nation's first museum dedicated to craft" (Braznell, 1999, p. 203), institutionalized craft within the museum context, enhancing craft's legitimacy. Too, the Museum opened at about the same time as Shop One was featured in a lengthy *Craft Horizons* article (Brown, 1956). The MoMA exhibits, along with a host of related events and activities, generated press coverage for crafts and modern design in specialty magazines and, more significantly, by the wide circulation, sometimes large format, photo-heavy, glossy weeklies— including *Life*, *Look*, and *Time*—to which millions subscribed. Print media coverage conveyed certification for modern design, including crafts. The stories reported as well as taught readers an aesthetic and a way of living. As discussed above, one "problem" encountered by craft retailers is the narrow and shallow shape of its consumer contours. With

relatively few potential consumers and perhaps even fewer with the financial means to support an all-crafts retail store, the attention brought by mainstream media reports about two New York City museums and their exhibitions served as powerful credibility builders.

In addition to unpredictable and largely uncontrollable media reports, Shop One exploited and capitalized on synergies with nearby Rochester institutions, especially the not-for-profit worlds of museums and education. Ron Pearson acknowledged this, describing an "arts triangle" formed by Shop One, SAC, and the Memorial Art Gallery of the University of Rochester (Braznell, 1999, p. 201). The triangle was supported by (then) especially strong local industries (notably Eastman Kodak and Bausch + Lomb and, beginning later in the '60s, Xerox) and a symbiotic relationship with the annual Finger Lakes exhibitions hosted at Memorial Art Gallery where Shop One artists would also sell their work and win awards. Together, these factors led Braznell to characterize Rochester as "vibrant" and "a mainspring of postwar American Crafts" (Braznell, 1999, p. 213).

Despite travails and agonies about marketing, advertising, and promoting a unique business venture, the 1960s brought prosperity and probably profitability to Shop One.[6] In addition to that which was on display, "a great deal of work is done to order, with the craftsman working closely with his customer" (Winebrenner, 1956, p. 32). Much later, SAC faculty member William Keyser affirmed this, recalling that Shop One's

**FRANS WILDENHAIN SCULPTURE
IN THE BETTY TINLOT COLLECTION**
Circa 1960
*Unidentified photographer. RIT Archive Collections,
Paul Rankin collection in memory of Lili Wildenhain*

presence "led to a lot of commissions" for the artists who exhibited there, especially Tage Frid (Keyser, 2011). And, as mentioned above, Pearson's and Prip's onsite workshop presence intentionally and further enhanced the likelihood of custom work. Shop One shows were reviewed regularly and enthusiastically in the city's two daily newspapers. For instance, the *Democrat and Chronicle*'s Jean Walrath commented, "The house of many delights at the moment is Shop One with its exhibition of Ruth Asawa's sculptures made of air and wire" (Walrath, 1963, p. 10E).

In 1960 Elizabeth (Betty) Tinlot became Shop One's manager, a position she held until 1969, when she moved to Cambridge, Massachusetts, to open her own crafts store, Ten Arrow Gallery, which was modeled on Shop One. The Shop's longest-lasting manager, she had a good eye and was "a whiz" at display. She also was good at recruiting new customers. Married to Dr. John Tinlot, a University of Rochester physics professor, she drew connections from that substantial pool. Rochester native Barbara Cowles, wife of ceramist Hobart, joined Shop One as a part-time sales clerk in 1963, later becoming its manager. Shop One's artists and exhibitors were more often than not men; customers, Cowles recalls (2010a), were more often women "because women buy presents for weddings and their friends." Gallery openings at Shop One were popular and "attended by a lot of well-heeled people" according to a late '50s SAC student employee (Gernhardt, 2011). Kurt Feuerherm (2011), an

exhibiting Shop One artist, reports that after any kind of opening at Shop One there was a big party—in addition to the opening's party. Shop One, he remembers, "had a great mixture of contemporary craft" along with ethnic art, including Navajo and Tibetan, because Wildenhain "was very interested in antiquities." Indeed, in the '60s, Shop One's inventory expanded. Frans and Marjorie Wildenhain began taking trips to Mexico and returned with local art, ponchos, and shawls. Eddythe Shedden, future owner of the Oxford Gallery, brought back Floccata rugs and woven bags from Greece; Ron Pearson urged Shop One to carry Marimekko fabrics, dresses, and hats beginning in 1968.

For SAC students, Shop One became their classroom for practical experience in art and commerce. One student reported that every other week, SAC graduate students would all go to Shop One "to see Frans's finished work" (Fina, 2011). And Julia Jackson, a 1960 SAC graduate, stated that at Shop One, "Delivering work [to Shop One] was an educational experience, pieces were appraised and critiqued, information concerning previous sales generously shared, which helped to provide direction for new work" (Jackson, 2008).

Marketing refers to the strategies, including media channels and the messages intended to alert buyers to that which is being sold. Promotion and publicity seek to exploit free media coverage, in the guise of news reporting and absent the self-serving motives of advertising, as a way to signal existence, enhance reputations, and subtly influence consumer behavior. Advertising seeks to accomplish similar goals by paying for strategically placed and designed message insertions.[7] To publicize and promote itself, Shop One relied on a few strategies to foster foot traffic as well as sales to remote locations.

Among the most commonly used and least expensive forms of advertising, even today, is direct mail.[8] Marjorie McIlroy knew this from the beginning, back in 1953, and the habit persisted. Shop One used fliers, small-sized posters, fold-out postcard-sized fliers and postcards, often printed on heavy and sometimes roughly textured paper, to advertise shows and exhibits and to remind recipients of Christmas shopping opportunities. The latter, of course, is an old trick. Long before Shop One, tying the holiday to gifting and both to crafts had been exploited for sales purposes at the National Society of Craftsmen's 1906 debut show. As *The New York Times* remarked that year on December 1: "the first appearance of the society on any stage is chosen not without canniness, for this is the season of Christmas." The story explained the objects would "appeal to the perplexed shopper who wants to get something reasonably artistic, something that stands by itself" and is handmade "thereby removing it from objects which are multiplied by machines" (quoted in Waters et

FRANS WILDENHAIN

Artist-Craftsman

Shop 1 is pleased to announce an exhibition of the work of Frans Wildenhain, the eminent potter, painter, sculptor, and teacher.

Mr. Wildenhain will show recent pottery and ceramic reliefs. In a retrospective spirit, he will include some of his accomplishments from the 1930's. These early pieces speak eloquently of the scope of his craft.

Mr. Wildenhain has always battled the cross-currents of voguishness with a firm conviction and a strong hand.

His recent work suggests observations and influences from a trip to Puerto Rico. The elemental forces of the sea and land are felt and shaped. In some pieces shell-like forms, neo-classical references and fragments and shards seem to thrust themselves out of the form.

Mr. Wildenhain's work is to be found in many collections including Objects: USA.

You are cordially invited to meet Mr. Wildenhain at a preview of his exhibition, Friday, May 28 from 7 to 9 pm. The exhibition will continue from May 29 through July 3, 1971.

SHOP1

**SHOP ONE FOLDED BROCHURE FOR A
FRANS WILDENHAIN SHOW, MAY 29–JULY 3, 1971**
5.25 x 7.75 inches
Private collection

al., 2011, p. 43). As the collegiate journalist reported early in Shop One's development, crafts make for excellent Christmas gifts. Shop One exploited this, along with its seemingly ever-present appeal to exclusivity, in paid advertising and by postcard distribution. One holiday-time ad for Shop One challenged customers to "Be original this season. Give an original." Christmas, of course, comes but once a year. Different appeals had to be made for purchases during the year's other days. Nonetheless, Shop One issued virtually annual Christmas pitches in postcard format and paid ad space in, especially, Rochester area weekly newspapers.

A wordy ad, probably in the weekly *City Newspaper*, for Frans Wildenhain's "Signed editions at Shop 1" emphasized their "beauty and practicality" and the fact that "Shop 1 Original Signed Editions are a way to buy the finest work at a reasonable cost." A 9-inch diameter bowl, for instance, was priced at $30 as was an 11-inch vase with black gun metal exterior glaze and sienna glaze inside. Another ad, for Wendell Castle's "stackable chairs molded of black, red, white or yellow in indestructible fiberglass" also pushes the "Signed Editions" strategy. The ads were created by Significs, a local boutique ad agency run by a collector and crafts enthusiast, Douglas Baker. He viewed signed editions by the artists as "the way [for the Shop] to make money," repeatedly emphasizing this feature in the advertising copy

FOLD-OUT POSTCARD FOR A SHOP ONE FRANS WILDENHAIN EXHIBIT AND FEATURING THE "STENCIL" LOGO
Circa 1970, 22 x 3.75 inches
Private collection

he created for Shop One (Baker, 2010). Long before, of course, critic Virginia Smith had written about the merits of craftsman-signed work in her 1953 article about Shop One; Smith, though, was referencing the work of others, not the Shop One artists as did Baker. Another Baker/Significs ad for a Shop One Wildenhain show, dated February 9, 1970, billboarded recent work from his trip "last summer in Chotoku-Shokoku-ji, Japan"; the same ad forecast the following Shop One show, "Salt Kilns," an exhibit of salt glaze pots by Karen Karnes and Mikhail Zakin.

Baker became involved with Shop One toward the end of the 1960s. In addition to his own collecting passions, he was interested in becoming a Shop One partner (Baker, 2010). Typically, in his ads, a photograph of an object occupied two-thirds of the ad with the remaining space for text and the Shop logo. His agency also created what would become a new, but transitional, logo: the stencil-like presentation for SHOP 1 would occupy significant real estate in the text-dense ads placed in *City Newspaper* and, "occasionally" the daily *Democrat and Chronicle*. Direct mail appeals, intended to generate mail order sales, often were "destined to be pinned up on a wall," he acknowledges. Ads and mailers frequently employed puns: "Shop 1. The Gifted One." Finally, Baker produced three 30-second 16-millimeter commercials for television, though whether they were broadcast is unknown. He reports producing the TV spots gratis so he could "use the

reel as a portfolio piece to leverage other work," from more flush clients (Baker, 2010).

For William Keyser's first solo show at Shop One (February 14, 1971), a mustard-colored fold-out postcard with his name and a photo of a zebra wood coffee table was distributed (Keyser, 2011). A 1971 postcard invited recipients to a Frans Wildenhain show (May 29–July 3, 1971) of works influenced by his trip to Puerto Rico; the card identified him as an "Artist-Craftsman" who "has always battled the cross-currents of voguishness [*sic*] with a firm conviction and a strong hand." Postcards were distributed bulk rate to a mailing list maintained by Shop One. Too, they were given to the artists whose work was being shown for their own distribution. The cliché about "preaching to the choir" may accurately and positively characterize the effectiveness of this advertising strategy, though in some instances the recipients were craftspeople more interested in selling their own crafts.

Though its advertising reach was restrained as much by finances as the media then available, Shop One proved successful during the 1960s. Pearson suggested one reason why Shop One "made it:" "The combination of four owners, whose artistic standards people could depend on, made an enormous difference" (Dienstag, 1972, p. 22). Retail customers could count on Shop One, like its merchandise, to offer "considerable product differentiation and

competition based primarily on quality and design rather than price," further underscoring the notion that demand for art and craft was virtually identical (Aerni, 1987, p. 3). The seeds planted in the 1950s, when consumer interest in home furnishings expanded after the wartime restrictions were lifted and economic prosperity occurred, blossomed for Shop One in the 1960s. Exhibitions by museums, expansion of craft curricula at colleges and universities, and the development of craft fairs all served well Shop One's interests.

Tage Frid left Rochester for a teaching position at the Rhode Island School of Design in 1962. Between 1969 and 1970, Stanley Glassman, the man who early on placed Shop One consignments in the typewriter store near Shop One, was manager. Barbara Cowles moved from part-time to full-time employee in the 1960s and became Shop One's manager in 1970. Ron Pearson left Rochester for Deer Isle, Maine, in 1971, opening his own studio and affiliating with Haystack Mountain School of Crafts; he retained his partnership status (Cowles, 2010, slide 63). In March 1972, Shop One added three partners—wood sculptor Wendell Castle, manager Cowles, and SUNY Brockport metalsmith Tom Markusen—and prepared to move from Troup Street to 221 Alexander Street, just outside of center city Rochester ("696 Gallery," 1972; "Shop One Center Adds," 1972). The new location opened April 1.

Keith Moon's furious drumming on "I Can See for Miles" (1967) alerted listeners just as *The Killing of Sister George*

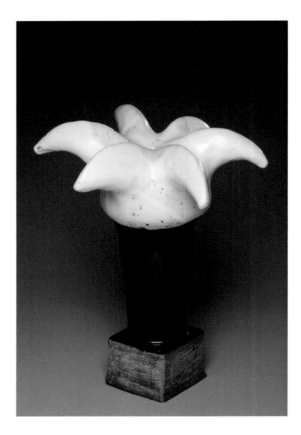

STONEWARE
18.5 x 14.5 x 12.25 inches, reduction fired

THE SHOP ONE
221 ALEXANDER STREET LOCATION
As photographed in Fall 2011

(1968), one of the first X-rated movies released in the U.S., telegraphed to movie viewers that there was something in the air. What was there, of course, was not idiosyncratic to the struggles experienced by Rochester since the early 1950s: downtowns were dying. To stop the hemorrhaging of people, businesses, and housing—many of which were fleeing to and developing in suburban areas—highways circling the city and a new shopping center were envisioned. Midtown Plaza, the nation's first downtown enclosed shopping mall, was discussed in 1958 and opened in 1962 (McCally, 2007). The Inner Loop roadway, discussed as early as 1951, was virtually completed by the end of the decade (McKelvey, 1956), and an "outer loop," Interstate 490, connected the Inner Loop to the New York State Thruway (Smith and McKelvey, 1968, p. 22), effectively splitting the city and RIT's campus. RIT had informally discussed moving its campus in the late 1950s; the decision to leave downtown occurred at the end of 1961 (Gordon, 1982, pp. 246–257). Both construction for and the new roadways themselves cut off Shop One from downtown, making "it necessary for customers to drive to Clarissa Street [an impoverished neighborhood] to access the store" (Cowles, 2010, slide 65). All were deterrents to Shop One customers. In September 1968, RIT held its first day of classes at its new 1300-acre campus in suburban Henrietta, virtually abandoning downtown. Gallery owner Shirley Dawson, who had once singled out RIT as "the single biggest influence" on the Rochester art scene in the past century,

also claimed that "the biggest catalyst" in the demise of the Rochester art scene "was RIT's withdrawal from the City both literally and figuratively. The new campus built on the outskirts of Henrietta removed students and faculty from any commitment or interaction with city life" (Dawson, 2008). Another gallery owner, Clara Wolfard (2003, p. 20), added: "The 1960s was the era of increasing use of ground transportation The encircling city loops enveloped the old Third Ward like a cocoon. The enclosed area could be reached only by circuitously entered side streets." She and her husband, Teddy, moved their gallery out of the Third Ward neighborhood.

DECLINE: 1972–1976

In the first paragraph of her retrospective article, Dienstag (1972, p. 18) called Shop One "one of the first, serious outlets for American crafts, and certainly the granddaddy of all crafts stores in this area." "Granddaddy" was a most telling descriptor. After 20 years, no longer a novelty in Rochester, by the early 1970s Shop One was in competition with numerous small-scaled boutiques, hippie shops, and upscale art galleries, virtually all of them located outside of city center. Shop One had become a little like the antiheroes in Sam Peckinpah's graphic anti-western, *The Wild Bunch* (1969): men beyond their prime and out of their time. Unlike the first move, from Ford to Troup Street, motivated by cramped space and unexpected popularity, Shop One was

now beset by economic woes. The April 1972 move from Troup to 221 Alexander Street was a gamble prompted by several factors; each was tied to the others by an underlying economic thread. Costs of operation coupled with migrating customers, disruption and customer inconvenience due to highway construction, and the removal of RIT and SAC from its neighborhood all were motivators. As were new ways of doing business, including the inventory Shop One would carry. For instance, from October 11 to November 8, 1969, Shop One presented its first exhibit of Albert Paley's jewelry followed by a November 15 to December 4 exhibit of Wendell Castle's work, including his plastic molar furniture. The earlier entry of colorful Finnish fabrics, Marimekko, probably suited the era's hippie aesthetic but not necessarily Shop One's reputation and seemed incongruent with its brand.

Positioned at the northern end of Monroe Avenue, a well established if somewhat uneven retail strip running between the I-490 outer loop and the city's Inner Loop, the Alexander Street location was a large Victorian house that had been converted to apartments. Across the street from Genesee Hospital (now demolished) and close to an increasingly gentrified and trendy Park Avenue neighborhood, Alexander was viewed as a "better area" with greater possibilities for walk-in foot traffic than Troup Street. Customers could park on the street in front of the shop as well as in a lot behind the house. The first floor was gutted

SHOP ONE LOGO ON GIFT BOX
Circa 1973, 8.25 x 2.25 inches
Private collection

for Shop One's retail space; the apartments upstairs were retained and, when rented, provided monthly income. Large floor-to-ceiling plexiglass bubble windows, that appeared to be vertically tipped skylights, were installed on the Shop's first floor. There was 50 percent more floor space than at Troup, and the freestanding, clear Lucite display cubes, the white walls, and the track lighting gave the space a contemporary, "cosmopolitan" appearance (Cowles, 2010, slide 67, 69). To kick off the Shop's new digs, Baker prepared a full-page ad for the daily newspaper's Sunday magazine, *Upstate*, including a freshly designed logo: the number 1 was integrated inside of the "O" of Shop and when presented vertically the logo gave the appearance of braided rattan (Baker, 2010). To announce Shop One's opening, there was a press party—a novelty for the store, as was the size and placement of the ad. New shows, the press was told, would be scheduled every six weeks.

Shop One's opening show was "The Five Owners Show," April 3–29, 1972. The April 2 full-page black and white *Upstate* ad promised "recent work by the owners of Shop 1. Ronald Pearson, jeweler, and Frans Wildenhain, potter, original founders of the Shop in 1953, are now joined by Wendell Castle, furniture designer, Tom Markusen, metal worker, and Barbara Cowles, shop manager." A complementary color brochure was created as a mailer. The ad and mailer each featured square

photographs showing details of metal, jewelry, fiber, and wood objects. The copy explained, "Now Shop 1 has moved and is being re-discovered at 221 Alexander Street, with new ideas, new inventory; same old commitment: to exhibit and sell the finest works of artist-craftsmen." A postcard invitation to the April 1 preview also mentions the availability of "Marimekko!" Later the same year, Shop One offered a Glass Invitational Show featuring six artists that ran from October 16 to November 11.

A June 12, 1973, *City East* newspaper ad for Father's Day was headlined "POP!" in a frilly Victorian font that stood in sharp contrast to Shop One's crisp, clean logo running vertically down the right lower third of the ad. The ad's copy mixed the now traditional appeal to exclusivity with a cheeky admonishment. Sans serif font for the copy instructs gift givers: "Be original. Shop the one and only! Give him a little something (instead of a big nothing)!"

At least twice, probably 1973 and 1974, the Shop advertised atypical mid-November to end-of-year exhibits underscoring the broadening of the store's offerings. The ads alert readers with their headline statement: "What's Cooking at Shop 1." One ad's photograph depicts an egg at the center of a frying pan atop a finished wooden plank and with the cracked halves of the egg's shell and a wire whisk next to the pan. Centered in the ad is the vertical logo and the copy at the bottom third entices customers to "take our cooks [*sic*] tour: omelette pans from France,

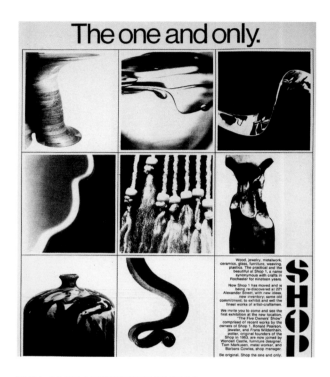

FULL-PAGE ADVERTISEMENT IN
UPSTATE MAGAZINE
April 2, 1972, 12.5 x 10.75 inches, designed by
Douglas Baker, announcing the opening of the Shop One
Alexander Street location
Private collection

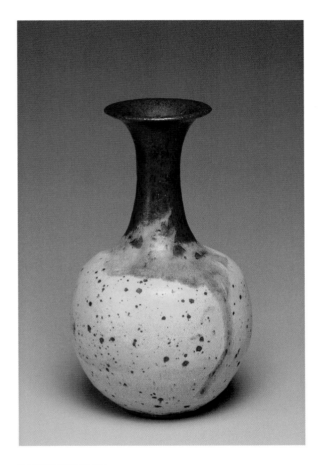

EARTHENWARE
12.75 x 4 inches, reduction fired

spice jars from Sweden, wire whisks from Japan" Too, the copy notes, "An incredible storehouse of hand- and machine-made things that make a fine art of cooking and dining." These shows were, perhaps, an attempt to dovetail with Paul Smith's "Objects for Preparing Food" exhibit (1973) at the Museum of Contemporary Crafts. Former exhibitor Kurt Feuerherm (2011) asserts that following the move to Alexander Street, Shop One "didn't do the kind of shows that would bring people in." Clearly, Shop One was broadening—or diluting—its brand with the inclusion of such inventory as imported cookware and books about crafts and craftsmen. A small, undated vertical print advertisement for the Alexander Street venue billboarded "The One Sale. Storewide Clearance," January 2 through 11.

Partner Thomas Markusen—"probably the best businessman" at Shop One, according to Baker (2010)—had his work featured in a February 8 to March 15, 1975, exhibit. The advertising mailer suggested a show of the kind loyal Shop One customers would expect. Behind the scenes, though, "the sky had darkened" (Cowles, 2010, slide 72). On March 29, 1975, Barbara Cowles sent a letter of resignation effective May 1, 1975, to Wendell Castle, Frans Wildenhain, Ronald Pearson, and Douglas Baker. "Dear Boys," she wrote, "I feel our philosophies have become so widely divergent as to hinder the smooth running operation of the shop" (Cowles, 1975). Continuing, "I trust we will be able to come to an amicable agreement on the purchase of my shares"

and closes wishing them "the best of luck and a successful future for Shop One."

A short while after Markusen's show, a newspaper report indicated change of some substance was afoot for Shop One. Sally Walsh reported in the *Democrat and Chronicle*: "The Gallery that has long been known for quality in crafts has been revamped along the lines of a Manhattan gallery. The production crafts are on the way out and one of a kind crafts are coming in The man primarily responsible is the new manager, Gary Smith, who once headed the SoHo branch of the Andre Emmerich Gallery in New York City" (Walsh, June 27, 1975). (The Emmerich Gallery, opened in 1954, was a focal point for Color-Field painting and monumental abstract sculpture.) But sustaining an art gallery within the perimeter of the city was proving more and more difficult, as Dawson noted. Another Walsh report in the Fall of 1975 described the closing of Archive Gallery on East Avenue while indicating, "The biggest changes are taking place at Shop One, now the New York Gallery at Shop One" (Walsh, Fall 1975, p. 2C). According to Cowles (2010a), the store's name change was Doug Baker's suggestion. Too, along with the name and manager change, the local aspect of Shop One diminished: "more and more artists from New York were brought in" (Cowles, 2010, slide 72). Walsh's story closes with a perhaps unintentionally ominous forecast by Smith: "'We're not closing by any means. The changes

POSTER FOR A FRANS AND LILI WILDENHAIN JOINT SHOW AT SHOP ONE
May 31 to June 27, 1975, 24 x 18 inches
Private collection

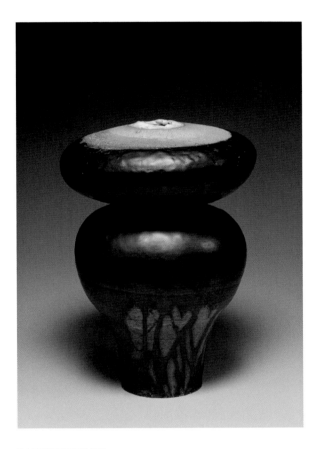

EARTHENWARE
15.5 x 10.75 inches, reduction fired

we've made this summer have not met with a lot of people's approval but if we hadn't made them we'd have closed this summer. Staying alive is what it's all about.'" Earlier in the report Smith mixes braggadocio with flattery: "The gallery is 'on an uphill swing,' Smith said. 'We're taking chances, laying out cash for advertising and considering opening a New York City branch.'" Walsh continues, "Smith believes strongly in the commercial gallery's role in the educational process." And, "Smith is very optimistic about Shop One and the market for crafts. 'Rochester is now on the right side, there's nothing negative in the picture, there is interest, it's ready.'" Again quoting Smith, Walsh reports: "'People are coming to realize that art is something for the soul.'" "Shop One, he concedes, sells both the decorative Marimekko fabric and first rate paintings but Smith has made it a point to separate them."

Neither the bragging nor the optimism lasted very long. Within six months, the New York Gallery at Shop One on Alexander Street closed. In a March 4 notebook entry, Frans Wildenhain tallied the costs of Shop One's operation at more than $16,000 annually, including the $650 monthly rent. Below the total he wrote: "Who the h ... can pay for that" (Wildenhain, 1975–1976). The same entry indicates a meeting about Shop One that he did not attend, though "Barbara went." At that meeting, apparently Wendell Castle suggested relocating the Shop to his home in Scottsville.

A few pages later, Wildenhain writes: "Shop One is gone. March 15 Alexander St. is closed. Plans to continue in Scottsville at Wendell's." The move to Alexander Street had tripled the shop's expenses but "the sales had not" (Cowles, 2010, slide 72).

Again, Walsh reported, "The owners say they are moving because the experiment proved economically unviable due to the recession, high overhead and a lack of Rochester sophistication but the recently resigned manager Gary Smith had another story" (Walsh, March 26, 1976). Reporting in the *Democrat and Chronicle*, Walsh's story revealed a clear and unresolvable tension between manager Smith and the Shop One partners: he claiming to have authority to initiate and shape the direction of Shop One, perhaps including his own vision for it; the partners insisting that Smith was hired to execute the decisions they had arrived at (Walsh, March 26, 1976). According to Smith, "It was my stipulation when I was hired that I was to run the place, but they [the partners] tried to put their fingers back in the pie rather than let things develop" (quoted in Walsh, March 26, 1976). It was meddling by the partners, not the location, that was the problem, according to Smith: "Rochester is ready for first class art," he said.

Walsh's reporting is a thumbnail history of Shop One following Smith's hiring. His first move, she wrote, was to change the look of Shop One from what he called a "flea market" to an art gallery. "Everything was just thrown

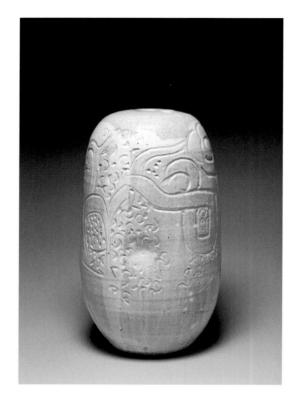

EARTHENWARE
20.25 x 11 inches, reduction fired

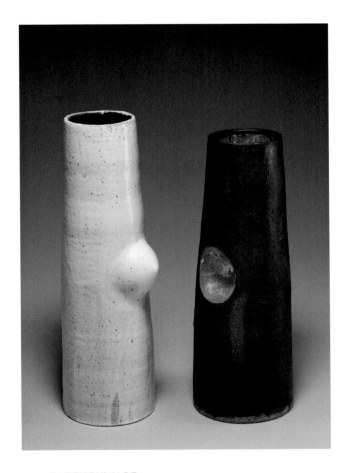

LEFT: **EARTHENWARE**
27 x 8 inches, reduction fired

RIGHT: **EARTHENWARE**
24.75 x 8.5 inches, reduction fired

together," Walsh reports Smith as saying: "100 things on a shelf by 100 different craftsmen. Nothing could make an impact. This was where my personal philosophy of art and objects came to the foreground. I tried to make every artist's work have an impact" (quoted in Walsh, March 26, 1976). One recalls the 1956 *Craft Horizons* story: Shop One, "the only store in the city selling nothing but hand crafts," offers merchandise displays such that, "The total effect is uncluttered and casual. Each craft seems to enhance the others. The customer gets the clear idea of what a particular object will look like in a tastefully decorated room" (Brown, 1956, pp. 20–21). Walsh's reporting continues, quoting Smith: "'My expectations had been a four- or five-year grind The [partners] couldn't see the larger picture Shop One didn't need saving. It just needed to be left alone. There were too many people involved. It was a clash of egos and somehow there was an inability of the craftsmen-owners to see how an art gallery, as opposed to a retail shop[,] works'" (quoted in Walsh, March 26, 1976).

Walsh's report of Shop One's closing also presented the partners' announcement that they would move to ceramist Nancy Jurs' studio in Scottsville, 15 miles from Alexander Street, where it would be open on weekends. A May 14, 1976, *Democrat and Chronicle* art column without a byline reported, "The City of Rochester's loss is Scottsville's gain." The story indicates Shop One moved from Alexander Street to 11 Maple Street, Scottsville, and held its opening

May 8, 1976. "Shop One also plans to open a branch in the new [strip mall] shopping center, Hippopotamus, across from Monroe Community College and add new partners" (untitled clipping, May 14, 1976). Shop One at Hippopotamus, the column continued, would "focus on well-designed high-volume items such as Marimekko fabric and plastic household goods. Then the Scottsville gallery will handle the slow-moving one-of-a-kind collector's items exclusively." One notes the Scottsville location's emphasis on exclusivity, including its modest operating hours, "collector's items," and by exclusion, the goods community college students could afford.

An undated black and white *City Newspaper* advertisement for SHOP ONE AT HIPPOPOTAMUS taped inside Frans Wildenhain's 1975–76 notebook announces "a new collection of sculpture and pottery by FRANS WILDENHAIN beginning October 20th." The store was located at 125 White Spruce Boulevard, and the ad indicated, "the artist will be on hand to receive patrons" from 4 to 6 p.m. In the same notebook, next to the ad, in Wildenhain's hand is this entry: "Bob [Johnson] bought 2/3-plus, must be 2000 [dollars]. Oct. 20" (Wildenhain, 1975–1976). Wildenhain, the longest lasting of the four original Shop One principals, bore, and perhaps fostered, the symbiotic push and pull between creativity and commerce. Bauhaus to the end. The Shop One outlet at Nancy Jurs'

studio in Scottsville was open on Saturdays and the outlet at Hippopotamus for about a year "then it just died" (Jurs, 2011).

CONCLUSION

At the beginning of the 20th century, Biloxi potter George Ohr and East Aurora, New York, marketer Elbert Hubbard separately though similarly exploited their quirky, eccentric personalities and appearances for self-promotional purposes. Ohr was a potter—a creator; Hubbard fancied himself an author but was more a tireless marketer and (self) promoter. Hubbard was financially far more successful than Ohr because he recognized, embraced, and practiced modern advertising and public relations. Like Shop One a half-century later, the Ohr and Hubbard enterprises appealed to a similarly slender, shallow, and homogenous consumer base. Of the three, Hubbard's Roycroft enterprise lasted longest and was the most successful at its time. Beginning with a small-scale print shop, Hubbard built an entire campus comprised of various workshop and manufacturing buildings for leather, metal, and wood products as well as an Inn to accommodate guests and a Chapel where lecturers of international reputations could address audiences. Despite the sliver-sized population that was both literate and with financial means, Hubbard's Roycroft for more than three decades sold books, magazines, and inspirational pamphlets

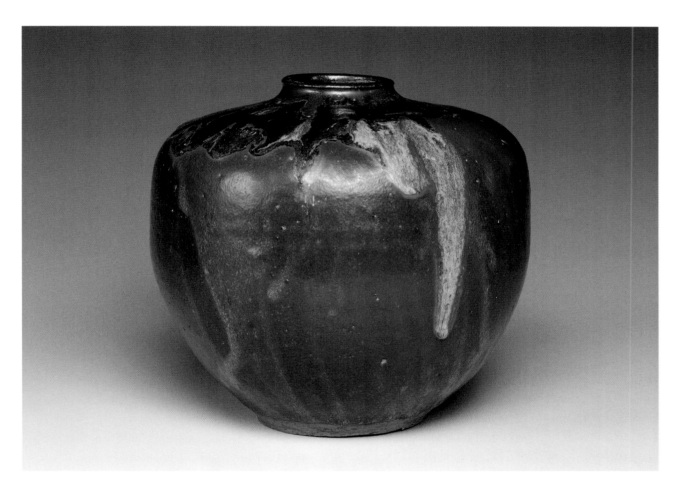

STONEWARE
9.25 x 10.75 inches, reduction fired

as successfully as he previously had sold soap for nearby Buffalo's Larkin factories. Shop One lacked Hubbard's promotional ingenuity. [9] At Shop One, the principals were experienced and widely recognized creators of various crafts; as businessmen, they were amateurs working at an enterprise for which there were few business models and against formidable odds.

The construction of expressways slicing through downtown Rochester began in the 1950s when the city's population was in excess of 300,000.[10] The demolition of once grand homes and neighborhoods to accommodate roadways, coupled with mid-'60s urban "unrest," produced vacant or deteriorating residences, and signaled clearly the demise of downtown Rochester. The highway construction was completed in the late '60s, but like many once-thriving urban areas, businesses, customers, and residents moved from the city's core gradually outward to once rural areas. Attention to and the value of residential properties in the city slid, sometimes precipitously. Not until the late 1970s and early 1980s did urban gentrification—accompanied by its own set of problems—began to take hold.

The first part of Shop One's tenure occurred at a time when not only was it common, it was part of the ritual for women to wear white gloves and men to don hats for their trips downtown. By the late 1960s, the uniform most commonly seen was decidedly more casual. Progressive rock and free-form radio on the FM band began to break

the tight Top-40 "teeny-bopper" AM radio music formats and their audiences. Thanks to a film classification system initiated at the end of 1968, movies gained license to show and tell whatever they pleased without prior restraint. More importantly for the present context, consumer behaviors began to change (for a recent discussion see Binkley, 2007). In many ways, the 1970s counterculture functioned as the antithesis to trained craftspeople. In tandem with population shifts, movements and changes in retail venues and inventories, attrition among the Shop's founders, various social alterations were not harmonious and compatible with Shop One's wandering management, brand, principles of operation, and inventory. As sure as Camelot ended for Arthur, so, too, did it end for Shop One.

Shop One's principals lacked awareness of the significance of their novel enterprise. As the simplest of examples, they "never took any pictures at the openings," and "did not keep any records," neither sales nor shipping receipts (Cowles, 2010a). The Shop never developed a clear and coherent marketing plan; it had a limited repertoire of advertising and promotional strategies. Its customers wax warmly nostalgic, and frequently at great length, about their visits to the shop and the specialness of the experience as much as the goods they purchased; its customers, though, were a tightly knit, homogenous cohort that did not expand meaningfully. Shop One's crafts felt justifiably personal to their customers. The genuinely unique qualities

of handcrafted goods helped to extend a kind of shared proprietorship between customers and creators. Shop One left a profound legacy that includes more than 70 craftsmen whose work it represented and, in some cases, Shop One provided the platform upon which their own success was built. Too, the Shop One model served well as a reference point for other business operators. Two former managers, for instance, each initiated their own craft galleries: Barbara Newton Towner, the earliest manager, opened and operated Cloud 7 in Aiken, South Carolina, from 1957 to 1971 and Betty Tinlot, who held the longest tenure as manager at Shop One, opened and operated Ten Arrow Gallery in Cambridge, Massachusetts, for 20 years (1969–1989).

In 1968, the old Third Ward area surrounding Shop One's Troup Street location began hosting a small, neighborhood craft fair: the Corn Hill Festival. Today, ironically, the Corn Hill Festival gathers some 400 craftspeople and draws a quarter million visitors over two days each July. Ahead of its time, Shop One made possible the large-scale market for crafts.

NOTES

[1] I intentionally omit television from this list as it was just beginning its diffusion. TV would soon usurp the content role previously held by movies (i.e., conservative family fare). Because TV siphoned off its audiences, movies turned to more adventuresome content.

[2] The brief report of the convention was followed by an article entitled, "The Future of Handicrafts" cited by Mainzer (1988, p. 260).

[3] An example of Shop One letterhead stationery states: "24 Ford St. Rochester 8 N.Y. Hamilton 5178". Shop One collection. University of Rochester, Rush Rhees Library, Department of Rare Books and Special Collections. Rochester, NY.

[4] Martin (2011) reports the University of Rochester's "old" campus (1861–1930) was located in the square bounded by University Avenue, N. Goodman Street, Prince Street, and College Avenue. "The College for Men relocated to the River Campus and the College for Women remained behind until 1955, when the separate colleges were merged into one and the women students joined the men on the River Campus."

[5] Organized by curator Edgar Kaufmann Jr., his family were the well-known department store

retailers who had fully embraced modernism with their Frank Lloyd Wright commission for Fallingwater in the late 1930s. "Modern" refers as much to a style as it does a point in time. For the first reference, "modern" is also a retrospective term, since contemporary buyers likely call what they purchase "new," not modern. Modernism also can be a marketing problem, since the futuristic-sounding "modern" is not synonymous with "mainstream." Whereas the MoMA exhibit title asserted, curator Edgar Kaufmann inquired as in his text's title: *What is Modern Design?* An October 21, 1951, *Los Angeles Times* "Home" magazine cover is titled, "What Makes the California Look" without punctuation. The cover's photo depicts a broad range of modern objects in a room setting. Although Kaplan (2011, p. 27) contends the *Times* asked a "question so pressing it was posed on the cover," I argue the *Times* was making an assertion about style, not an inquiry.

6 Financial records for Shop One could not be located for scrutiny. However, among Frans's personal records (in a private collection) is the notation for January to June 1971: "$706.01 income from Shop One." And, in the same collection, his 1970 Federal tax return reports $4244 in sales at Shop One with $939 in profit reported on Schedule C.

7 The stylized fictional nostalgia of the advertising industry as presented by television's *Mad Men* is

today's magnetic "camp;" exposure to actual examples of 1950s and '60s advertising artifacts is less compelling. When we encounter the artifacts, we think them unsophisticated and naïve. Doubtless, this is a function of presentism: the complaint that yesterday's work fails to measure up to today's more evolved and enlightened standards—standards that, by the way, we congratulate our present selves on innovating and implementing.

8 Today, in addition to all the direct "junk" mail arriving in one's mailbox, is the spam filling one's email box. The push medium driver for the present exhibition, intended to move people to the exhibit's website, was a two-sided postcard snail mailed to galleries across the country.

9 Shop One also lacked Hubbard's substantial financial backing. Hubbard resigned from Larkin in 1893, receiving an approximately $65,000 settlement from the firm (Quinan, 1994, p. 7).

10 By 2000, Rochester had lost 34 percent of its 1950 population. New York State (2004, p. 7) reports population figures for Rochester sliding from 332,488 in 1950; to 318,611 in 1960; 296,233 in 1970; 241,741 in 1980; 230,356 in 1990; and 219,733 in 2000.

REFERENCES

Aerni, April Laskey (1987). *The Economics of the Crafts Industry*. Unpublished doctoral dissertation, University of Cincinnati.

American Studio Ceramics 1920–1950 (1988). Minneapolis: University [of Minnesota] Art Museum.

Austin, Bruce A. (1986). "Cinema Screen Advertising: An Old Technology with New Promise for Consumer Marketing." *Journal of Consumer Marketing*, 3, Winter, pp. 45–56.

Baker, Douglas (2010). Personal interview with Bruce A. Austin, April 22.

Binkley, Sam (2007). *Getting Loose: Lifestyle Consumption in the 1970s*. Durham, NC: Duke University Press.

Braznell, W. Scott (1999). "The Early Career of Ronald Hayes Pearson and the Post-World War II Revival of American Silversmithing and Jewelrymaking." *Winterthur Portfolio*, 34 (4), Winter, pp. 185–213.

Brown, Conrad (1956). "Shop One: Here is a Model for Craftsmen Who Dream of Opening a Retail Outlet." *Craft Horizons*, 16 (2), March/April, pp. 18–23.

Bullard, Helen (1976). *Crafts and Craftsmen of the Tennessee Mountains*. Falls Church, VA: Summit Press.

Clark, Garth (2000). "Otis and Berkeley: Crucibles of the American Clay Revolution." In Jo Lauria (Ed.), *Color and Fire: Defining Moments in Studio Ceramics, 1950-2000* (pp. 123–156). NY: Rizzoli.

Cowles, Barbara (1975, March 29). Letter of resignation, carbon copy. Collection of Douglas Baker.

Cowles, Barbara (2010). "Shop One—Four Craftsmen & a Dream." PowerPoint presentation.

Cowles, Barbara (2010a). Personal interview with Bruce A. Austin, April 1.

"Craftsmen Exhibit Work in Troup St. Shop" (1953, November 12). *Rochester Times-Union*. Shop One collection. University of Rochester, Rush Rhees Library, Department of Rare Books and Special Collections. Rochester, NY.

"Craftsmen Open Studio in Reconverted Loft" (1953, January 23). *Rochester Times-Union*. Shop One collection. University of Rochester, Rush Rhees Library, Department of Rare Books and Special Collections. Rochester, NY.

Dawson, Shirley (2008, 30 April). "Look Into the Future." http://rochesterartreview.blogspot.com/search?updated-min=2008-01-01T00%3A00%3A00-08%3A00&updated-max=2009-01-01T00%3A00%3A00-08%3A00&max-results=9

Dienstag, Eleanor (1972, September 26). "Happy Birthday, Shop One." *Upstate* (Rochester *Democrat and Chronicle*, Sunday magazine). Shop One collection. University of Rochester, Rush Rhees Library, Department of Rare Books and

Special Collections. Rochester, NY.

Edwards, Robert (2004). "Robert Reviews, *Byrdcliffe: An American Arts and Crafts Colony*." Swarthmore, PA: Robert Edwards American Decorative Arts.

Eris, Alfred (1951, May). "They Learn Crafts for Careers." *Popular Mechanics*, 97, pp. 143–146.

Falino, Jeannine (2010). "Restless Dane: The Evolving Metalwork of John Prip." *Metalsmith*, 30 (1), pp. 45–51.

Farmarco, Joe (1998). "Berry Picking: A Personal Portrait of the Craft of Albert & Edwina Berry." *Style 1900*, 11 (2), Spring, pp. 64–70.

Feuerherm, Kurt (2011). Telephone interview with Bruce A. Austin, October 4.

Fina, Angela (2011). Telephone interview with Bruce A. Austin, November 8.

Fish, Marilyn (2006). "Two Smiths of the West: Albert Berry and Dirk Van Erp." *Style 1900*, 19 (3), Summer/Fall, pp. 60–67.

"The Future of Handicrafts" (1918, March). *American Magazine of Art*, 9 (3), pp. 192–195.

Gernhardt, Henry (2011). Telephone interview with Bruce A. Austin, October 31.

Gordon, Dane R. (1982). *Rochester Institute of Technology: Industrial Development and Educational Innovation in an American City*. NY: Edwin Mellen Press.

Green, Nancy; Wolf, Tom; and Robertson, Cheryl (2004). *Byrdcliffe: An American Arts and Crafts Colony*. Ithaca: Cornell University Press.

Hill, Jeffrey (1989). "Albert Berry: A Northwest Craftsman." *Arts & Crafts Quarterly*, 2 (4), pp. 4–5.

Horton, Donald and Wohl, Richard R. (1956). "Mass Communication and Para-social Interaction: Observations on Intimacy at a Distance." *Psychiatry*, 19 (3), pp. 215–229.

Jackson, Julia Browne (2008). Letter to Barbara Cowles, September 8.

Jefferies, Janis (2011). "Loving Attention: An Outburst of Craft in Contemporary Art." In Maria Elena Buszek (Ed.), *Extra/Ordinary: Craft and Contemporary Art* (pp. 222–240). Durham, NC: Duke University Press.

Jowett, Garth (1976). *Film: The Democratic Art*. Boston: Little, Brown.

Jurs, Nancy (2011). Telephone interview with Bruce A. Austin, November 10.

Kadubec, Philip (2000). *Crafts and Craft Shows: How to Make Money*. NY: Allworth Press.

Kaplan, Wendy (2011). "Introduction." In Wendy Kaplan (Ed.), *California Design 1930–1965: Living the Modern Way* (pp. 26–59). Cambridge: MIT press.

Kestenbaum, Stuart (2006, Fall). "From the Director." *Haystack Gateway*, p. 1.

Keyser, William (2011). Telephone interview with Bruce A. Austin, November 2.

Korde, Kurt (1955, July 10). "Greenwich Village Rises in City: Old Third Ward Changes." Rochester *Democrat and Chronicle*, p. 3B. Shop One collection. University of Rochester, Rush Rhees Library, Department of Rare Books and Special Collections. Rochester, NY.

Krakowski, Lili and Cowles, Barbara (n.d.). "The Making of Heirlooms." Unpublished manuscript.

Ludwig, Coy L. (1983). *The Arts & Crafts Movement in New York State, 1890s–1920s*. Hamilton, NY: Gallery Association of New York State.

Mainzer, Janet C. (1988). *The Relation Between the Crafts and the Fine Arts in the United States from 1876 to 1980*. Unpublished doctoral dissertation, New York University.

Martin, Nancy (2011). Email to Bruce Austin, November 29.

McCally, Karen (2007). "The Life and Times of Midtown Plaza." *Rochester History*, 69 (1), Spring.

McIlroy, Marjorie (1953). Letter dated September 26, 1953 to Virginia Jeffrey Smith. Shop One collection. University of Rochester, Rush Rhees Library, Department of Rare Books and Special Collections. Rochester, NY.

McKelvey, Blake (1956). "Rebuilding Rochester and Remembering Its Past." *Rochester History*, 18 (1), January.

McKelvey, Blake (1965). "Names and Traditions of Some Rochester Streets." *Rochester History*, 27 (3), July.

McKelvey, Blake (1970). "The Visual Arts in Metropolitan Rochester." *Rochester History*, 32 (1), January.

Nasstrom, Heidi (2008). *"Live in the Country with Faith": Jane and Ralph Whitehead, the Simple Life Movement, and Arts and Crafts in the United States, England, and on the Continent, 1870–1930*. Unpublished doctoral dissertation, University of Maryland, College Park.

New York State Comptroller's Office (2004, December). "Population Trends in New York State Cities."

"The 1917 Convention: The American Federation of Arts" (1917, July). *American Magazine of Art*, 8 (9), pp. 356–365.

"The Old Crafts Find New Hands" (1966, July 29). *Life*. Shop One collection. University of Rochester, Rush Rhees Library, Department of Rare Books and Special Collections. Rochester, NY.

Pearson, Ronald (1973). "John Prip." *Craft Horizons*, 33, February, pp. 20–25, 73.

"Priscilla Hardwick Merritt, 1913–1996" (2006, Fall). *Haystack Gateway*, p. 2.

Quinan, Jack (1994). "Elbert Hubbard's Roycroft." In Marie Via and Marjorie B. Searl (Eds.), Head, *Heart and Hand: Elbert Hubbard and the*

Roycrofters (pp. 1–20). Rochester, NY: University of Rochester Press.

Robbins, Rogene A. and Robbins, Robert O. (2003). *Creating a Successful Crafts Business*. NY: Allworth Press.

Rosen, Wendy (1998). *Crafting as a Business*. Baltimore: The Rosen Group.

Rouse, Marilyn (1953, December 11). "Shop I Offers Unique Gifts to Harried Shoppers." *The Tower Times*. Shop One collection. University of Rochester, Rush Rhees Library, Department of Rare Books and Special Collections. Rochester, NY.

Sager, Susan J. (1998). *Selling Your Crafts*. NY: Allworth Press.

Schwartz, Alexandra (2010). *Ed Ruscha's Los Angeles*. Cambridge: MIT Press.

"Shop One: A Unique Craftsmen's Venture in Rochester N.Y." (1954, Summer). *Handweaver & Craftsman*, pp. 45–46. Shop One collection. University of Rochester, Rush Rhees Library, Department of Rare Books and Special Collections. Rochester, NY.

"Shop One Center Adds Three Partners" (1972, March 16). *Rochester Times-Union*, March 16, 1972. Shop One collection. University of Rochester, Rush Rhees Library, Department of Rare Books and Special Collections. Rochester, NY.

"696 Gallery Expands; Shop One Move Nears" (1972, March 14). *City East*. Shop One collection. University of Rochester, Rush Rhees Library, Department of Rare Books and Special Collections. Rochester, NY.

Smith, Henry Bradford and McKelvey, Blake (1968). "Rochester's Turbulent Transit History." *Rochester History*, 30 (3), July.

Smith, Virginia Jeffrey (1955, November 17). "Modern Sculpture Rates Praise in Local Show." *Rochester Times-Union*. Shop One collection. University of Rochester, Rush Rhees Library, Department of Rare Books and Special Collections. Rochester, NY.

Toffler, Alvin (1973). *The Culture Consumers: A Study of Art and Affluence in America*. NY: Vintage Books.

Unidentified source (1959, November 12). Clipping. Shop One collection. University of Rochester, Rush Rhees Library, Department of Rare Books and Special Collections. Rochester, NY.

Untitled clipping (1976, May 14). *Democrat and Chronicle*, p. 2C. Shop One collection. University of Rochester, Rush Rhees Library, Department of Rare Books and Special Collections. Rochester, NY.

Walrath, Jean (1963, May 5). "Sculptures Fashioned of Wire and Air." *Democrat and Chronicle*, p. 10E.

Shop One collection. University of Rochester, Rush Rhees Library, Department of Rare Books and Special Collections. Rochester, NY.

Walsh, Sally (1975, June 27). "Big Changes at Shop One." *Democrat and Chronicle*. Shop One collection. University of Rochester, Rush Rhees Library, Department of Rare Books and Special Collections. Rochester, NY.

Walsh, Sally (1975, Fall, undated clipping). "It Was a Long Haul to Sell Art." *Democrat and Chronicle*, pp. 1, 2C. Shop One collection. University of Rochester, Rush Rhees Library, Department of Rare Books and Special Collections. Rochester, NY.

Walsh, Sally (1976, March 26). "Shop One Takes a Step Back." *Democrat and Chronicle*, pp. 1, 2C. Shop One collection. University of Rochester, Rush Rhees Library, Department of Rare Books and Special Collections. Rochester, NY.

Waters, Deborah Dependahl; Cunningham, Joseph; and Barnes, Bruce (2011). *The Jewelry and Metalwork of Marie Zimmermann*. New Haven: Yale University Press.

Wildenhain, Frans (1976–1976). Notebook. Paul Rankin collection, gift in memory of Lili Wildenhain, RIT Archives.

Windschuttle, Keith (1986). *Working in the Arts: A Guide for Enterprise, Employment and Assistance*. St. Lucia: University of Queensland Press.

Winebrenner, D. Kenneth (1956, January). "Shop One." *School Arts*, pp. 29–32. Shop One collection. University of Rochester, Rush Rhees Library, Department of Rare Books and Special Collections. Rochester, NY.

Wolfard, Clara (2003). "Perspectives on Art and Community: A Personal Odyssey." *Rochester History*, 65 (3), Summer.

Wolfe, Tom (1972). *The Kandy-Kolored Tangerine-Flake Streamline Baby*, pp. 62–89. NY: Pocket Books.

Wood, Jane (1973). *Selling What You Make*. Baltimore: Penguin Books.

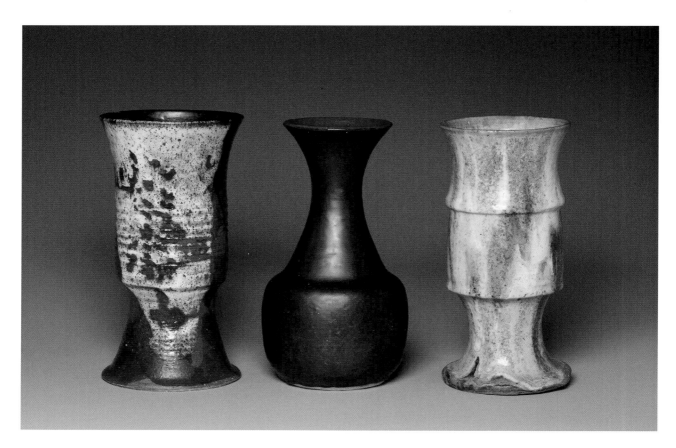

LEFT: **STONEWARE**
10.5 x 5.5 inches, reduction fired

CENTER: **STONEWARE**
10.25 x 6 inches, oxidation fired

RIGHT: **STONEWARE**
10.25 x 5 inches, reduction fired

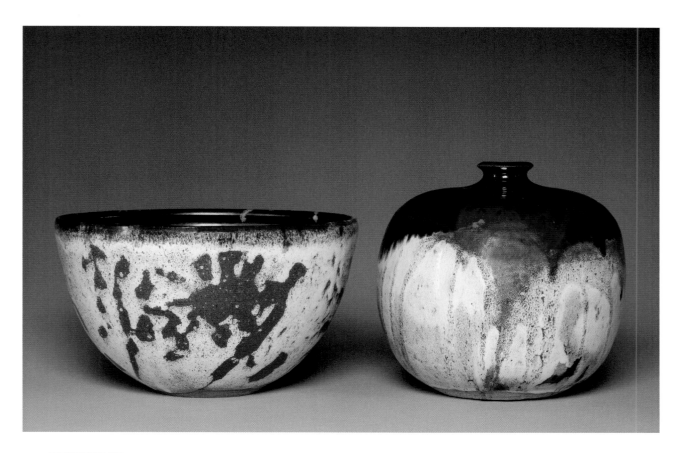

LEFT: **STONEWARE**
6.25 x 10.25 inches, reduction fired

RIGHT: **EARTHENWARE**
8 x 9.5 inches, reduction fired

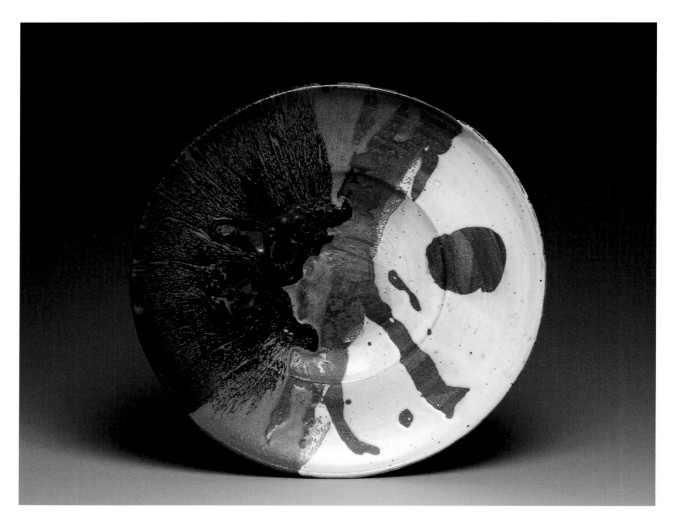

EARTHENWARE
2.5 x 17 inches, reduction fired

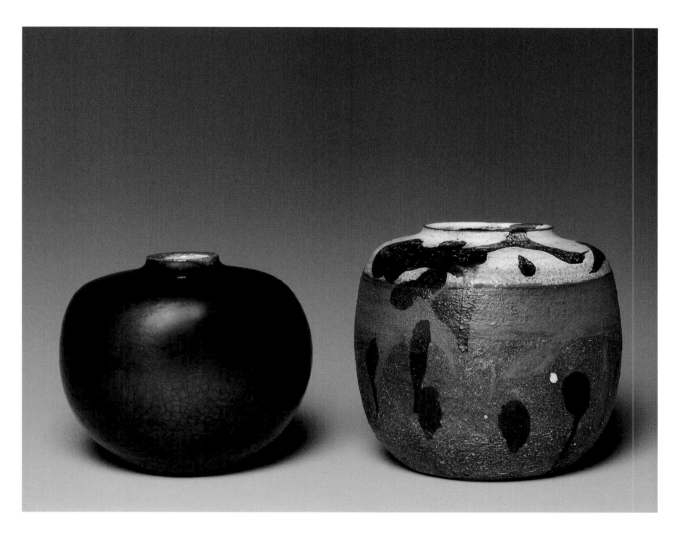

LEFT: **EARTHENWARE**
7 x 6 inches, reduction fired

RIGHT: **EARTHENWARE**
7.5 x 6.75 inches, reduction fired

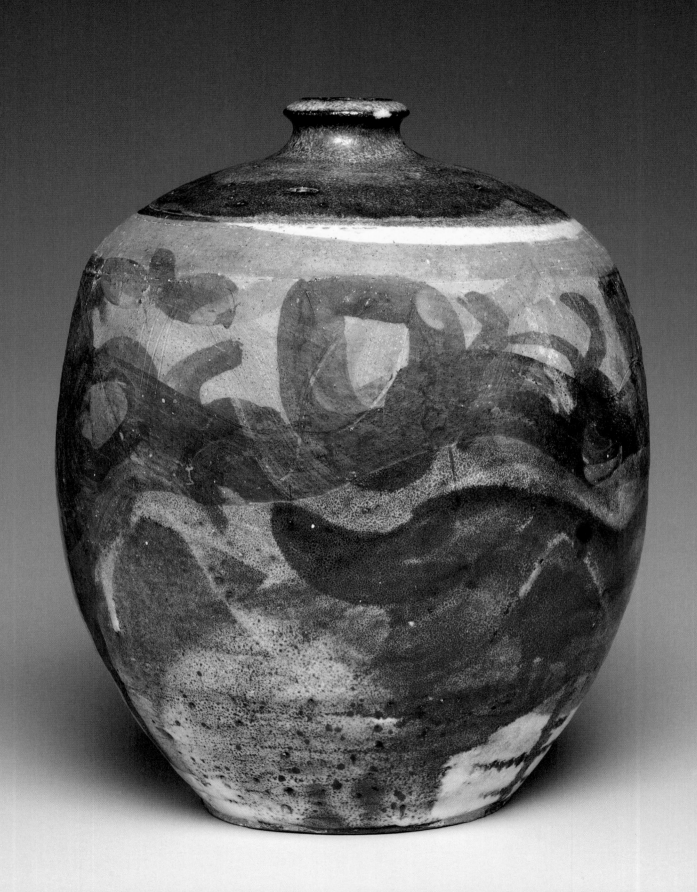

6

INTERVIEW WITH ROBERT BRADLEY JOHNSON

BRUCE A. AUSTIN

I told [then] RIT President Albert Simone that what I liked about Wildenhain's pots was that they were spooky. He asked, "Is that the technical term?" (Robert Johnson, 2011)

In mid-2010, Robert Johnson donated his collection of 330 pieces of Frans Wildenhain pottery to RIT. He credits RIT ceramics Professor Rick Hirsch, also one of Wildenhain's last students, for planting the idea that led to the gift. Beginning with his first purchase at Shop One in 1955, Bob collected steadily, enthusiastically, and voraciously, for more than a quarter century, assembling the largest and most diverse single-owner collection of Wildenhain's work from across the artist's most prolific period. He was driven and decisive. "I didn't poke around and was always number one in line when he had a show," Bob reports. Too, he remembers, "My last contact was with Lili," Frans's third wife. "I went to a private sale, when things from their house were offered. The only item I bought, of all things, was a millstone. And I don't know how I did that. I had a Volkswagen at the time."

Today, Johnson lives with Winn McCray in a rural country farmhouse outside of Rochester that they purchased in 1971, restored, and, over the years, expanded. Impeccably

EARTHENWARE
9 x 6.25 inches, reduction fired

furnished and decorated, it's set-ready for an upscale magazine's photographer. The couple is as comfortable with one another as the visitor is in their company. Each is soft-spoken yet effervescent, dryly humorous while reflective. They don't complete one another's sentences as much as they embellish and footnote them. At one point, as we discussed where and at what cost Bob had purchased Wildenhain pots, Winn disappeared to another room and returned moments later with a folder containing a few dozen early '70s original receipts—some from Shop One, others from Frans's Laird Lane home. Later, as Bob discussed a building, Winn drew down a volume from the bookshelves and leafed through the text until he found the building being discussed. He then opened the book to the title page, showing me architect Philip Johnson's inscription to Bob's father.

I met with Bob and Winn on several Fall 2011 Wednesday afternoons. Each time we took our assigned seating, such that all were afforded a wonderful view of the gardens and expansive property. Sunlight streamed into the room through nearly floor-to-ceiling glazing. Bob sat in an armchair next to a table lit by the Wildenhain lamp that was among his first purchases; Winn sat in another armchair at Bob's left; and I held down one end of an eight-foot sofa. The space they live in is generous—not palatial, but comfortably large. Still, it is difficult to imagine where more than 300 pieces of pottery once had been placed, without stacking them up like cordwood. The cathedral-ceiling room

is substantial and bright, visually monopolized by a Steinway concert grand piano. Surprisingly, the instrument does not spatially dominate the room. One wall is wholly comprised of glossy, white painted built-in bookshelves where novels amicably share space next to scientific journals, museum catalogs, and nonfiction works on contemporary social concerns.

"You can't keep all of them," Bob says about the size and breadth of their collections. "But Winn doesn't like to throw things out." Winn adds: "Neither one of us does. It just piles up. But we throw out different things." At least initially, Bob dismisses any notion that he was a collector prior to encountering Wildenhain's ceramics. In fact, he had an interest and was actively engaged in collecting well before arriving in Rochester.

The easy conversational path we enjoyed during those visits mirrored the process that led to Bob's fascination and devotion to "The Collection." The asides ranged seamlessly from global warming and hydro-fracking to speculation on the universe's size and late '50s social life among Rochester's art and music lovers. But these listen better than they read. And so the text that follows is Bob speaking to readers, the stitched-together product of about seven hours of conversation and absent the kibitzing of an interviewer.

● ● ●

ROBERT JOHNSON AND WINN MCCRAY IN
THE LIVING ROOM OF THEIR HOME, 2010

I was afraid to meet Frans Wildenhain the first time. Nobody seemed to have as big a personality as he did. But he was very nice, very friendly, and with a certain aura of, "Well, here's somebody important." He had "star quality," as our friend George Pratt used to say. [Pratt, 1914–88, curator of film at the International Museum of Photography, was author of *Spellbound in Darkness: A History of the Silent Film*, 1966.] That someone was a "star type" meant they had a magnetism making them the center of attention, were difficult to deal with, and you just couldn't take your eyes off them. There was a command that emanated from him. Frans invited me to his house for parties and things. Not very many, you understand. We weren't best friends, not what you'd call "bosom buddies;" I was kind of on the outskirts. Mostly, I went to the big party on his birthday in the spring. The tree peonies man, Bill Gratwick, would be there with peonies blossoms. And Frans would introduce me to everyone as the person who allowed him to put a new roof on his house.

There's nothing I'm aware of in particular that steered me toward collecting. I think it was just genes. My parents' genes.

My father was a commercial architect in New York. A specialist in marble and stone, further specializing in buildings such as synagogues, he worked with architect Philip Johnson [no relation] on different buildings, including Lincoln Center. There was a nice write-up about my father

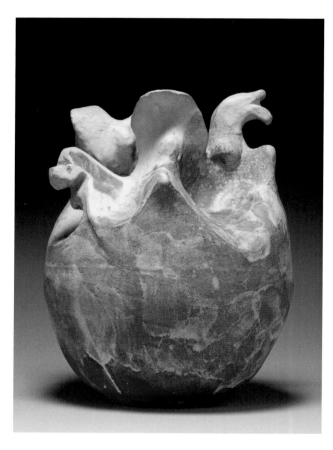

STONEWARE
18 x 14.25 x 13.75 inches, reduction fired

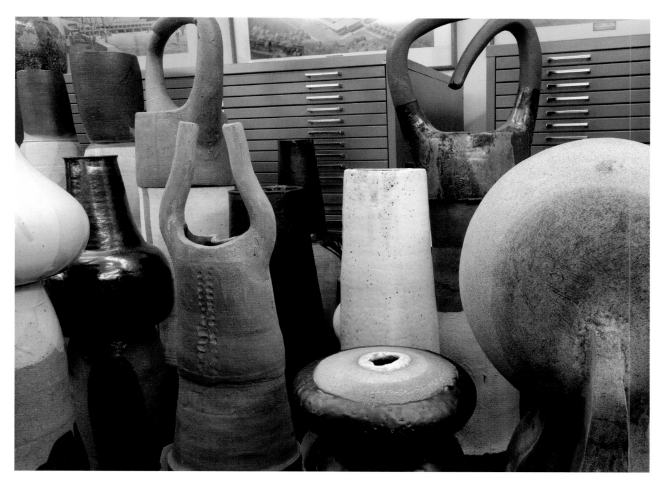

A SMALL PORTION OF THE JOHNSON COLLECTION
OF WILDENHAIN POTTERY AS IT ARRIVED AT THE
RIT ARCHIVE, JULY 2010

in *The New York Times* with pictures of his beautiful marble stairway, leading from the lower floor to the ticket offices for the New York City Theater in Lincoln Center. It was a wowser! But my father was very "ehh" about it.

Philip said my father was going to be given the marble and stone job for the Chippendale-top building in New York [originally AT&T, now Sony]. But my father didn't want to do it because he had to walk up and down so many stairs to get to the site from the subway. And he was having problems with angina. So Philip told him, "Well, just have a heart bypass, like I did." Just a little operation—that was his attitude!

One time, when I was visiting my parents for the weekend, my mother and father were invited to a party out at Johnson's Glass House [built in 1949, in New Canaan, Connecticut]. "Oh," my mother said, "I don't want to go there again." But I said, "I'd love to!" and went along. The occasion was a meeting of a bunch of architects from Europe. Most were dressed in shorts and socks. It was just sort of a casual party. Philip Johnson introduced my father to everyone as, "The greatest stone man in the country." A friend of mine said, "I wonder what he meant by that?"

What kept me going with my collecting was that I found Wildenhain's pottery more interesting than most of the alternatives. Wildenhain never ran out of inspiration. He once spent a winter in Key West and later created a pot called Key West Afternoon. It's a beautiful blue on bottom

and quite handsome. His work didn't telegraph a singular "style." The pottery didn't evoke from the viewer, "Oh, this is the style of this guy. What's his name?" The pots by other artists were very useful and nicely made, but after a while they became tiresome. Wildenhain liked to do creative things, and most people are a little wary of that: when the art is a bit too "off" from what they've seen and are used to. A lot of potters strive for perfection of glaze and form. And I can appreciate that, but it gets dull after a while. Frans was more creative and was willing to try things that no one else thought of. Of course, the problem with being a big fish in a small pond is when the mud puddle you settle into dries up more rapidly than you thought it would; it's sort of like being a frog in Texas these days.

Some people concentrated on the imperfections as a reason to not buy something. But I tended to think, "Hmm, that's interesting." For reasons that are probably most peculiar; I'm being facetious, because it's hard to say. What it's most like is performance in music, where between one fine performance and another you can get conductors who produce very different results. And the difference between them is barely detectable, certainly not by most people, but it could be all the difference in the world, musically. In grammar school, I was always the smallest one in the class. I was also valedictorian, so I got beat up a lot. I received a scholarship to attend MIT and a scholarship to RPI [Rensselaer Polytechnic Institute]. And I also had one of

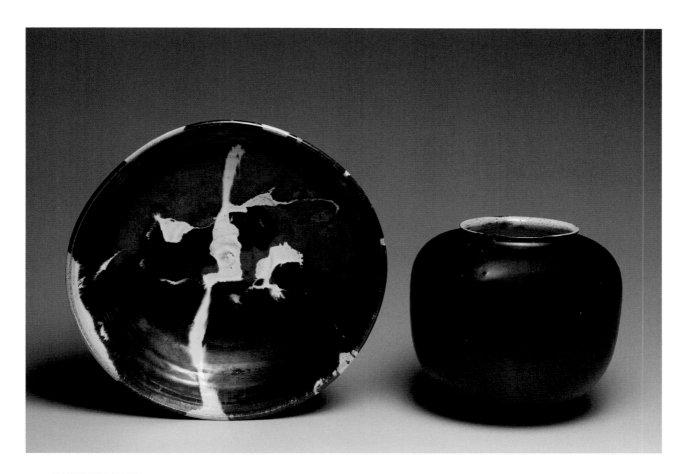

LEFT: **EARTHENWARE**
3.75 x 14 inches, oxidation fired

RIGHT: **EARTHENWARE**
9.25 x 9.75 inches, reduction fired

those four-year New York State scholarships to RPI. So I
went to RPI. One scholarship covered my tuition (back in
those days, tuition was $750 a year), and I started
collecting records as a freshman, using the money from
the other scholarship to buy them. I lived like there were no
money problems.

Although I started RPI studying chemistry, there was
something very unsatisfactory to me about it. I got tired
of all the long, complicated equations. Too, I wasn't awfully
good at mathematics. And my friends in the Chemistry
Department seemed to walk around with holes in their
pants and shirts, from acid dripping on them. But I liked the
physics classes, so I specialized in physics. But, really, all the
time I was much more interested in music and I wondered
why I was at RPI. My appreciation for music is a reflection of
my father's tastes.

For a while, I thought I might go on and get a doctorate
in Physics. A personal friend, who was a dean at the
University of Rochester, Arthur L. Assum, set up a meeting
for me with the head of the Physics Department. What
turned me off completely about getting the doctorate was
when the department head said: "You'll have to work on the
degree and not be interested in anything else; you have to
devote your entire life to it." And I thought: I'm not capable
of that. I think my friend put the Physics head up to it.

It was relatively easy for anybody who graduated from
a school like Rensselaer to get a job in those days. I got an
offer from RCA in New Jersey and from other places. I went

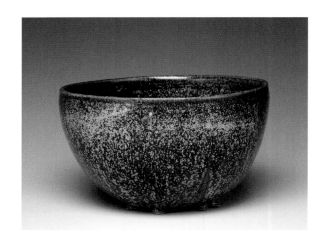

STONEWARE
5.75 x 9.75 inches, reduction fired

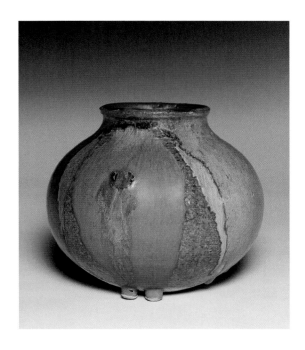

EARTHENWARE
8 x 7.5 inches, reduction fired
Private collection

to IBM for an interview, and everybody at IBM seemed to be wondering about me, "Who's this suspicious person, who's this stranger?" It was disturbing and unfriendly. Kodak recruited me and when I went there for my interview, I got on the elevator and everyone was bitching about the weather. And I thought: they do *this* in an elevator! Kodak was a better atmosphere and they were the most relaxed, fun group that I'd visited as a job candidate.

Since Kodak was Rochester based, it was also an ideal match for my interest in music. At RPI, I was the pianist for the glee club. There were all these singers and a conductor, and me, pounding away at the piano. What would be more perfect than to land in a place like Rochester, New York, because I was interested in technology and Rochester had the Eastman School of Music.

I came to Rochester in 1954 and my job was as an optical engineer for Kodak. It's kind of dull, really. Optical engineers design lenses, the shape of lenses, and lens combinations for, say, camera zoom lenses. If you were associated with a big university, the big university would have you peering through huge telescopes at the universe. Today, when I read the latest article about the number of stars and planets, they're talking about trillions of universes. My mind is completely blown!

It turned out to be relatively easy to collect Wildenhain pottery. Of course it took a while for me to collect all of these wonderful pots. I didn't buy them all on one day. And he didn't make them in one day, either. I accomplished it

when most people didn't like them. His work wasn't always practical, but that didn't matter to those who liked the shape of things. Back then, I was one of a few Wildenhain pottery collectors. There was another fellow in Rochester, a doctor who was enthusiastic about Wildenhain, too. He'd turn up at shows and I'd have to get there first, so I could get the good pieces. Sometimes maybe, all of the pots at the show. I think this is why Wildenhain at first had suspicions about me—so many of his pots in one set of hands. But I wasn't buying the pottery for fear that were it not for me, nobody else would preserve these things. I was buying them because I liked them. And I had enough money to be able to afford them; even though salaries were pretty good in those days, it was kind of piddling compared to what you can get today. I doubt the money made much of an impression on Frans. That's what made him so honest as an artist.

I worked at Kodak's State Street office and Kodak got me a room in the downtown YMCA. I moved in and wondered where the Eastman School of Music was—it was right across the street. Ideal! This was instant home. I had my own living room. The other good thing about the "Y," that few people knew about except for those "in the know," was that they had a fantastic chef and tremendous meals. It was usually possible to get Lobster Newburg and Roast Beef au jus with Yorkshire pudding. George Walker, a pianist and composer who made quite a name for himself, and I used to sit there and have meals with others all of the time. Too, the YMCA was a very convenient place to live since I didn't have a car at the time.

When I first got to Rochester I became a denizen of Kilbourn Hall. And I met Clair Van Ausdal, who told me about Shop One, had a car, and drove me there. The people running Shop One were friends of the artists, and the artisans themselves. Ronald Pearson would be there as a salesperson. Customers had contact with the people who created the crafts, although you couldn't count on it. Shop One was charmingly inefficient in that way, because the people working there were more interested in the artistic nature of what they were handling or working with than with the business of retail. I saw a painting at Shop One, liked it very much, and bought it. It hung for years in my apartment at the "Y." And the reason I moved out of the "Y" was because people were breaking in and stealing things from my room.

I also sang and was a paid tenor in local church choirs, including such places as St. Paul's, the Third Presbyterian Church, and one of the Lutheran churches. The choir members would scoot from one church to another, depending upon when they were hiring, or whether you knew the director, or where the director was going next.

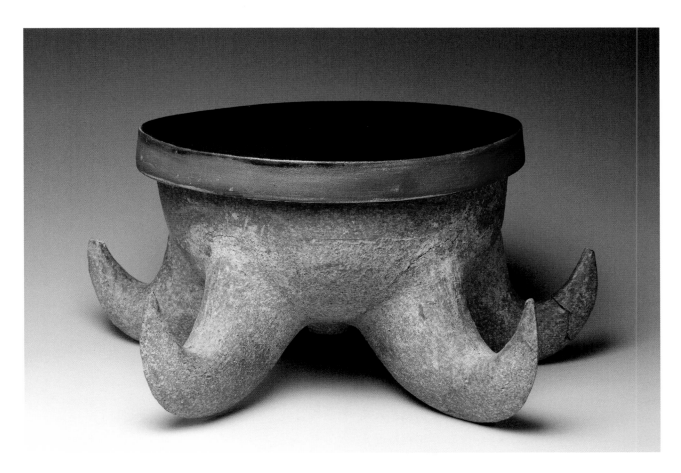

STONEWARE
9.5 x 20.5 x 19.5 inches, reduction fired

The best music we performed was at St. Paul's where we occasionally had an orchestra and David Craighead was organist.

Too, I studied piano at the Eastman School with Jose Enchaniz for quite a few years. He told me that I could become a concert pianist. And so there I was. I was not only working at Kodak, but also studying with one of the top people of the Piano Department at the time. However, the newspaper once reported the salaries of University of Rochester faculty. And what I read was that I was earning more at Kodak than most of the Eastman School faculty. I thought: maybe I should concentrate more on Kodak than on the piano. Plus, I was scared to death playing at recitals, which didn't say much for my future in music. Since I was enjoying what I was doing at Kodak, and began doing more interesting work there, I quit the piano lessons.

Because I was tied up with the School of Music, Kodak, and my interest in collecting records, collecting other things didn't really kick into high gear until I had a bit more space. Although, when I was an undergraduate, I bought a nice old camel blanket from a fraternity brother in 1952. He sold it to me because his fiancé said she would not live in a house with it there. "Period!" If I was a little bit braver I probably should have said, "Well, you shouldn't marry her." At any rate, I got the blanket and it's wonderful.

What started me collecting Wildenhains was when I moved into a large apartment at 7 Prince Street in 1959.

The apartment was in an old Victorian Gothic house that has since been turned into some sort of an office. I had the downstairs, front apartment with a living room—it was huge. And so I filled it up with things. I bought a contemporary credenza, for instance, and I needed a lamp to put on it.

I knew about Shop One. I went there, not particularly to buy a lamp, but they had a lamp for sale. It was wired up and everything. And I thought, "I need one of those." So I bought the Wildenhain lamp at Shop One, the first Wildenhain I ever bought. First pot I ever bought. I bought other things at other places, like pole lamps and God knows what else was popular back in the late '50s. That's how I got started, even though I was remarkably unaware of the finer points of ceramics. I didn't appreciate the lamp's artistic importance, I just liked the lamp. Later, I bought a few more Wildenhains and after a while, I had no place to put them. So then I thought, "Oh, I'll become a collector." And that's how I solved that problem.

Living right next door to us on Prince Street was A. J. Warner in a house built by his father, J. Foster Warner, a famous Rochester architect. A. J. was music critic for the newspaper and personal friends of the Duke and Duchess of Windsor, and he rode around Europe with opera singer Mary Garden one summer in her car. Warner hosted after-concert parties and invited the performers to his house. Practically every great musical artist who ever came to Rochester had been to a party there.

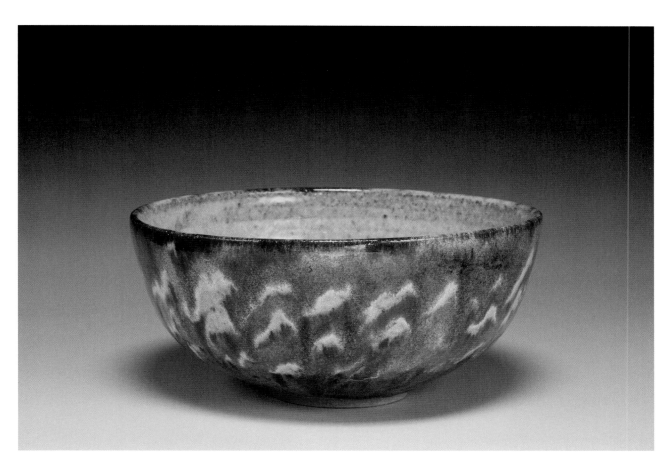

EARTHENWARE
4 x 9.75 inches, reduction fired

A. J. would invite me over to practice on his piano. It was the only one I used for a period of time. And this was right up my alley. I would move all the "Happy Birthday" cards and such that were on the piano and that came from the Duke and Duchess of Windsor, and put them on the nearby table, lift the lid to the piano, and pound away. It never occurred to me that I was carving off more than I could possibly chew. I was shameless!

Eventually, I was able to buy a small concert grand piano from a woman for a ridiculously low price. It hadn't been tuned since the '40s when her daughter left home. She had advertised it for $300. I went to see it and said I was interested in buying it. "Well," she said, "I can't sell it to you for that price now." "Why not?" I asked. And the lady replied, "Because I offered it to my neighbors for $100 less than the advertised price and they turned it down. So, now it will cost you $200!" I got the darn thing and moved it into the apartment. The neighbors would comment on how I would pound away on it incessantly. And then, didn't I get another larger piano, using the first one as a trade to purchase the concert grand. The piano dealer gave me a ridiculous price for the one that I had bought earlier.

Over time, my work at Kodak changed from what it was when I came in as an optical engineer. People there were aware, a great deal more aware than I, that I was probably in the wrong place. I started working on motion picture equipment and eventually I had 15 or more patents. All having to do with motion pictures. The one that I thought

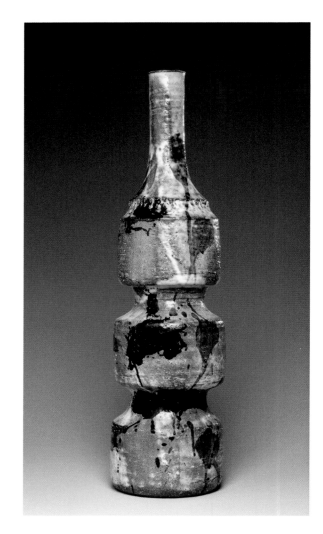

EARTHENWARE
24.5 x 6.5 inches, reduction fired

was the most important was the patent involving sound on 8-millimeter film. Then we went to Super-8mm, an attempt to make the maximum use of the width of the film to obtain the biggest, best picture quality. I was one of many engineers that Kodak had passed through trying to get this to work. I came up with a new approach, which I didn't know was new. I was just sort of young and stupid at the time. But it worked, even though everybody said it wouldn't. And of course it made obsolete everything out there. And everyone had to buy new equipment.

Sometimes it takes a couple hundred years before appreciation develops. Certainly that's true of musicians. There are some people who can't get enough of Wagner; I'm one of them. But a lot of people would turn it right off because it's so boring to them. For Wildenhain's pottery, and this is going to sound silly, I picked what I thought were the best pieces. I was able to tell instantaneously by looking at them. I wasn't comparing, since he didn't do a "series" that all looked approximately the same, and would have required a little bit more time to pick out the best of the bunch. The shape and the glaze of the pot were probably the most important aspects, if you have to create categories of importance, and the fact that there were these interesting imperfections. Every time you look at the piece you see something a little different. What I knew is that Wildenhain's works were not widely popular. And maybe that was another reason I was interested. Whatever I had gotten, and compared to other pieces from other potters in the area,

was interesting and usually pleased me. I am a great believer in what Oscar Wilde said: "I have the simplest of taste. I'm always satisfied with the best."

Once, somebody who worked for me, without telling me or telling anybody in the Kodak organization, sent in a die casting that we had come up with to see if we could win a prize in a trade magazine. It was a zinc die casting for holding mechanisms such as sprockets, bearings, shafts, those sorts of things. The prize was a cash award. And I won it. But I didn't know anything about it. Boy, was management ticked off because this was not allowed, for an individual engineer at Kodak to win an award that way. Especially if there was money involved. I took the check and signed it over to Rensselaer Polytechnic Institute, because they were always after me to give them money. That was a big mistake; then they put me in charge of our class contributions for the next year.

I ended up with an interesting career. I worked at Kodak at the State Street headquarters, out at Elmgrove, and then back to State Street again. For a long period, I went back and forth at least twice a year to California. Mostly to Los Angeles, sometimes San Francisco, for meetings of the Society of Motion Picture and Television Engineers. Kodak didn't make me a representative for the company to SMPTE, they made me an "observer." This was back when the planes had propellers.

While out West, I would take time off, drive up the coast to see the redwood forests and things like that. I had a lot of time to kill when traveling for the company. They didn't expect you to show up until about 9 o'clock in the morning, and then they all wanted to go home a little early. I visited art galleries wherever I could. And I remember there was a dealer who specialized in jade and had something I was interested in. However, it was very large and would have had to be shipped to Rochester, so I didn't buy it. As some people did with Wildenhain's work, I think I was just looking for an excuse not to acquire it.

When we were at Prince Street we had lots of plants. And we damaged the floor there because of our watering of the plants. When we moved out to the country, we asked the architect to put tile in front of this room's windows. That way we wouldn't wreck the floor. But he said that would look awful and to just do the whole floor in tile. One problem with this room, which is so long, is that it was designed to be an ideal size for a small concert hall and had to carry the sound. Putting in the tile floor, then laying oriental rugs around, and then placing the Wildenhain pots on top of the rugs and underneath the piano helped very much. We clustered the pots in a group and they added a little "extra" to the sound.

I went to Shop One to purchase Wildenhain pots in the relatively early days, before we moved out here. At

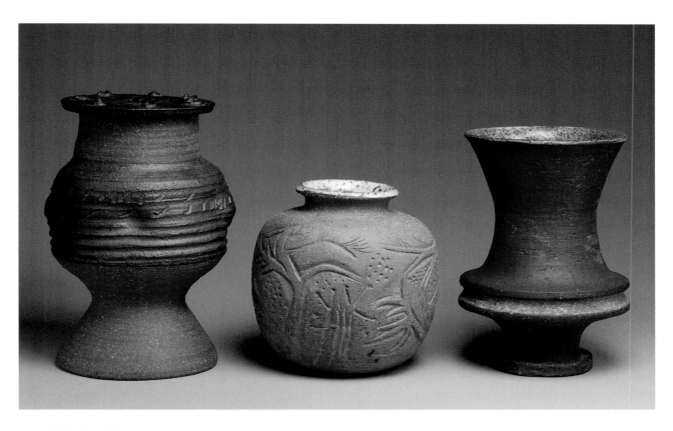

LEFT: **STONEWARE**
12.5 x 8 inches, reduction fired

CENTER: **STONEWARE**
9 x 8.75 inches, reduction fired

RIGHT: **EARTHENWARE**
11.5 x 7.75 inches, reduction fired

the Troup Street location they would have shows that were in one room and the other rooms had a stationary stock of materials. It struck me as not so much a shop, but a museum where you could buy things. Shop One was a terrific idea for a commercial place. But, when we moved out here, again blissfully unaware of the rest of the world, it was always such a long drive to wherever we wanted to go that we just worked in the yard instead of going anywhere. And there was so much to do here. We tried to make growing vegetables interesting, which turns out to be not an interesting thing at all. Because the biggest problem is you get too much and then you give it away, And when people won't take it, especially zucchini, then you have to freeze it or can it. Of course you can poison yourself with the canning process.

When Shop One moved to Alexander Street, it didn't work as well for us. They not only changed locations but the ambiance, the flavor of the place. Someone from New York City came in to run it, and they ran it like a New York City gallery. He'd show something that would last a month, disappear, and then something different would come in. There was a central focus on this artist or whatever the show was. And then you rarely saw the things again. And I don't think Rochester worked that way. Rochester took longer to appreciate things, I think.

In the early 1980s, I joined a group that was trying to interest Kodak in TV work. Not what management really wanted, and I thought it would be a hard sell. Greenlaw was the name of the Kodak fellow who was putting together the program and he told top management that a few years down the pike, ordinary Kodak film cameras would be sold only through the nostalgia trade. It was a very good analysis of what might, and did, happen. They wanted me to be a Kodak representative in Silicon Valley. I didn't feel as though I had the background for anything like that and I panicked a little bit. I didn't know a damn thing about digital technology. At the time, I was working with the most advanced computer. It was fairly large and totally limited and ridiculous when you look back on it. We were allowed to put some things together, but it got to the point where I saw that Kodak was sort of stuck. And then along came this remarkable offer from Kodak for retirement. I could afford to retire, so in 1984 I did—and many others did, too.

One of the things we're aware of is that we've got a lot of stuff packed away. We're just loaded down. But it helps to hold the house on its foundation during earthquakes. Part of the business of being idiotic pottery collectors was probably a talking point amongst friends: "They're the crazy people who have more pots than you can possibly imagine." But, do I ever miss the Wildenhain pots? I miss clutter. You realize that putting them together in such a way that they don't appear to fight each other in your sights is a real challenge. And having so few of them reduces that to a non-problem. I miss the pots. There's no doubt I miss them.

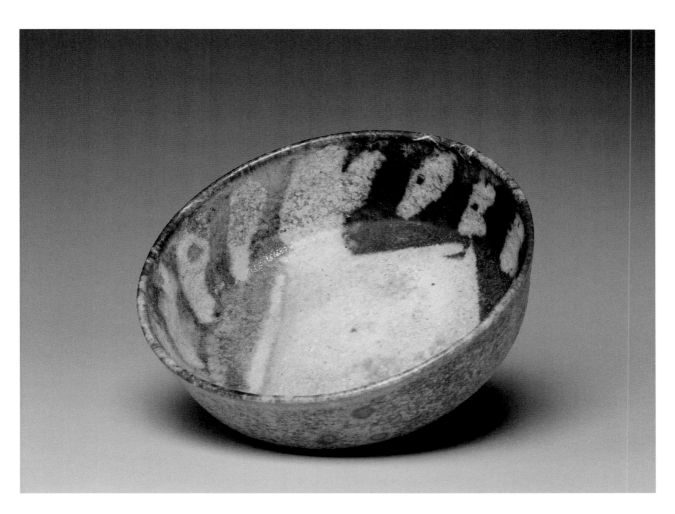

STONEWARE
2.75 x 6 inches, soda fired

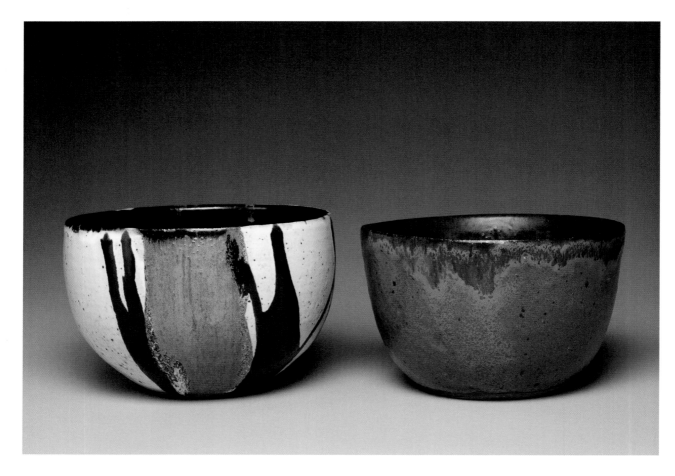

LEFT: **STONEWARE**
5.75 x 8 inches, reduction fired

RIGHT: **STONEWARE**
5.5 x 7.5 inches, reduction fired

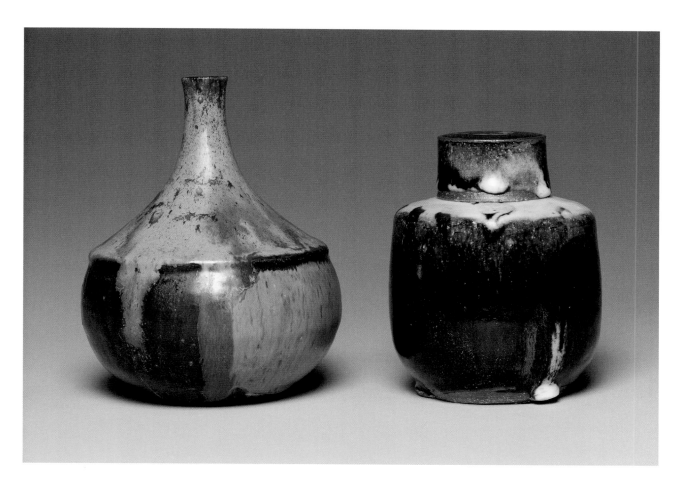

LEFT: **EARTHENWARE**
7.5 x 6 inches, oxidation fired

RIGHT: **EARTHENWARE**
6 x 4.75 inches, reduction fired

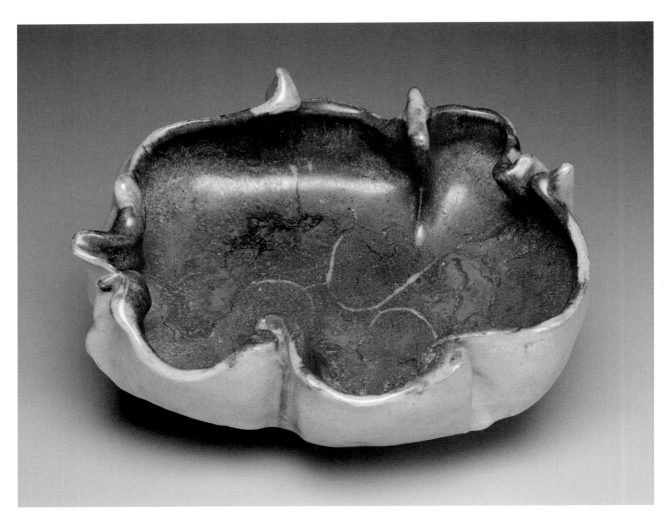

EARTHENWARE
5.5 x 11.25 x 9.75 inches, reduction fired

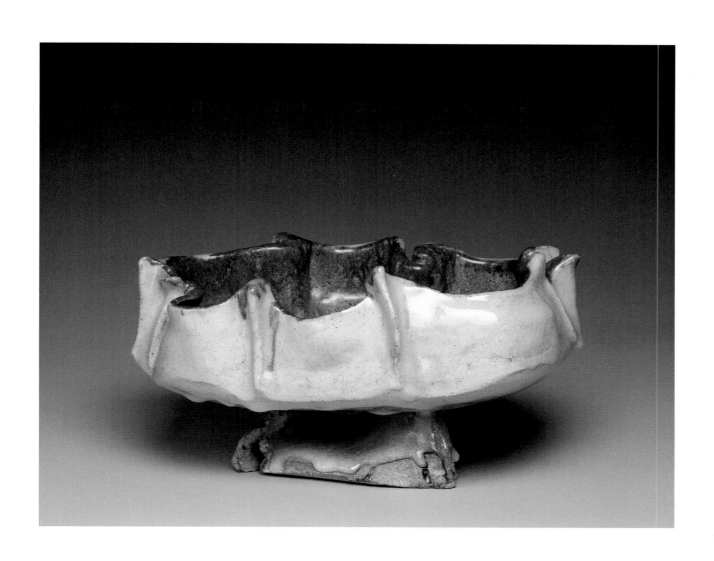

BRUCE A. AUSTIN

Rochester Institute of Technology

College of Liberal Arts

92 Lomb Memorial Drive

Rochester, NY 14623-5604

www.rit.edu/wild